A HANDBOOK OF ROMANESQUE ART

A HANDBOOK OF ROMANESQUE ART

BY

J. J. M. TIMMERS

THE MACMILLAN COMPANY

Library of Congress Catalog Card Number: 79–80800

Translated by Marian Powell

First American Edition 1969

First published in the Netherlands in 1965 under the title *Atlas van het Romaans*
Copyright © 1965 by N.V. Uitgeversmaatschappij Elsevier

This edition was first published in Great Britain in 1969 by Thomas Nelson and Sons Ltd

The Macmillan Company

Printed in the Netherlands and Great Britain

CONTENTS

THE BRITISH ISLES

✝ ○ Church

SHETLAND

Kirkwall
ORKNEY

HEBRIDES

Glenmore

SCOTLAND

ATLANTIC OCEAN

NORTH SEA

Forth ✝ Dunfermline
Clyde
✝ Kelso

Tyne
✝ Durham

Bann

ISLE OF MAN

Ripon ✝ York
Ouse

IRISH SEA

Tuam ✝
Shannon

Humber

Dublin ✝
Glendalough ○

Lincoln ✝

Southwell ✝
Trent

ENGLAND

Norwich ✝
Ely ✝

Cashel ✝

Barrow

Peterborough ○

Severn

Ouse

Worcester ✝
Hereford ○
Tewkesbury ✝
Gloucester ○ Oxford ○ St. Albans ✝
Iffley ✝ London ✝
Malmesbury ✝ Rochester ○
Thames Canterbury ✝
Old Sarum ○ ✝ Winchester
Romsey ✝
Exeter ○ ✝ Chichester
ISLE OF WIGHT

ENGLISH CHANNEL

FRANC

PREFACE

When attempting to treat within a small compass a subject as comprehensive as Romanesque art, the writer is forced both to make a limited selection of material and to stress certain aspects at the expense of others: only thus can he escape the risk of superficiality. Most emphasis in this book has been given to architecture, the mother of all the arts. Then come sculpture and painting, subjects closely related to architecture; and finally the applied arts. The author has tried as far as possible to avoid the slippery path of controversy and argument, since the limited scope of the work made it undesirable to stray far from the main theme. At the same time he has attempted to express his own views, even where they deviate from current opinion.

Moreover the writer has tried to avoid the mistake, so often made, of projecting the image of a past civilization upon a Europe with nineteenth- or twentieth-century frontiers. For instance, Alsace, Lorraine and part of northeastern France belonged to the German countries in the Romanesque period, whatever changes may have been made in subsequent times. The same applies to the bishoprics of Liège and Utrecht, in other words, eastern Belgium and the Netherlands of the present day; while Flanders and Hainault in the period under discussion were within the French zone of influence. History is our witness that we are not guilty of political bias.

Romanesque art is at present enjoying a period of great popularity, especially as regards its purely visual qualities. This is not really surprising, for modern man is attracted more by abstract and stylized themes than by any kind of naturalism, the more so since he is increasingly confronted on all sides by a super-abundance of realism in daily life. But to admire only the anti-naturalistic aspect of Romanesque art implies an almost total lack of understanding. This art movement can be approached in the right manner only by learning exactly why it avoided realism, by understanding the spiritual motives inspiring it, by knowing its background and the whole of which it formed part. If the following pages are helpful in creating this attitude, the writer will have achieved his purpose.

J. J. M. TIMMERS

1. ROMANESQUE ART:

ITS NATURE AND ORIGIN

It is obvious that, like any other style of art or architecture, Romanesque not only reflects a particular attitude to life, but at the same time constitutes a certain phase in a wider development. It was a phenomenon that grew logically out of its predecessor, however different this may have been. Eventually it was to become what Foçillon called the *première définition de l'Occident*, i.e. the first style that belonged wholly to the West. In other words Romanesque has to be set over against the art of eastern Christendom, and this in spite of the fact that in architecture, and even more in art, the influence of the East, and in particular of Byzantium was not negligible. This was due not only to the persistence of Byzantine prestige, but even more to the many specific contacts which existed throughout the period between West and East, as a result of the Crusades and of trade relations — which were by no means limited to Byzantium.

These first manifestations of western self-consciousness began to take shape *c.* 950, after a long period of groping and experiment. Why did it happen just at that time? What ultimately caused it? Was it a recovery after the chaos and disasters which attended the last convulsions of the Migration Period, i.e. the invasions of the Norsemen, Magyars and Saracens? Was it the closer contact established at this time between the peoples on both sides of the Alps and of the Pyrenees? Was it the integration of all the Western peoples into one Church, which developed into an all-embracing and unifying organism both as regards doctrine and organization? Or was it the gradual consolidation of great European states, which, in spite of their political independence, felt themselves united within western Christendom under Rome? The *première définition de l'Occident* was brought about not by any one of these alone but rather by their combined effect. For the first time we can identify a style and common forms which, although they vary in expression from nation to nation and region to region yet possess a unity that transcends all divergencies. The Romanesque architecture of Normandy may differ from that of Aquitaine, and this in turn may differ from that of Pisa or Apulia, but all betray trends that are clearly and unmistakably Romanesque.

The term 'Romanesque' was first used in the nineteenth century by the French antiquarian de Gerville, who in 1818 referred to *l'architecture lourde et grossière . . . opus romanum dénaturé ou successivement dégradé par nos rudes ancêtres*. Notwithstanding the disparagement expressed in this first mention of the Romanesque—*opus romanum dénaturé*—we nowadays realize more and

more clearly that de Gerville was correct in his definition. The classical Roman tradition which preceded and overlapped the Early Christian period was an important, possibly even the most important, point of departure in the development of all Romanesque art.

The first steps in the visual arts were guided by Byzantium. On the other hand, apart from several external influences, the contributions of the various barbarian races were to be decisive factors, particularly in the decorative field.

The visual arts provide an important clue to understanding the essence of Romanesque. It was by nature abstract just as in the life of the spirit; it was concerned solely with the supernatural which it approached with a grave solemnity. It eschewed all realism. In contrast to classical art, which represented the divine in human terms, it transposed earthly forms into spiritual and abstract conceptions. When towards the end of the period— that is, around 1200—a certain measure of realism crept back into art, it was a sign either of the approach of Gothic or else of Italian influence from over the Alps where the spirit of classicism had never been entirely extinguished.

What were the common elements so characteristic of all Romanesque architecture? Primarily they were to be found in an urge towards monumentality, a unified and purified conception of space, and in the harmonious balance of proportions. Now these characteristics were also typical of Latin classicism. From a purely formal point of view, the development of Gothic consisted of a gradual violation of this Romanesque harmony and unity, by emphasizing height and depth at the expense of width, and by the diffusion of a no longer rational kind of space. Gothic thus represented the victory of the Transalpine spirit over the Latin tradition. It was hard won but decisive, and this was the main reason why northern Gothic was never able to flourish in Italy.

In this process the technique of vaulting played an important part. It used to be said, and is still at times repeated, that this architectural feature was explained by the necessity of replacing the open timber roofs of the basilicas, in order to avoid the risk of fire and to strengthen construction. The static problem of the pressure of vaulting on the side walls was said to have led in turn to the use of heavier masses, of small windows, strong pillars and piers, and of buttresses to strengthen the walls. Undoubtedly this theory contains a large element of truth. But it is wrong to explain a style, which is a spiritual process, by arguments based on material and practical consideration. On the contrary the opposite should be the case. Thus it was a change of taste and a different aesthetic point of view which in turn had their origins in a new and vigorous state of mind, which led architects to find new solutions for technical problems. In any case, it would have been surprising if builders had taken seven centuries to realize that timber ceilings burn more easily than stone vaults, especially as the Romans

had already mastered the techniques of vaulting, and numerous examples of their achievements were still to be seen.

It seems evident that the clear and brightly-lit basilicas matched in spirit the declining years of classical civilization; whereas the severe, solemn and majestic Romanesque naves, vaulted and dimly lit, with their massive detail and thoroughly plastic conception of architecture striving after contrasts of light and shade were symptomatic of an entirely different mental attitude. Romanesque man felt small and insignificant confronted by the mystery and majesty of Almighty God and the awesome prospect of life after death. Compare, for example, the interiors of the basilicas at Rome or Ravenna (Plate 2) with Sant' Ambrogio at Milan (Plate 17). All the same, the conception of space in the last is harmonious and typically Latin.

Western architects were to adhere in essentials to the types of church created in late antiquity. For the most part the basilican plan remained in favour: a wide and lofty nave, with lower and narrower aisles; a transept, and an enclosed choir which was usually semi-circular. But even when this shape was rejected in favour of a centrally-planned structure, as in Charlemagne's Palatine Chapel at Aachen (Plates 5 and 7), the round or polygonal central space, surrounded by lower aisles, had Early Christian prototypes in both Italy and Byzantium, e.g. Sta Constanza and S. Stefano Rotondo in Rome; S. Lorenzo Maggiore in Milan, S. Vitale in Ravenna, and SS. Sergius and Bacchus in Constantinople. A centrally planned structure with four equal branches opening from each side of a higher square space, such as the Carolingian church at Germigny des Prés (Plate 6), is in some respects similar to the mausoleum of Galla Placidia in Ravenna (Plate 1). Smaller churches like Sta Christina de Lena in northern Spain, which has a nave without aisles, remind us of a building such as Sta Balbina in Rome, whose origin may even go back to pre-Christian times.

In the Carolingian period none of this is surprising. Like other founders of short-lived empires, fascinated by the ideal of the *Imperium Romanum*, Charlemagne also attempted to graft on to the art of his own time that of the Roman Empire. This Carolingian 'Renaissance' was the first example of a neo-art, and as such was the typical product of an epoch in ferment, which had not yet found its own style. This borrowing from antiquity was carried to such lengths that columns, capitals and other works of art were transported from Rome and Ravenna to Aachen—no easy matter at that time— where architects incorporated them in the emperor's building projects. True, the bronze doors and gates of the Palatine Chapel were cast locally, but whence came the craftsmen who carried out this work? In any case, the art of Charlemagne's court, based on antiquity, prepared the way for one of the first forms of Romanesque: Ottonian art.

Already in the Early Christian period an element was introduced which was to become of great significance in the Romanesque era, namely, the crypt or undercroft. The custom of building churches over the graves of

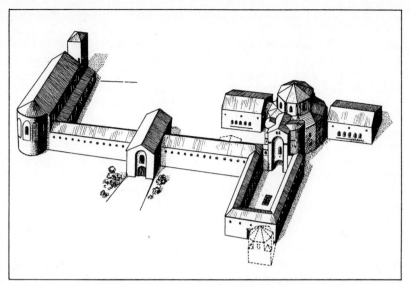

Reconstruction of Charlemagne's palace and the Palatine Chapel, Aachen.

martyrs, with access to the catacombs, is evident in various very ancient structures in Rome (e.g. S. Lorenzo and Sant' Agnese, both *fuori le mura*). The use of *memoriæ*, i.e. tomb structures entirely or partly above ground, culminated in the construction of Constantine's St Peter's, in which at a later date a so-called ring-crypt was inserted giving access to the *confessio*. This was a subterranean room in front of the actual tomb (*memoria* or *martyrion*). The ring-crypt consisted of a semi-circular passage, approached at either end from inside the church, and following the curve of the apse, with a straight passage leading back from the middle to the *confessio* under the high altar. The whole of this structure was built under a raised choir. It is not surprising that many Carolingian and later Ottonian churches should have been inspired by this late sixth-century arrangement in old St Peter's. At St Gall, for instance, several passages led from the ring-crypt to the saint's tomb. Flourishing martyr-cults and the translation of relics from the catacombs to churches inside the city walls of Rome, led to the development of more spacious crypts forming veritable subterranean churches. That of Sta Maria in Cosmedin dating from the last quarter of the eighth century is probably the oldest of these. The veneration of more than one saint in one church necessitated the setting up of an ever increasing number of altars in separate chapels round or near the presbytery. This consideration probably lay behind the construction of a second choir, sometimes with its own transept at the western end of the nave. Another related development

was what is called the westwork. This was a tower or complex of towers rising out of a multi-storeyed structure at the west end of the church. A celebrated early example of one of these was recorded in a drawing of the abbey church at Centula (St-Riquier) in France. Others still survive at Corvey and Werden in Germany. In the latter country in particular westworks remain a conspicuous feature of Romanesque churches.

Ravenna's part in the development of the Romanesque was not confined to the supplying of structural fragments. Not only churches but also the secular residences of the later emperors, and the Ostrogothic kings and Byzantine exarchs, directly influenced the architecture of the adjoining Po valley. The plan of the three-aisled basilica, usually without a transept, was taken up and copied there fairly frequently. But further north, too, the style of Ravenna appears to have exerted its influence: the external division of the walls by pilaster strips and arches which enclose the windows (Plate 3) and enliven the walls, was imitated on the exteriors of Ottonian churches, and possibly contributed to the appearance of the Lombard style. The fact that the architects of Ravenna favoured polygonal apses (Plate 3), sometimes decorated with blind arches and rows of windows under an arcade supported by small pillars, may also have had some effect in the north. It is, moreover, a remarkable fact, not yet satisfactorily explained, that the visual arts of the Mosan region were influenced in their subject-matter by those of Ravenna.

It should also be taken into account that Romanesque architects studied the remains of Roman buildings, especially in regions where these were numerous. This is obvious in Burgundy, particularly at Autun (p. 80); in Provence (p. 98), and elsewhere in southern France (p. 98), not to mention Italy. The regions under Roman influence also included the valleys of the Rhine and Meuse. The so-called *basilica* at Trier, which was in fact the *aula regia* of the imperial palace (Plate 8), evidently inspired Charlemagne to imitate it in his own palace at Aachen the remains of which are still preserved in the walls of the town hall. Moreover the basilica at Trier was articulated with arches and pilaster strips like those in Ravenna. The Porta Nigra in

1. The mausoleum of Galla Placidia in Ravenna is a cruciform structure with a square cupola. The exterior is decorated with blind arches. **2.** The Early Christian basilicas with their perfect spatial balance are classical in spirit. **3.** The exterior of Sant' Apollinare in Classe has blind arches surrounding the windows. **4.** In the mausoleum of Theodoric in Ravenna, imported motifs are blended with classical themes. **5, 7.** Charlemagne's palace chapel in Aachen is a copy of S. Vitale in Ravenna (which in its turn is based on Byzantine examples), and contains classical columns from Ravenna. **6.** The church of Germigny-des-Prés also is Carolingian. **8.** The so-called *basilica* in Trier, the *aula regia* of the Late Roman imperial palace, is akin to Ravenna. **9.** The Porta Nigra, also in Trier, provided numerous useful motifs for the Romanesque architects.

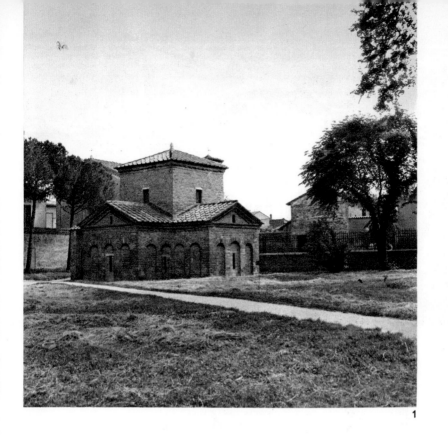

1

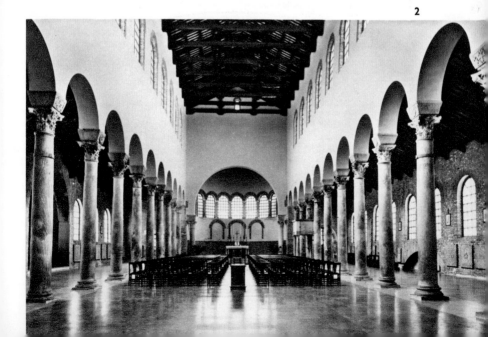

2

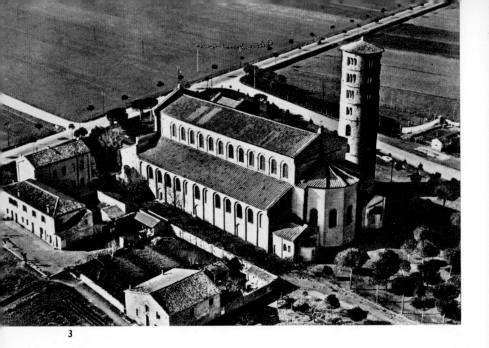

3

4

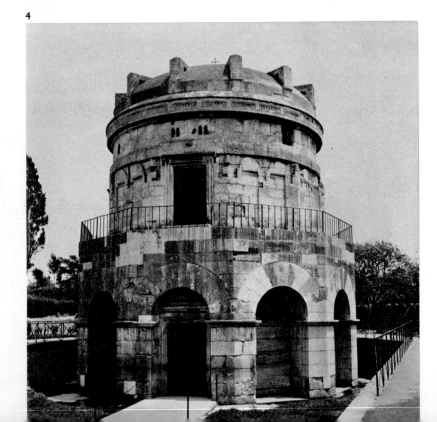

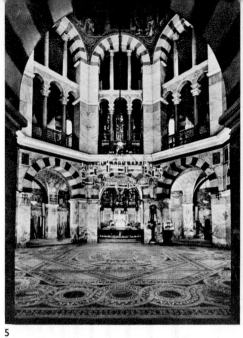

5

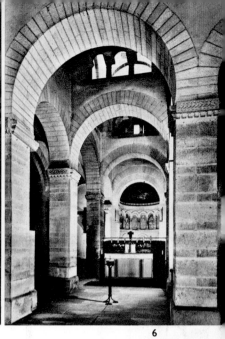

6

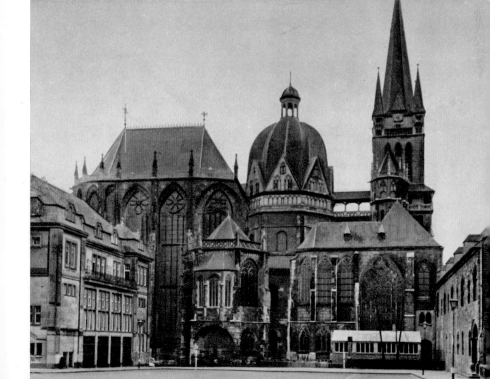

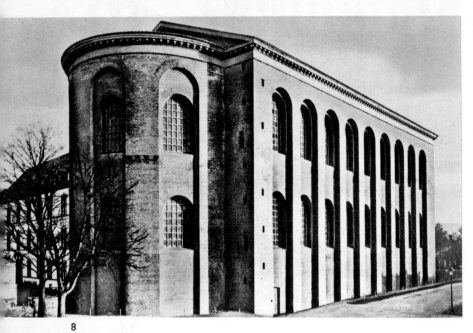

8

9

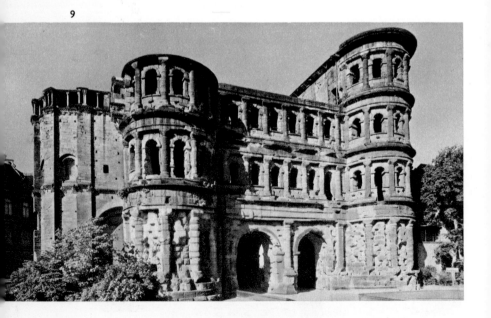

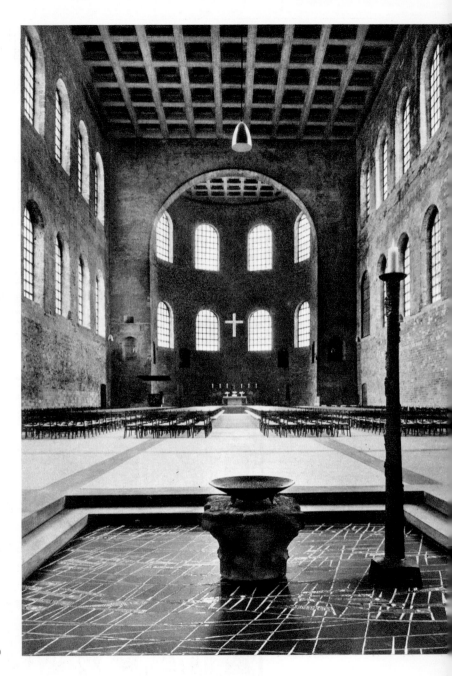

11

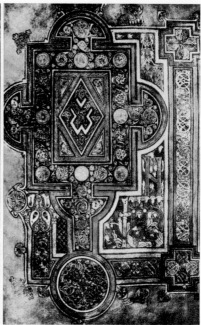

12

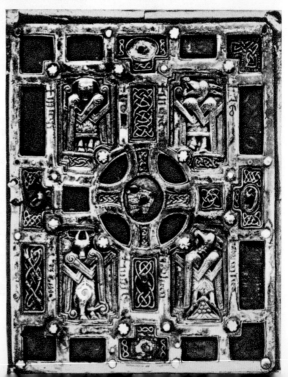

13

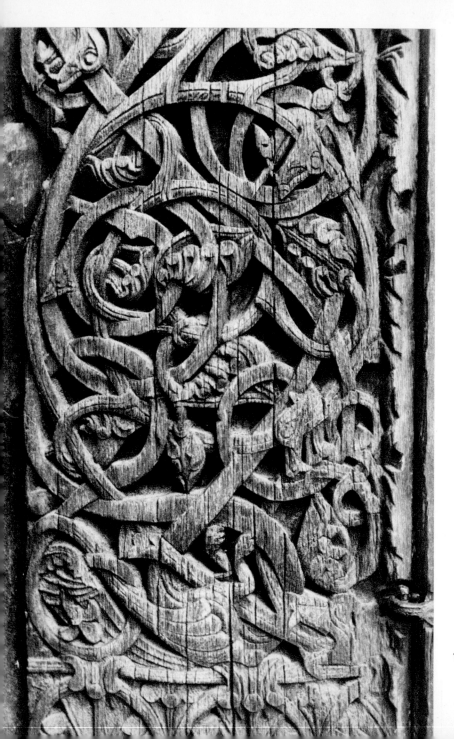

15

Trier (turned into a church during the eleventh century by the addition of an apse) (Plate 9), with its arches framed by half-columns and architraves, also provided a range of architectural forms from which Romanesque architects could benefit. In the valley of the Meuse, sculptors and silversmiths were inspired by Gallo-Roman themes. It seems probable, for instance, that when Rainier of Huy made his bronze font at Liège (Plate 171) he was thinking of a Roman stone *puteal*, or well-head; and that the bust of St Alexander in Brussels was based on that of a Roman emperor. One could mention countless similar examples.

On the other hand the contributions of the various Teutonic tribes were also of great importance. Those which at the time of the Migration advanced into western Europe from the east brought with them for their own abstract decorative art. This was related to that of the Celts who had for centuries occupied France, the British Isles and Northern Italy (Gallia Cisalpina) and who by then had been thoroughly romanized. The principal motif of barbarian art was the interlace. In all probability, they originally used branches or vegetable strands, but later, in the regions where they finally settled, we find interlaces in stone or wood sculpture, in metal, or in line-drawing on parchment. Sometimes fantastically stylized animal motifs were incorporated into the interlace. Three main groups may be distinguished. The first comprised a series of stone reliefs, no doubt originally vividly coloured. The distribution of these ranges from the Dalmatian coast to the Po Valley and seems to be connected with the peregrinations of the Lombards who after 568 settled in north and central Italy (Plate 4). From there the artistic skill of the tribe spread in all directions, and was later to provide the Romanesque art of Lombardy with a model of abstract decoration as well as a taste for grotesque monsters. A second group is centred on Scandinavia, where it must have been brought by the ancestors of the Vikings or the Norsemen who were later to terrorize western Europe. Their art is known to us (e.g. in the fantastic wooden sculpture of the Oseberg ship) and its influence persisted right through the twelfth century

10. The basilica in Trier is related to Early Christian structures. **11.** The Lombard *tempietto* at Cividale: detail. **12.** Irish miniatures show a preference for extremely intricate interlace. **13.** Related motifs are found in metal-work: Irish book-chest. Nevertheless, interlace motifs in their purest form are found in Lombard decorative art; they usually consist of intertwined triple bands (cf. illustration on p. 23). On the whole, the human figure is avoided; on the rare occasions when it does occur, it is inaccurate and purely ornamental. **14.** Ivory plaque from Genoels-Elderen (Belgium): the border decoration of this relief, which probably dates from the Carolingian period, is reminiscent of the Lombard interlace motif. **15.** Related art forms are found in Scandinavia. They survived up to the twelfth century; cf. the carved panel from the timber 'stave church' at Borgund (Norway).

21

and beyond in the carving on the timber stave churches (Plate 15). A third branch of the Teutonic family, the Anglo-Saxons, proceeded far to the west and eventually settled in England. Their art, first found in metal work (Plate 13) and later more especially in the rich decoration of manuscripts (Plate 12), also made lavish use of interlace motifs.

In all these kinds of art the human figure presented an exceptionally difficult anomaly and it usually either degenerated into caricature or else became pure ornament.

Incidentally, the extent to which these Teutonic tribes remained nomadic is remarkable. The Lombards, right through their history, even as late as the eighteenth century, were to scatter all over Europe as craftsmen, architects and stonemasons. The Normans had a less savoury reputation, but as migrants they settled in western France and in Sicily. The Anglo-Saxons like their Irish neighbours chose a more peaceful method of exerting their influence on Europe. They produced the great missionaries of the seventh and eighth centuries who were to spread Christianity among the last pagan Germans of the mainland.

The contribution of the Migration peoples to the development of the new art of Europe was mainly confined to decoration. In architecture, the Mediterranean remained unchallenged. It is true that Theodoric's mausoleum in Ravenna (sixth century) contains, apart from a number of specific antique motifs, features which were unknown in classical times such as the enormous Istrian monolith, 35 feet in diameter, which serves as a cupola, and the abstract ornamental moulding underneath. The zigzag jointing of the arches is not classical either. But perhaps it is just the combination of classical and non-classical elements which makes this building strike us as being already almost Romanesque in character (Plate 4).

The Lombard remains at Cividale del Friuli, of which the famous *tempietto* (near Santa Maria in Valle) is the most important, are of a later date. The *tempietto* consists of a square groin-vaulted room and a rectangular choir of equal width, which is lower and has three parallel barrel vaults resting on horizontal architraves supported by pillars. On the exterior we find the same pilaster strips and blind arcading as in Ravenna. Nothing remains of the mosaics which once decorated the vaults, but we may still see the stucco decoration inside, on the wall over the entrance. On either side of the central window, above a richly decorated archway, are three figures in high relief (Plate 11). Originally they were polychrome and their colours corresponded to those of frescoes on the walls. Here and there, especially in the lintel above the entrance and in the window frames, the characteristic interlace motif recurs. It is now thought that the whole dates from the eighth or ninth century. In every way it is a forerunner of the Romanesque method of decoration with sculptured arches and relief friezes.

Another important element of Romanesque art is its predominantly monastic character. Much of the credit for it is ultimately due to the work of

missionary monks who laid the foundations on which Romanesque culture was to be based. It is noteworthy that it was again the Irish and Anglo-Saxon monks who took the lead. Together with the Gospel, they introduced the interlace motif of their insular art into the continent, where it was to find its way even into Carolingian works of art, as for instance the famous ivory diptych of Genoels-Elderen (Brussels: Plate 14). All the great cultural

(Left) Irish initial, and *(right)* Lombard relief with interlace motif.

centres of the pre-Romanesque era were monasteries. St Gall in Switzerland, Reichenau on Lake Constance, Bobbio and Monte Cassino in Italy, Echternach between the Rhine and Meuse; Montserrat and Ripoll in Catalonia; St-Martin at Tours, Centula (St-Riquier), Fleury (St-Benoît-sur-Loire), Cluny and countless others in France; Werden, Hersfeld and Limburg-an-der-Haardt in Germany. These are only a random selection from an immense number. It is incredible how much Western civilization owes to the monasteries. It was they, who during the 'dark ages' preserved classical civilization. It was in their *scriptoria* that the works of Greek and Latin authors were copied and studied. It was they who, together with the Church as a whole, enabled Christian civilization to enrich itself with the heritage of Ancient Greece and Rome, in the course of a cultural epoch lasting more than a thousand years. They were also in many respects the principal mediators between Romanesque art and classical antiquity. In Burgundy, the reformed Benedictines of the Cluniac congregation started a European movement whose influence reached far beyond the boundaries of their province or even of France as a whole, which made a significant contribution

to the common element in the Romanesque style. On the other hand the Cistercians introduced a touch of virile simplicity, subsequently to be reflected in the churches of the mendicant orders.

The order and unity of the Byzantine Empire presented a sharp contrast to the confusion and chaos created in the West by the fall of the Roman Empire. It is therefore not surprising that as early as the fifth century, the Eastern Empire achieved a definite style with an iconography of its own. The West, still groping, gladly borrowed from the store of Byzantine riches, not just themes and ideas, but also techniques and skills. The Fourth Crusade (1204) expended its energies on the sack of Byzantium, and all kinds of works of art still in Western collections remind us even now of this unedifying episode in the relations between East and West. But the West had profited from Byzantine forms and styles much earlier than this. They were to be found in the buildings, mosaics and paintings of Rome and Ravenna. They were transmitted to other countries by means of ivory reliefs and precious fabrics. The latter moreover introduced other influences at second hand, for the art of Sassanid Persia (224–642) exercised an influence over Byzantium through imported woven fabrics. All kinds of motifs, among them linked animal figures, were passed on to the West, where Romanesque sculptors eagerly made use of them in the design of capitals, bases and various other forms of decorative sculpture.

Summing up one might say that in the period extending from the fourth century, when the first large basilicas were built for the purpose of Christian worship, to the second half of the tenth century, when the first western European style of the Middle Ages emerged, various elements presented themselves at different places and times, which influenced each other and were gradually linked into a definite style. The chief factors were: the classical and Early Christian heritage; the contributions of the migrating tribes, contemporary Byzantine culture, the Sassanid East, and not least Islam. The process of fusion was deeply affected by the Carolingian Renaissance and the monastic orders. One important qualification that should be made, however, is that in architecture, in some ways the most important of the arts, structural developments by 950 had as yet scarcely begun to affect the basic form of the basilica. The degree to which the basilica was transformed is one of the surest yardsticks of Romanesque development.

2. ITALY

GENERAL INTRODUCTION

Just as Italy in this period was politically disunited, so also the Romanesque art of the country was extremely varied. There were divergencies not only between the regions (e.g. the Lombard, north Tuscany, Rome with its classical and Early Christian past, and the south with its ethnographical

complications represented by Greeks and Arabs), but also at times between city and city, or cities and their surrounding countryside. One can detect such tensions between Pisa and Florence for instance, or between Milan and the rest of Lombardy. Moreover the maritime cities of Italy were open to all manner of influences from the Middle East. It was through them that the West became aware of Sassanidan fabrics and Armenian architecture. All through the period Byzantine styles, either indirectly from Ravenna or directly as a result of Venetian trade, were to be of lasting significance. This was already apparent in Italian art under the Ottonian and Salian dynasties, when the widespread Early Christian inspiration of the preceding Carolingian period gradually gave way to the rigidity and symmetry of Byzantium: compare, for instance, the reliefs of Cividale (eighth–ninth century) with the altar ciboria in Sant' Ambrogio, Milan (c. 1018–1045) or at Civate (late eleventh century). The same development may be discerned in painting and mosaics. Architecture, while still preoccupied with basilican church designs, freed itself of the slavish imitation so characteristic of the Carolingian period.

ARCHITECTURE IN NORTHERN ITALY

The development of Romanesque architecture in northern Italy was largely concerned with two features: a system of external decoration, which eventually merged with the wider problems of architectural sculpture; and a system of internal articulation which culminated with the introduction of vaulting. These themes were probably connected right from the start, although the decoration is generally considered first. In its earliest form the latter consisted of vertical pilaster strips connected at the top by small blind arcades or arched recesses, three or four between each pair of pilasters. The name 'Lombard bands' is sometimes applied to this distinctive kind of ornament, which made an early appearance in Lombardy, e.g. S. Vincenzo al Prato, Milan, Agliate, etc. But its origins have been sought in the Early Christian buildings of Ravenna and Syria, and that it came to Italy from the East seems practically certain. From Italy it spread with few modifications round the western Mediterranean to Catalonia; up the Rhône Valley, across the Alps to the Rhineland and the Meuse, to south Germany, Austria, Dalmatia, Poland and the western parts of Russia, and even to Scandinavia. This very widespread distribution has been connected with the hypothetical movements of masons from Como, the *maestri comacini*, but it is perhaps best to leave this aspect of the matter open and simply accept the occurrence of Lombard bands as evidence for the primacy of Italy in the genesis of Romanesque art forms.

The presence of Lombard bands alone is not sufficient to qualify a building for the description 'First Romanesque'. The former is a style of ornament; the latter refers to a style or phase in the history of architecture. In the last analysis it was a preoccupation with the structural and aesthetic problems of vaulting that turned the pre-Romanesque basilican architecture

of northern Italy into Romanesque, even if the number of vaults that have actually survived is not large. Inevitably Italian architects must have consulted the surviving monuments of imperial Rome for instruction in the techniques of vaulting; and it is therefore not surprising to find them experimenting with the principal Roman types of vault, i.e. the barrel and the groin, and the reinforced groin which became in due course the ribbed vault. Vaults eventually took the place of the open wooden roofs of the earlier basilicas and in doing so they set in motion a whole sequence of other modifications. Basilican walls carried on slender columns were unable to sustain the heavy weights and thrusts of masonry vaults. Thus barrel vaults, which needed more or less continuous support from below, were often constructed over thick and solid walls. Groined and ribbed vaults, in which the main thrusts were concentrated at the four corners, entailed the development of the reinforced or compound pier. These either replaced or disrupted the sequence of columns in the basilican arcade, and led ultimately to the conception of the bay as a fundamental element in church design. Bay systems, once recognized, had a life of their own, in the sense that they were not always crowned by vaults. For instance, they could be formed by diaphragm arches across the naves or aisles of churches.

Another way in which vaults affected basilican church design was through the necessity of providing adequate buttresses. Barrels and groins require different systems of buttressing—one continuous, the other interrupted. It is obvious that continuous buttressing at the critical levels was more or less incompatible with high clerestory windows—which was usually sufficient to explain why groined or ribbed vaults were preferred for main spans. In a church of any pretension, before the invention of flying buttresses, high vaults were usually buttressed by some species of gallery over the side aisles; and this is one reason why the gallery became a fairly ubiquitous feature of the full Romanesque church everywhere. But again, like bays, galleries could be, and were, used simply for the sake of the monumental dignity which they introduced into a church. They were one of the ways of altering the basic proportions of the building, and in particular of giving height to the elevation.

These remarks apply to the Romanesque architecture of Europe as a whole; but there are reasons for believing, in spite of the lack of much of the relevant evidence, that some of the crucial first steps in the transformation of the basilica into the Romanesque church, were taken in northern Italy. The contribution of northern Italy to this process has been much debated, especially the vexed question whether or not ribbed vaults were first used there. It cannot be denied that from this point of view Lombardy was much more in sympathy with the architecture of transalpine Europe than with that of the rest of Italy, where apart from isolated exceptions such as Montefiascone and Acerenza, vaults do not seem to have been considered an indispensable feature of the Romanesque church. On the other hand

medieval church vaulting is one of the achievements where the debt to Rome, if indirect, is at least unambiguous. The technical skills involved were part of the latest phase of the classical tradition, and they can only have reached north-west Europe from the Mediterranean. For this reason alone the claims of Italy demand a sympathetic consideration.

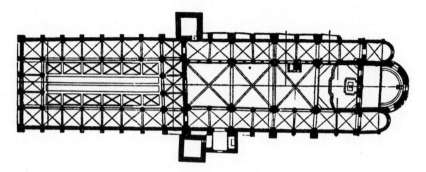

Groundplan of Sant' Ambrogio, Milan.

In spite of the loss of many of the major monuments, it is still possible to trace the stages through which the idea of the great church passed in northern Italy during the Romanesque period. Thus the nave of Sant' Abbondio at Como (mid eleventh century) only really differs from the Carolingian S. Salvatore at Brescia in the height of its main columns — instead of being monolithic shafts they are constructed from several blocks of stone, like piers. The cushion capitals, which surmount these, are smaller than the piers themselves and are presumably re-used. This puts them among the earliest examples of the type known. Otherwise, the double aisles, the open-timbered roof, and the indications of an atrium, all betoken Early Christian prototypes.

On the other hand, in the nave of Lomello (near Pavia) which cannot be much later than Sant' Abbondio, if at all, there is already a fully developed bay system, with diaphragm arches. But the decisive step was the introduction of vaults over major spans. Already at Agliate a barrel vault was constructed over the choir, in contrast to the open-timbered roof of the nave. At Sant' Abbondio there is a similar contrast although the choir vault there is groined and flanked by supporting towers. The date of Sant' Abbondio's choir is later than that of the nave, but presumably it precedes the papal dedication of 1096. The groined vaults of the nave of S. Teodoro at Pavia must be approximately contemporary.

These examples of groined vaults may have been earlier than the more famous ribs of Sant' Ambrogio, Milan, but there is no certainty that the two types were not developed side by side. Many Milanese churches had to be

rebuilt after disastrous fires in the 1070s; and in one of these, S. Nazzaro Maggiore, there are ribs which seem to pre-date 1100.

Be that as it may, Sant' Ambrogio and S. Michele at Pavia (after 1117) are by common consent regarded as the surviving masterpieces of Lombard Romanesque. Both have ribbed vaults; bay systems with alternating piers that result in square compartments for both nave and aisles, thus making vaulting easier; and galleries over the aisles. Sant' Ambrogio has no transept, while S. Michele has; and they differ also in the amount of sculptural decoration which they contain. S. Michele being far more profuse in this respect (Plate 18). No doubt many of the peculiarities of Sant' Ambrogio arise from the fact that it is basically a reconstruction of an earlier church on the same site; a tenth-century apse was incorporated and the atrium was an archaic feature deliberately preserved. This is an arcaded forecourt extending the full width of the church, with an open loggia across the front of the church (Plate 16).

One other north Italian church calls for comment. That is S. Fedele at Como (Plate 20). Its east end has three apses, one for the choir and two for the transepts. It may have been influenced by late Roman buildings (e.g. S. Lorenzo at Milan) but the home of such church designs in Romanesque Europe was Cologne. Another German feature is the open dwarf gallery round the eastern apse. This occurs in a number of Italian churches, but none of those known are certainly earlier than the German ones. The idea is an obvious development of the niches and arcades of First Romanesque, and it was only possible in churches with thick walls. The interaction between Germany and Italy at this time (*c.* 1100) was particularly close, and possibly not all in one direction.

What Sant' Ambrogio was for Lombardy, the cathedral of Modena was for Emilia (Plate 21). We know the name of the architect: Lanfranco. He began the building in 1099. It is built of brick but the exterior has a marble facing. Outside there is an elaborate external gallery round the choir, which assumes the character of a triforium. The same forms are repeated inside. The threefold division which characterizes this triforium, at the same time

16. Sant' Ambrogio, Milan, forms the starting point of the Romanesque style in northern Italy. **17.** In the interior we note Lombard alternation and square bays with rib vaulting. **18.** The façade of S. Michele in Pavia is a pure example of Lombard architecture. **19.** Piacenza Cathedral represents a subsequent phase of development. **20.** S. Fedele in Como contains an impressive trefoil-shaped chancel; the apse is surrounded by an open 'dwarf gallery'. **21.** Modena Cathedral is the most important Romanesque structure in Emilia. It is a perfect example of the work of the architect Lanfranco. Of great interest is the triforium, which continues around the entire building and is repeated in the interior. **22.** In contrast to Lombard churches, the façade is basilican in character and is decorated with characteristic porches supported by stylofore lions.

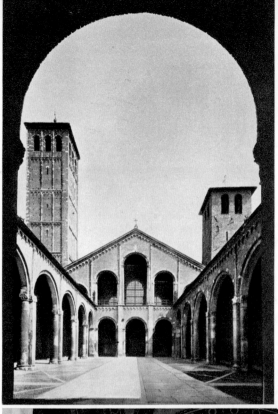

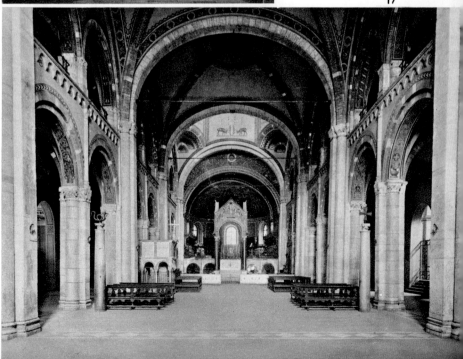

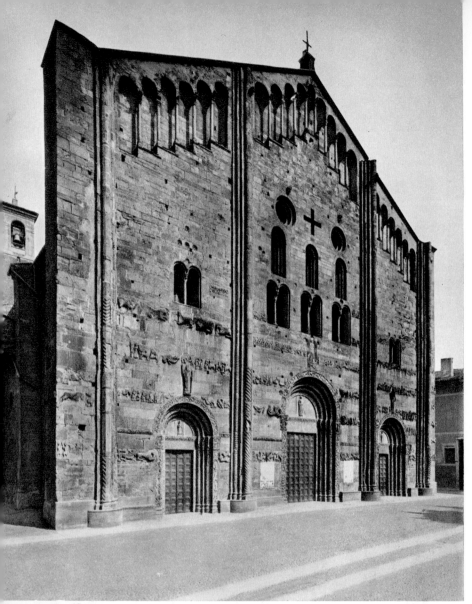

18

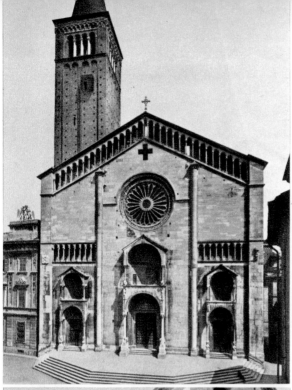

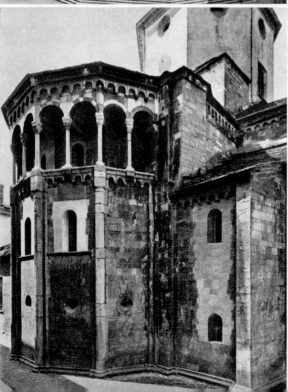

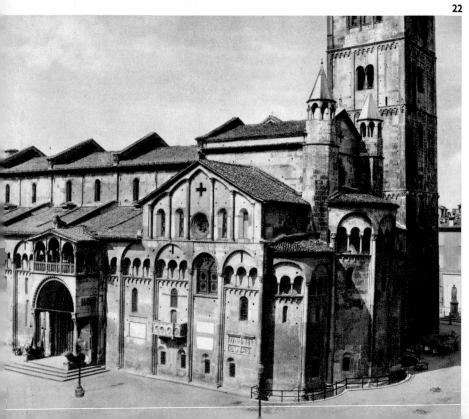

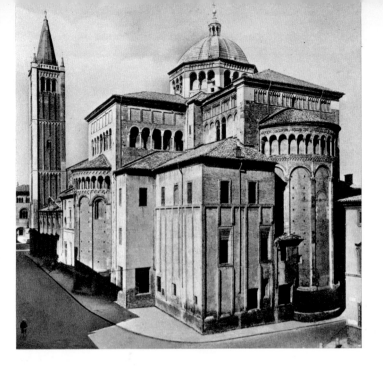

23

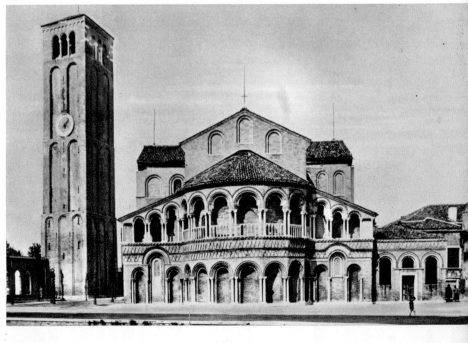

24

25

26

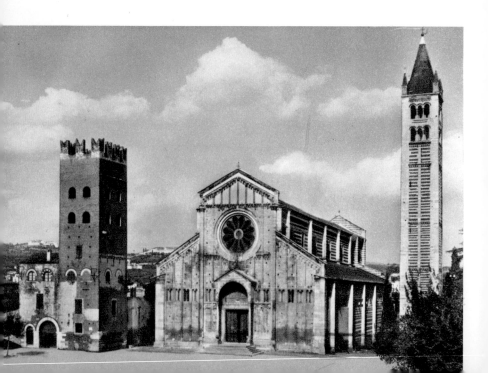

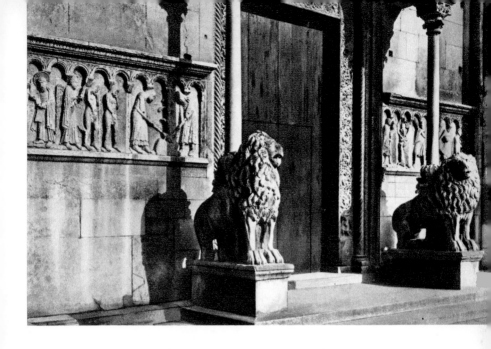

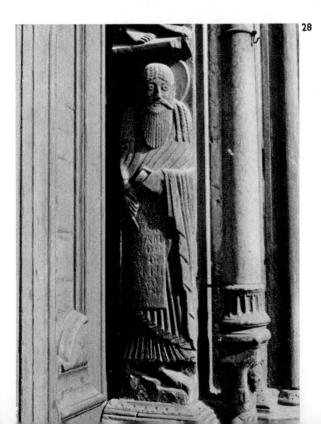

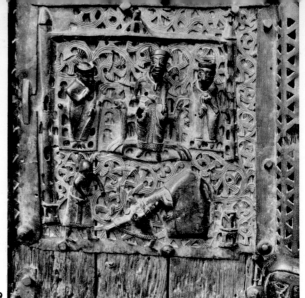

29

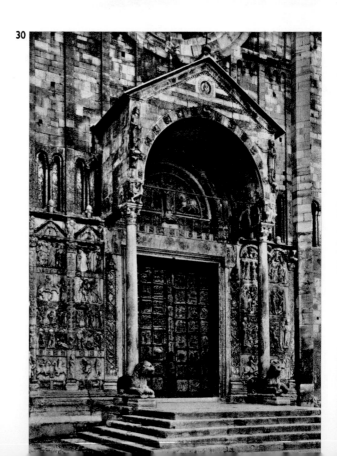

30

determines the structure of the façade both horizontally and vertically, although the magnificent rose window by Anselmo da Capione, which replaced an earlier, probably much smaller one towards the end of the twlefth century, to some extent disturbs the balance of the third and highest stage. The columns of the projecting central porch were supported by two Roman lions, a theme which was to be imitated all over Lombardy and Emilia and far beyond. The loggia-like second storey of the porch corresponds to the triforium zone, thus creating a direct link between the vertical and horizontal lines of the façade, characteristic of the monumental unity of all Lanfranco's work. The sculptural decoration of the panels of the façade and that of the *pontile* in front of the crypt will be discussed separately.

For a proper appreciation of the interior, it is essential to remember that the Romanesque church had an open-timbered roof—the vaults were added in the fourteenth century. Originally there were diaphragm arches which were probably round, not pointed. The internal triforium has a more gentle rhythm than that on the outside; it corresponds to that of the arcading, and is interrupted by powerful pilasters carrying the diaphragm arches. Here too the harmonious unity between horizontal and vertical lines predominates.

Lanfranco's design exerted considerable influence: the abbey church of Nonantola and the cathedrals of Ferrara and Cremona, as far as their Romanesque sections are concerned, are reminiscent of Modena. The same applies, although perhaps to a lesser degree, at Piacenza, Parma and Fidenza (Borgo S. Donnino). Most of these churches have porches with tribunes carried on lions. The cathedral of Piacenza, begun in 1122, is the only one in the series where the latter theme is repeated three times on the façade (Plate 19). At the same time, Lombard motifs (such as the shape of the façade which is related to that of S. Michele in Pavia, and the vaulting), blend with the Modenese features mentioned. The rose window here has retained its original form. Parma Cathedral, too, was rebuilt after the earthquake of 1117, and also has a Lombard façade in the manner of Modena. Of greater importance is the east end: a clear, massive and serenely decorated

23. The eastwork of Parma Cathedral is a miracle of perfect balance, and centuries later was to inspire Bramante. 24. The choir of the cathedral of Murano has exterior arcading on two levels. 26. The façade of S. Zeno in Verona shows affinity with Modena. The rose window was enlarged in 1178. 25. It has a fairly simple interior, lacking a triforium. Originally the church had an open roof construction. 27. Around 1100 Wiligelmo embellished the west porch of Modena Cathedral with sculpture. He was influenced by Aquitania and by ancient sarcophagi. 28. The figures of prophets on the west porch of Cremona Cathedral are more old-fashioned in style. 29, 30. The earliest sections of the bronze door-fittings of S. Zeno in Verona were influenced by Lombard art. The lay-out of the scenes is of an expressionist and predominantly decorative nature.

group surmounted by an octagonal dome at the crossing which was to inspire Bramante centuries later (Plate 23). In the interior French influence is noticeable in the rectangular bays with quadripartite vaults, and also in the composite piers; but this does not conflict with the Italian character of its spatial integration. We may also observe Lombard and Emilian themes elsewhere in northern Italy, e.g. in Piedmont, in the Sagra di S. Michele which resembles a hilltop citadel, and at Trento, where the cathedral was built in 1212 by Adamo di Arogno. But here we meet the influence of German Romanesque once more, in this case that of Speyer.

Venice and its hinterland occupied an exceptional place in the architecture of this period. It served as intermediary between the Romanesque West and the Byzantine East, while the strong Early Christian tradition of Ravenna, Aquileia and Istria (Parenzo) must also be taken into consideration. The design of S. Marco in Venice was evidently modelled on the Holy Apostles at Constantinople, with five circular cupolas and a groundplan in the shape of a Greek cross. The western arm is surrounded by an *endonarthex*, a low gallery consisting of a continuous series of small dome vaults. The only Romanesque features of this building are a number of decorative relief sculptures. The nearby cathedral of Murano is permeated with the spirit of Ravenna; externally it is decorated with blind arcading which, around the choir, deepens into niches behind small arches on double pillars, and on the second tier turns into an open gallery (Plate 24). It is obvious that here the Romanesque preoccupation with contrasts of light and shade asserted itself, and that generally in the lagoon region, the Lombardo–Emilian dwarf gallery was given a strong local yet also Byzantine twist.

It is not surprising that further inland the influence of Lombardy and Emilia increased once more. S. Zeno in Verona, for instance (rebuilt 1120) is again connected to Modena Cathedral. Here too the rose window was subsequently enlarged, this time in 1178 by Briotolado Balneo (Plate 26). The interior also reminds us of Modena, but the whole is less plastic, mainly as a result of the absence of tribunes or even of a triforium. Originally the church had an open roof structure; the existing timber vaulting dates from the Gothic period (Plate 25). The porch is related to that of Modena, but lacks the tribune on the second stage; it was in this form that the Emilian porch was to have a great future and was to be copied everywhere, even outside Italy (Plate 27).

Finally we must mention the magnificent chancel of Sta Maria in Bergamo (1137); the three apses with their dwarf galleries perhaps betray the influence of the east choir of Speyer Cathedral, built around 1100, possibly inspired by, or with the co-operation of, *maestri comacini* (see below).

SCULPTURE IN NORTHERN ITALY

Romanesque sculpture in northern Italy consists of two distinct styles: the Lombard and the Emilian. The former is a direct descendant of the art of

the Migration Period and has no connection with classical antiquity. It is chiefly a decorative art, and consequently strictly stylized. It has a propensity for grotesque animal figures which at times become almost abstract in form, and for all kinds of vegetable themes. Its motifs are carved in shallow relief, and therefore have little plastic force; nor does it show great concern for rhythm and balance. This again indicates its non-Latin origin. It is less polished than Emilian sculpture, but full of naïve fantasy, and closer to folk art with its preference for grotesque monsters. Yet it is deficient in expression and poetical inspiration. Unlike the Emilian sculptors, who practically always signed their work, the stonemasons of Lombardy are anonymous.

Emilian sculpture is the antithesis of that of Lombardy in nearly every respect: it is polished; it mastered the human figure and evidently made fruitful use of the heritage of classical antiquity. It is descriptive and epic, and its scenes are composed with care and skill. It is rational and intellectual; in short, it is a typically Latin and Italian product.

As a significant art-historical phenomenon, Emilian sculpture is of the first rank, and it would have been surprising if its earliest important master were to be found anywhere else than Modena. We refer to Wiligelmo, who between 1099 and 1106 created the sculpture on and around the main porch of Modena Cathedral. We are also indebted to him and his school for numerous capitals, while at the same time other sculptors took part in the ornamentation of the church. Wiligelmo's most important work is to be found in the four frieze panels showing scenes from the book of Genesis, on either side of the main porch (Plate 27). The marking of the drapery and at times the shapes of the heads as well, show affinity with the contemporary sculpture of Aquitaine (St-Sernin, Toulouse, 1096, and the cloisters of Moissac, completed in 1100). On the other hand it is obvious that Wiligelmo was inspired by antique carved sarcophagi: the figures are placed, without overlapping, against a neutral background; one scene follows another without perceptible demarcation. The way in which he manages to sum up the meaning of a scene with the aid of only a few figures reminds us of classical tragedy. The supporting features, too, are merely suggested: a tree with a few leaves represents paradise; a few wavy lines water; the oblique moulding on which figures stand or walk is the earth. The figures are more expressive in their attitudes and gestures than in their facial expression, and this too recalls classical tragedy. Everything is simple and clear; there is nothing superfluous, and events follow one another in a slow rhythm.

The façade of the cathedral of Cremona, rebuilt in the course of the twelfth century, incorporates various sculptures surviving from its predecessor which, begun in 1107, was destroyed while still incomplete in the great earthquake of 1117. Among these are the four large figures of prophets on the main porch; they are the work of an able sculptor, more old-fashioned than Wiligelmo, to whose development he may have contributed (Plate 28).

The sculptors who, after Wiligelmo's death, completed the decoration of Modena Cathedral, obviously came under the influence of Burgundian sculpture, e.g. Cluny, Autun and Vézelay. The slender, plastic figures of some of the reliefs on the south façade are in style closely related to the best of the Autun sculptures. In others there are still traces of the Wiligelmo tradition, but altered and weakened as a result of the Burgundian influence: for instance on the *Porta della Pescheria*, where there are scenes from the legend of King Arthur and where, in the personifications of the months, Wiligelmo's dramatic skill gives way to idyllic representation of countrymen at work. Yet another master created the reliefs which crown the buttresses of the nave like Greek metopes: both clothed and naked figures in various fantastic positions and attitudes, influenced by Burgundy, but at times reminiscent of the archaic art of ancient Greece.

A certain Niccolò in 1135 decorated the porch of Ferrara Cathedral with the figures of prophets, and with an equestrian St George on the tympanum.. He was influenced by Wiligelmo, but also by the art of Toulouse, which led to far-fetched effects in the attitudes of the figures and in the rhythm of outlines and drapery, creating a somewhat mannered impression. He overcame this mannerism to a great extent in the reliefs on either side of the main doorway on the façade of S. Zeno in Verona, which date from 1138. These represent episodes from the Book of Genesis and from the life of Christ, poetically and pictorially interpreted, with occasional vague indications of background and landscape. His assistant Guglielmo (not to be confused with Wiligelmo) was responsible for some of the scenes from the Gospel; his work is more arid and contrived than that of Niccolò.

Lombard sculpture of the same period now demands our attention. The entirely different approach of this art, which makes it quite distinct from that of Emilia, has already been referred to. We know it from the capitals and the stone pulpit of Sant' Ambrogio in Milan, from the various churches of Como, the pulpits of Isola S. Giulio in Lago d'Orta and of Gropina in the province of Arezzo, from the façade of S. Michele in Pavia (Plate 18) and many other places, not only in Lombardy but also in other regions of Italy. Moreover it was to spread further than that of Emilia, to many parts of Europe, especially the north. Again, the *maestri comacini* may have been involved. Its greatest achievements, such as the pulpit of Sant' Ambrogio, show the influence of provincial Roman and of Carolingian–Ottonian 'imperial art' as well as links with the pre-Romanesque Longobard art from the Migration Period. We notice furthermore how freely both schools crossed the boundaries of their respective territories: the capitals of Parma Cathedral in Emilia, for instance, are Lombard, although naturally somewhat under Emilian influence. This is evident from a well-known capital in the series, which in a sharply satirical manner represents two wolves and an ass, dressed as monks, with the inscription: *est monachus factus lupus ab asino sub dogmate tractus* (Plate 32). It is strange to see how the contact between

the popular art of Lombardy and the somewhat sophisticated art of Emilia led to this remarkable compromise. At the same time, Lombard influence can be discerned in the earliest panels of the bronze doors of S. Zeno at Verona (early eleventh century), where in the typically Lombard manner even human figures are deformed and merged into the decorative scope of the whole: or else stressed expressively without regard for the composition. Did the doors of Hildesheim play a part here, or did the German character of the Lombards lead to a similar result? (Plates 29–30.)

Around 1150 both Lombard sculpture and the school of Emilia lost much of their force. At the same time Provençal influence gained ground: the art of Arles and St-Gilles made itself felt, for example in the ornamentation of the porch of Lodi Cathedral and in that of Piacenza. But it is again in the cathedral of Modena that the culminating point of this movement is to be found, namely the sculptures of the so-called *pontile*, a gallery, supported by pillars, with a pulpit abutting on it; the pontile is placed in front of the crypt, which is almost entirely above ground-level (Plate 31). On the pulpit we find the *Majestas Domini* (Christ in Glory surrounded by the symbols of the Evangelists), a theme which, in this form, is also French. Linked to this is a series of episodes from the Lord's Passion, with the Last Supper in the centre, a wide panel whose majestic calm makes a studied contrast with the other, more agitated scenes. Here the somewhat primitive constraint of the earlier masters has completely disappeared. It is as if these sculptors no longer had any difficulty in the modelling of their figures and the grouping of their compositions. Among these artists was the greatest sculptor of the Late Romanesque period in northern Italy: Benedetto Antèlami. His earliest dated and signed work, the *Descent from the Cross* in Parma Cathedral, was created in 1178 and proves, particularly in the design of the drapery, that Antèlami too had absorbed the lessons learnt from the Provençal school, but had assimilated them in a personal manner. Southern French pathos is fused with the strict rhythm of the Byzantine tradition, resulting in restrained, somewhat melancholy piety. From 1196 onwards the master devoted himself to his chef d'œuvre, the sculptural ornamentation of the baptistry of Parma, a work of the very first order both in content and in artistic merit. The main doorway facing the cathedral square is flanked by the trees of Jacob and Jesse, while the architrave consists of scenes from the life of John the Baptist, the forerunner of Christ. The tympanum, surrounded by the twelve apostles, shows Mary with the infant Jesus with, on the left, the three kings, and on the right Joseph being warned by the angel. Here Antèlami was closest to his Provençal examples, especially to the left-hand doorway of St-Gilles, which it resembles in some of its features. On the other hand the west porch of the bapistry has no affinity with any other work. The sculptures on the door jambs represent the acts of charity, the workers in the vineyard and the ages of man. The tympanum and the architrave show, for the first time in Italy, the Last Judgement. Christ reveals

his wounds and angels carry the instruments of the Passion. On the surrounding arch the twelve apostles stand as co-judges. On the architrave angels blow their trumpets and the dead arise naked from their tombs (Plate 32). The southern porch is unique in its iconographical design: the flat framework of the door is interrupted only in the architrave by three medallions showing the Lamb of God, Christ and John the Baptist. The tympanum which amazed Burckhardt (in his *Cicerone*) with its *fast Mithreisches Aussehen* (almost Mithraic appearance), represents Sol and Luna in their celestial chariots, with between them the legend of Balaam and Josaphat. It is an allegory of the transitory vanity of earthly existence: a man sits in a tree eating honey, but at the same time two rats gnaw at the tree trunk, while underneath a winged dragon leers at his victim. The interior tympana of the doorways are decorated with reliefs representing respectively the Flight into Egypt, David playing the harp, and the Presentation in the Temple. The east wall is occupied by the *Majestas Domini*; the adjoining smaller niches contain the Annunciation and a number of angels. The magnificent allegories of the seasons and the calendar months, now scattered in the building, were undoubtedly created for this baptistry, but it is not known where and how they were originally to be placed. They are the culminating point of Antèlami's work, indeed one of the highlights of medieval sculpture as a whole (Plate 33). The figures—the illustration shows the personification of the month of December—are represented in high relief, and, as they occupy practically the whole of the available space, they appear to be detached from their background. They are touchingly human, doing their work with humble devotion and attention; spiritualized figures who contribute to the miracle of re-creation and thus not only maintain life, but at the same time tread the path towards a better existence. This emergence of man as an object of artistic representation indicates that the Romanesque period is approaching its end and that Gothic is at hand.

A powerful figure like Antèlami was bound to have numerous imitators. If the two great statues of David and Ezechiel on the façade of Fidenza Cathedral are not by a pupil, but, as some scholars maintain, by the master himself, they date from between the *Descent from the Cross* and the sculptures of the bapistry. The accompanying reliefs, on the other hand, are certainly the work of others. Nor are the allegories of the months from a ruined portal of Ferrara Cathedral by Antèlami himself, but by an artist who, though gifted, lacks the brilliant restraint of his great predecessor and tends to lose himself in descriptive detail. The influence of Antèlami's style spread as far as S. Marco in Venice, where the three archways of the main porch were decorated in 1240 with allegories of the months, virtues, representations of crafts and occupations, etc.—small scenes which, with their play of light and shade achieve a surprisingly spatial effect.

On the whole the art of painting freed itself from the ties of tradition to a lesser extent than did sculpture. The first great surviving cycle of Romanesque frescoes in northern Italy is that in the apse of S. Vincenzo at Galliano. It may be presumed that these paintings date from about the time of the dedication of 1007. The drawing style at Galliano betrays strong if not very specific evidence of the Early Christian-Byzantine tradition with which Italy seems to have come in contact again during the tenth century, if indeed such contacts had ever been seriously disrupted. Similarities have often been pointed out between Galliano and contemporary Ottonian painting north of the Alps. It is a moot point whether the influence in question moved from north to south or south to north; but either way it is clear that the art of Italy and Germany was beginning to reflect the political connections established by Otto I.

150 years later the stylistic situation in northern Italy had not appreciably changed. The best preserved twelfth-century wall paintings are those in S. Pietro di Civate, illustrating scenes from the Apocalypse. Technically these are among the most accomplished works of their time, and if they are more Romanesque than Galliano this is to be measured by the obvious allusions to Early Christian or Carolingian prototypes rather than in the development of a fundamentally new figure/drapery style.

After the middle of the twelfth century northern Italy comes more and more under the influence of contemporary Byzantine neo-Hellenism. The rhythm slows down, colour is inclined to be subordinated to an overall tonal impressionism; and the compositions, more free and open, achieve a primitive form of spatial illusion. Some scholars ascribe this to the influence of the Crusades, which, for the first time, brought the Western world into close contact with a more sophisticated world; not merely that of Islam, but more particularly that of the Byzantium of the Commenes, on which all the trade routes of the world still converged, and with them the cultural movements of the East. The renewed influence of Byzantine art of that period is noticeable in the frescoes, dating from *c.* 1200, which decorate the crypt of Aquileia Cathedral. It also manifests itself, though in a more restrained manner, in the dome frescoes, dating from *c.* 1260, of the baptistry of Parma (Plate 34). Here the influence seems to be that of the contemporary style of Byzantium itself; but at Aquileia, there is a provincial flavour which perhaps indicates that the local artists were inspired by works like the frescoes of Nerez in Macedonia (*c.* 1160).

On the other hand at Venice, which was the principal stronghold of the Byzantine tradition in northern Italy, the development of the mosaics of S. Marco indicate a somewhat different development. Whereas the earlier ones are still entirely in the spirit of Ravenna, the latter series show the influence of Ottonian miniatures, with Eastern abstraction combined with what we think of as characteristically Western expressionism. By 1200

however the mosaics have yielded entirely to the Romanesque technique of presenting Bible stories dramatically by means of figures in the round. This is particularly the case in the scenes from Genesis in the first atrium chapel. Possibly the well-known picture of the Last Judgement in the cathedral of Torcello also exercised some influence here.

ARCHITECTURE IN CENTRAL ITALY

In architecture the central part of the Apennine Peninsula presents an even less uniform image than the north. To begin with, scattered pockets of Lombard influence are found in the Marches, in Umbria and in parts of Lazio. Elsewhere, particularly on the east coast, Byzantine elements make themselves apparent. In Florence memories of classical antiquities and the Early Christian period were paramount; while in Pisa and Lucca Early Christian and Byzantine themes were fused into a characteristic new style, which was to exert an influence as far as Sardinia and the far south. Abbey churches scattered all over the country were built to French designs. On the other hand Rome itself played an inconspicuous part. Its only contributions to Romanesque architecture were its campaniles and the decorative work of the so called *marmorari romani*.

Undoubtedly the most important centres of architectural development were Pisa and Florence. The eleventh century saw a dramatic change in the balance of maritime power in the western Mediterranean. Control of the seas passed from the Saracens to the Italian republics, among which Pisa and Amalfi were the earliest to benefit. The cathedral of Pisa was the first great monument of the city's new prosperity. It was started in 1063 by an architect called Buschetto. The design was modified in 1088. There was a consecration in 1118; but work began again toward the middle of the twelfth century under the direction of a new architect, Rainaldo. This campaign, which went on into the thirteenth century, saw the extension of the nave westward and the construction of the present façade; the heightening of the clerestory, and the addition of the campanile and the baptistry to form the familiar group of buildings. Over and above the changes which

31. The Emilian sculpture in the 'pontile' of Modena Cathedral shows Provençal influence. **32.** Benedetto Antèlami was the greatest of the north Italian sculptors. The tympani of the bapistry in Parma are his work. **33.** His personifications of the months are spiritualized figures, already approaching free-standing sculpture. **34.** The dome frescoes of this baptistry were influenced by Late Byzantine neo-Hellenism. They achieved for the first time a convincing illusion of space. **35.** The earliest parts of the cathedral of Massa Marittima were built *c.* 1226 by Enrico da Campione. It was subsequently completed in the Gothic style. The influence of Pisa and Lucca is discernible. **36.** Ancona Cathedral is a Byzantine church translated into the Lombard idiom. Its groundplan has the shape of a Greek cross. The projecting porches rest on stylofore lions.

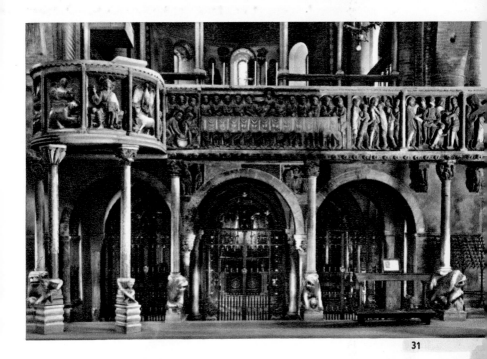

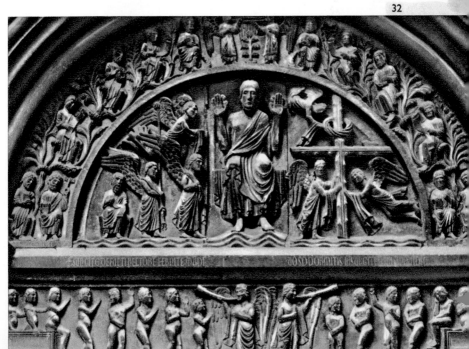

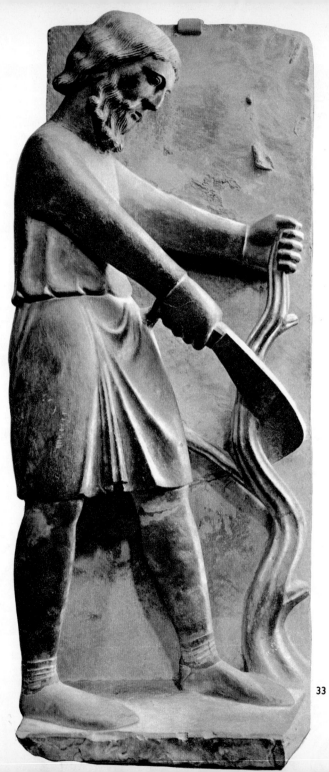

33 34

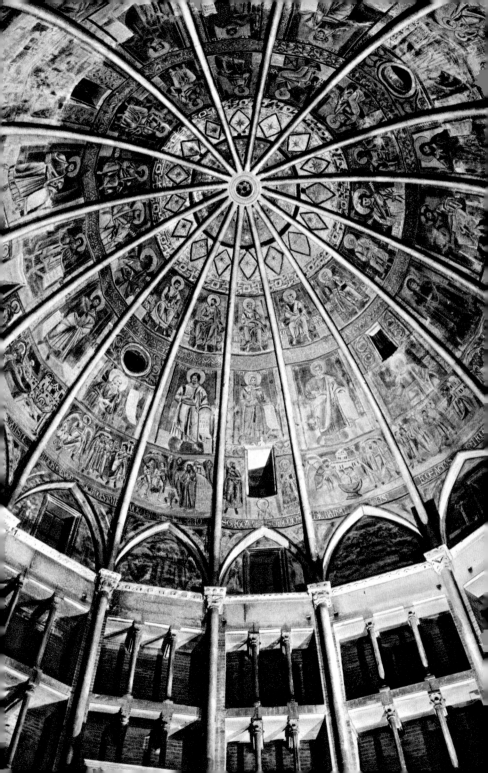

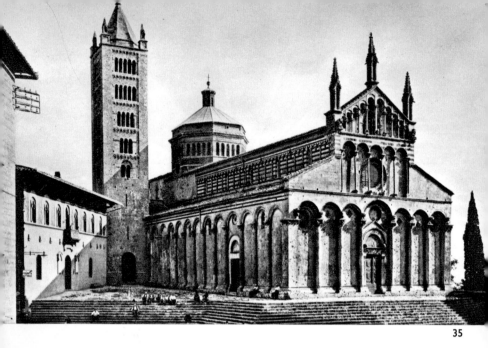

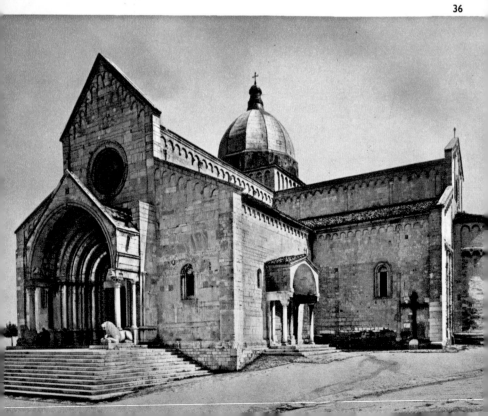

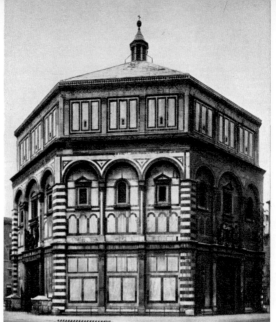

37

38

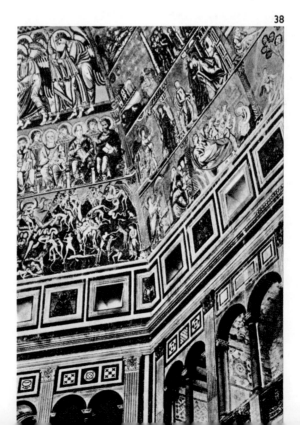

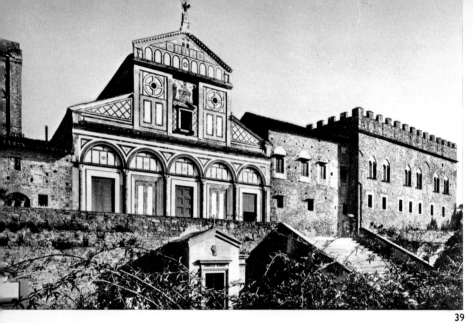

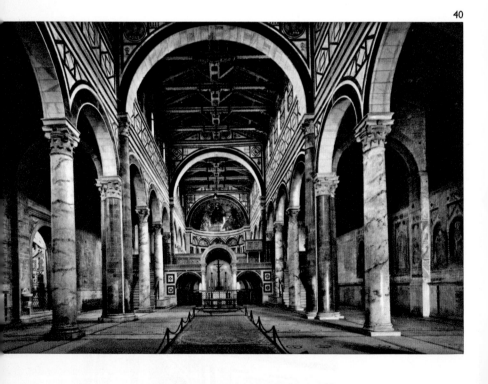

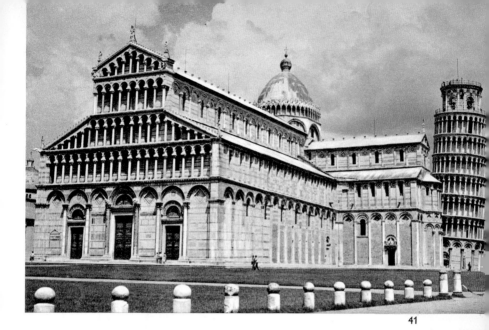

41

42

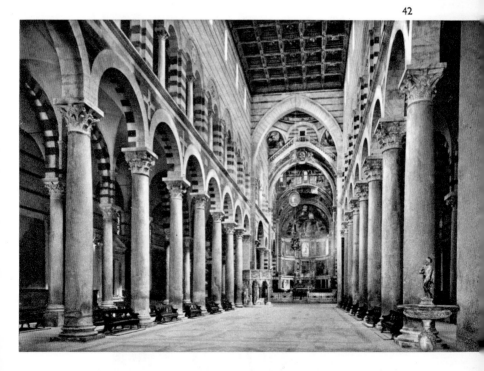

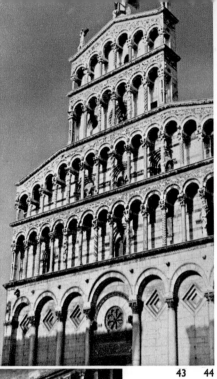

43 44

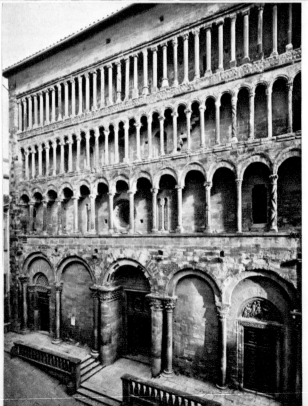

45

attended its construction, the cathedral has undergone much restoration in the course of its history, notably in the sixteenth and seventeenth centuries. It is therefore not easy to disentangle Buschetto's original design from later accretions. What is clear, however, is that none of the Pisan architects were inspired by the same conception of a great church as their north Italian contemporaries. Vaulting played no part in their thinking. The only Lombard feature is the external gallery round the apse—part of the twelfth-century work. In plan, the cathedral is a Latin cross, with apses at the end of the transepts; otherwise the church is essentially a galleried basilica of the Early Christian type. Internally there is no true crossing: the galleries over the side aisles cut the transepts off from the nave, perhaps to support the elongated cupola more effectively. The galleries themselves extend over both side aisles—a feature found in some Early Christian churches of the eastern Mediterranean. It is generally agreed that Buschetto's design owed much to that part of the world. For instance the external pilaster strips have their nearest counterparts in Armenian architecture. This could be explained by Pisa's maritime supremacy. On the other hand antique columns were re-used for the nave arcades, and the white revetments betray a very classical approach to architecture. This became even more apparent in the twelfth-century operations. The decoration work associated with Rainaldo shows Pisa to have been one of the main centres of the classical revival in Italian sculpture. However, the blind arcades, recessed lozenges, deep galleries of the façade and the leaning tower became the hall-mark of a distinctive local style. They appear in other Pisan churches, for example S. Paola a Ripa d'Arno, S. Frediano at Calci and, more colourfully, in S. Giovanni fuor Civitas. In the cathedral of Prato there are minor variations, while in Sardinia which was under Pisan domination, there are traces of fusion with Lombard elements. A good example is Sta Maria in Uta which has a Lombard exterior, but is entirely Pisan inside. Elsewhere, in churches built after the middle of the twelfth century, the Pisan features appear outside as well, e.g. Santissima Trinità in Saccaggia, and S. Gavino in Porto Torres.

37. The exterior of the octagonal baptistry near Florence Cathedral is covered in white and dark green marble. **38.** In the interior the artist was inspired by the Pantheon in Rome. The cupola is decorated with colourful mosaics, including a great deal of gilt. **39.** The design of S. Miniato al Monte, outside Florence, is reminiscent of late classical forms of Early Christian churches, especially in its façade and its decoration. **40.** Its interior is akin to that of the basilicas. **41.** Pisa Cathedral and its campanile, with their rows upon rows of open arcading, and blind arcading in the lower zone, are the masterpieces of Pisan Romanesque. **42.** The interior is again reminiscent of the basilicas. **43.** The style of Lucca is closely related to that of Pisa, but its details are more colourful, cf. the façade of the cathedral. **44.** S. Michele is another fine example of the Luccan style. **45.** Façade of Sta Maria della Pieve in Arezzo.

The other great centre of this style was Lucca. Indeed it is often referred to as the *stile Pisano-Lucchese*. The façade of the Lucca Cathedral was built in 1204 by Guidetto. Arcaded galleries in the manner of Rainaldo surmount a doorway with three wide arches. The small pillars and spandrels of the second stage are decorated with colourful inlaid work and here too, everything makes a wider and more open impression (Plate 43). S. Michele in the same town is closer in style to the Pisan example, although the upper arcaded galleries are constructed entirely in the manner of Lucca. In this church the lowest open gallery continues along the sides of the nave (Plate 44). Closer in style to Lucca than to Pisa is the *Pieve* in Arezzo. The wide arches on the ground floor are reminiscent of Lucca Cathedral, but the upper part differs from all previous examples in that it consists of three galleries of equal width, of which the upper one supports a horizontal architrave. There is no coloured ornamentation, but the shafts, capitals and bases of the pillars are varied in shape and decoration (Plate 45).

Proof of the continued vitality of the Pisan style in central Italy is provided by the cathedral of Massa Marittima (Plate 35). Enrico Campione apparently started it in 1226, and he was responsible for the Romanesque nave, which has three aisles and is entirely Pisan both internally and externally. The façade is a simplified version of the usual type. It is surmounted by three Gothic pinnacles ascribed to Giovanni Pisano. The transept and the choir were added in the fourteenth century and are Gothic in style.

The Romanesque architecture of Florence was even more deeply affected by the classical in idiom than that of Pisa. The starting point here was the small early eleventh-century church of Sti Apostoli—frankly modelled on an Early Christian basilica, but using newly cut columns of fine masonry. A further step in the same direction was taken by the architect who, after the middle of the eleventh century, reconstructed the well-known baptistry opposite the cathedral of Florence. He was clearly inspired by the Pantheon in Rome, especially as regards the interior. It is no slavish imitation, however. The ideas absorbed from Rome are adapted in a very personal and contemporary manner to a novel and characteristic design. The octagonal shape was derived from Early Christian baptistries, and the decoration of white marble and green serpentine from Prato are of a restrained severity which in no way resembles the pathetic megalomania of Roman imperial architecture. The colourful mosaics in the cupola, including a great deal of gilt, emphasize the warm intimacy of the whole, in contrast to the majestic but frigid coffering of the Pantheon (Plate 38). An exhaustive comparison of the two monuments is instructive in order to understand the similarities, but even more the differences, between Roman and Romanesque, even though the Romanesque has here been expressed in a typically Florentine manner. The external decoration is a schematical representation of the internal wall division, although, because of the high third stage, the propor-

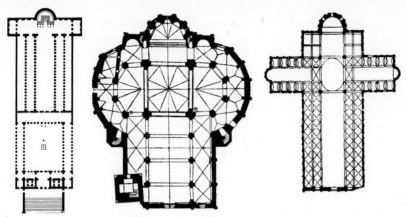

Groundplans of (from *l.* to *r.*): the original St Peter's in Rome, S. Fedele in Como, and Pisa Cathedral.

tions are slightly different (Plate 37). What at a superficial glance appears to be an arbitrary and even rather untidy ornamentation, on closer examination proves to be a miracle of balance and clear harmony.

The other masterpiece of Florentine Romanesque is S. Miniato al Monte. This was partly contemporary with the baptistry. Internally it is essentially an Early Christian basilica built over a spacious crypt, and transformed by the introduction of wider arcades, diaphragm arches, and corresponding compound piers. In this respect it resembles Lomello in Lombardy. But a strong classical flavour is imparted by the use of coloured marble for the piers, and marble revetments in the choir (extended to the nave in the eleventh century). The façade falls into two parts: the tower consisting of five regular arches, and the upper, slightly later, made up of more varied geometrical forms. The influence of this Florentine Romanesque style did not extend far outside Florence itself (the unfinished Badia at Fiesole is an instance), but within the city it persisted throughout the Gothic period and affected the early Renaissance architecture of Brunelleschi.

The pre-eminence of the Arno region of Tuscany in central Italy *c.* 1100 was partly due to its prosperity, partly to its special connection with the reformed Papacy through the Countess Matilda. Although it had by then become the centre of the reform movement in the Church, Rome itself contributed little to ecclesiastical architecture during this period, largely because it already had more than enough great churches dating from Early Christian times. Some of these were in need of repair, and their restoration in the thirteenth century called into being several famous ateliers of crafts-men. Even when churches were built in Rome, they remained faithful to the Early Christian type. This is obvious in the churches which were reconstructed at the beginning of the twelfth century after the devastation

caused in 1084 by Robert Guiscard. The most striking examples are S. Clemente, and Sta Maria in Trastevere which, in its present form, is slightly later. One essentially Roman creation was a type of campanile which occurs in large numbers and in all sizes—from very small to very large—both in Rome itself and in the vicinity of the city. They are made of brick and consist of a series of relatively low stages, each crowned by a complex cornice. Each stage, moreover, has a number of linked arches, generally blind in the lower, open in the upper zones, where they rest on marble pillars (Plate 46). The whole is topped by a low pyramidical roof. The pale colour of the pillars presents a lively contrast to the reddish-brown of the bricks, and this colourful effect is in some cases further enhanced by the insertion of coloured marble discs or even multicoloured majolica plates in the walls. This striving after colourful effects by introducing all kinds of marble panels (e.g. sliced classical columns!) in a geometrical pattern of mosaic bands, is characteristic of the work of the so-called *marmorari romani*, who decorated not only the floors of churches with these multicoloured inlays, but also various parts of the interior furnishings, such as choir-screens, altar-ciboria, ambones, Easter candlesticks, sepulchral monuments, etc. These workers belonged to a number of interrelated families: the Cosmati, Ranucci, Vassalletti (Bassalectus), etc. Hence the name, *Cosmati work* sometimes applied to this form of decoration.

But these *marmorari* were not just artistically gifted decorators, they were also skilled architects. We are indebted to two members of the Cosmati family for the well-known porch of the cathedral of Città Castellana, with its high central arch. This was built in 1210 by Jacopo di Lorenzo (who also built the cloisters of Sta Scholastica in Subiàco), and his son Cosma. Members of the Vassaletti family built and decorated the cloisters of S. Paolo fuori le Mura (1205–40) (Plate 47) and S. Giovanni in Laterano (1222–30). Needless to say, all these structures were decorated with *Cosmati work*, in which free use was made of gold as well as of coloured marble segments. We see here the first examples of the slender twisted pillars which were eagerly imitated in Italian Gothic. Although great variety of motifs is a special feature of the two *chiostri* of the Vassalletti, a strong classical tradition survives in the work of the *marmorari*, to which one may ascribe not only the harmonious shapes, but possibly also the combination of colour with the cool tint of white marble.

In Lazio outside Rome faithful adherence to this type of the Early Christian basilica is represented by the small eleventh-century church of Castel Sant' Elia. On the other hand at Tuscania, in the churches of S. Pietro and Sta Maria Maggiore, there is evidence of strong Lombard influence. The latter, which also contains Pisan and Umbrian elements, recalls Lombardy in the rich sculptural decoration of the façade. At S. Pietro the façade decoration is even more imaginative, particularly around the rose window where some of the twelfth-century themes anticipate the

visions of Dante's *Divine Comedy*. Lombard elements are also present in the churches of Viterbo; and Sta Maria de Castello in Tarquinion even has ribbed vaulting and compound piers.

The architecture of southern Tuscany and the region of Siena has a somewhat indeterminate character. Thus the *collegiata* of S. Gimignano is a basilica; the abbey church of Berardegual presents Pisan features; the cathedral of Sovana is Lombard in style and is related to Sant' Ambrogio at Milan; while at Sant' Autrino, begun in 1118, there is an ambulatory with radiating chapels, which in spite of the absence of vaults unmistakably betokens French influence.

Further inland, in Umbria, the façade of the cathedral of Assisi, built *c.* 1140 by Giovanni da Gubbiom has an unusual design of square panels, surmounted by three rose windows reminiscent of the Tuscania churches (Plate 59). The panels occur again further south in the Abruzzi, and on the other side of the Appenines, e.g. SS. Vincenzo e Anastasio at Ascoli Piceno, and in a slightly different form at Sta Maria in Piazza Ancona.

Finally it is in the cathedral of Ancona that we find traces of Byzantine influence mixed with the Lombard idiom (Plate 36). Building continued from the eleventh to the thirteenth centuries. The design is in the form of a Greek cross with a small central cupola. The arms have three aisles each and, apart from the nave, end in apses (i.e. like Pisa). There are, however, no clerestory windows and the interior is very dark. All this makes a very Byzantine impression. Yet the exterior is covered with Lombard bands, and there are projecting porches, the one at the west having the familiar north Italian lions.

SCULPTURE IN CENTRAL ITALY

Tuscany and central Italy are not entirely without figured capitals. There are some in the abbey church of Sant' Antimo, at Buggiano (prov. of Pistoia), in the cathedral of Sovana, in the churches of Stia and Gropina (prov. of Arezzo), etc. It is a remarkable fact that all these churches were based either on French (Sant' Antimo and Gropina), or on Lombard examples. On the whole the indigenous classical tradition rejected the figured capital: as a rule Corinthian shapes were used, occasionally the Ionic.

A similar deference to the antique preferred purely architectural lines and planes to the capricious use of ornament which happened in Lombardy. Even the porches are rarely sculptured. This preference for abstract decoration is predominant particularly in Florentine architecture of the eleventh to twelfth century. Marble-intarsia replaces the sculpture of other regions. Classical themes are freely used but also occasionally motifs derived from Eastern fabrics. On the whole the decoration of choir screens, ambones, altars, etc., is much more sober and restrained in Florence than the work of the *marmorari romani*. This applies also to colour. Florentine decoration

confined itself almost exclusively to white marble and green serpentine, materials which were readily available locally in the quarries of Carrara and Prato. The choir screen and ambo of S. Miniato al Monte provide rich examples.

The Romanesque sculpture of Pisa and Lucca is of much greater importance. In Pisa the greatest master was another Guglielmo, who between 1159 and 1162 made a pulpit for the cathedral. It was replaced about a century later by another one made by Nicola Pisano, and was then transferred to the cathedral of Cagliari in Sardinia, where it still stands (Plate 48). Guglielmo may not have been of Tuscan descent. As his work shows close affinity to the art of Provence, especially with that of St-Gilles, it has been suggested that he was a native Provençal. His reliefs are markedly sculptural, so much so, in fact, that they resemble free-standing sculptures, in contrast to the contemporary sculpture of Emilia, where relief is exactly what the name implies. Another sculptor, Gruamonte, who in 1160, together with his brother Adeodato, carved the Journey of the Three Kings on the architrave of Sant' Andrea in Pistoia, was a weak follower of Guglielmo. Nevertheless, his work inspires sympathy because of its naïve honesty (Plate 49). More forceful than Gruamonte, and more emotional in the composition of his figures, was Biduino. Like Guglielmo, he at times reminds us strongly of Provençal work. A dated architrave at S. Cassiano in Settimo puts his work there in the year 1180. Another in S. Salvatore at Lucca, appears to be of slightly later date. The first represents the legend of St Cassian and the entry of Christ into Jerusalem; that in Lucca relates an episode from the life of St Nicholas of Bari (Plate 50).

Towards the end of the century, Bonannus of Pisa, who was also the architect of the campanile at Pisa, was the leading figure in Pisan sculpture. In 1180 he made bronze doors for the main entrance of the cathedral, which were lost in a fire at the end of the sixteenth century. Six years later he made the bronze doors for the cathedral of Monreale in Sicily, and probably later still those of the *Porta di San Ranieri* in the south-eastern wall of the transept of Pisa Cathedral (Plate 52). It is difficult to define the origin of his art. Undoubtedly there are links with that of Guglielmo and Provence; but on the other hand it is rich in Byzantine motifs and themes derived from Eastern miniatures. This is already clearly apparent in the design for the doors of Monreale; but is even more so in the San Ranieri doors, where his sculptural ability has become much more marked. He has thoroughly mastered the modelling of the separate figures and the composition of the scenes. Moreover, he succeeds in stressing the meaning and the content of the composition by means of the design. His art is evocative: at times he catches our imagination by a single detail, and this ability lends a refined, poetical spirit to his work.

Throughout the twelfth century the sculpture of Lucca was directly influenced by that of Pisa. Biduino worked there, and the sculptures of the

wonderful font in S. Frediano, by Robertus, are also Pisan. A change is discernible around 1200, when Lucchese sculpture came under the influence of Lombardy and Emilia. It was at this time that the famous equestrian statue of St Martin sharing his cloak with a beggar was made. Now in the cathedral, it originally stood on the façade where it has been replaced by a copy. This glorious work, packed with classical allusions, shows affinity with the art of Antèlami, and is sometimes, though on no firm grounds, attributed to Guidetto, the architect of the cathedral front.

Elsewhere in Tuscany, too, we notice the influence of Antèlami in this period. The main doorway of the *Pieve* in Arezzo contains a rather weak tympanum, entirely in the Byzantine style, signed by Marchionne and dated 1216. But a much more gifted master carved reliefs representing the months of the year on the inner aspect of the arch (Plate 45). This unknown artist assimilated the lessons of Antèlami in a very personal manner in his remarkable chiaroscuro.

Finally we must refer to the art of carving in wood which flourished towards the end of the twelfth century in the border region between Umbria and Tuscany. Figures of the Madonna, Christ on the Cross, with the Virgin and John, and particularly the Descent from the Cross, were favourite subjects. They are composed of free-standing figures, but were nevertheless designed to stand against a wall. There are representations of the Descent from the Cross in the cathedrals of Tivoli and Volterra (Plate 51).

In Lazio, the sculpture of this period was largely included among the activities of the *marmorari romani*; which is to say that it was predominantly intended as ornament and hardly ever employed figurative themes. An exception is the marble Easter candlestick in S. Paolo fuori le Mura, Rome. It is apparently carved from an antique column, supported by an upturned Corinthian capital, and was made *c.* 1170 by Pietro Vassalletto and Nicolò d'Angelo. Here again it is clear to what extent these *marmorari* were influenced by antiquity: not only is the carved, column-shaped candlestick reminiscent of famous works, such as Trajan's Column; but the influence of Late Roman the Early Christian sarcophagi is clearly noticeable in the reliefs of the Passion, Resurrection and Ascension of Christ. This monument is about 20 feet high. Finally wood sculpture: during this period a somewhat rustic school of carving flourished in the Abruzzi, where wood madonnas of the type of the *Sedes Sapientiae* were made. The so-called *Madonna di Acuto* in the Palazzo Venezia in Rome, which probably dates from the early thirteenth century, may be singled out as an example. This school appears to have distant affinities with the regions of Rhine and Meuse, and with France, and was to continue well into the fifteenth century.

PAINTING IN CENTRAL ITALY

As elsewhere in Italy, Romanesque painting in this region is less varied and of lesser importance than the sculpture of the period. It did not come into

its own until the middle of the thirteenth century, when the Romanesque era was at an end. Since relatively few examples of the early period have survived, however, our impressions are necessarily incomplete and inexact.

In Rome the late eleventh-century frescoes in the lower church of S. Clemente were actually more modern in style than the apse mosaics—however magnificent—of the first half of the twelfth century, for instance in the upper church of S. Clemente or Sta Maria in Trastevere. The latter are based on Early Christian and Byzantine examples and as such must be regarded as belonging to the 'Renaissance' introduced by the *marmorari*. A somewhat similar phenomenon is discernible in the frescoes of the abbey church in Ferentillo in Umbria, though here it is rather a case of classical themes being translated into a popular idiom, thus introducing the first hints of realism. The same may be observed in the impressive cycle of twelfth-century painting on the walls of the nave of S. Giovanni a Porta Latina in Rome, representing episodes from the Old and New Testaments. Antique and Byzantine influences were here combined with those of contemporary miniatures (Plate 53).

In the twelfth century Umbria and Tuscany produced an impressive series of painted crucifixes. These included, apart from the figure of Christ, a number of smaller representations to left and right in the broadened extremities of the arms of the cross. These were indeed triumphal crucifixes, not only because they were placed above the choir screen, where they dominated the whole interior, as the Pantocrator of the apse had done before them; but also because in them the Redeemer is actually presented as the conqueror of death. Guglielmo in 1138 painted one such crucifix for the cathedral of Sarzana; Alberto Sòtio did the same for Spoleto in 1187. At about the same time a precursor of Giunta Pisano painted another for the church of Sta Chiara in Assisi, where there is a second specimen, originally in S. Damiano, which is reputed to have spoken to St Francis. The Museo Civico in Lucca contains an example made *c.* 1230 by Bonaventura Berlinghièri. Towards the end of the twelfth century another style of crucifix

46. Among Rome's rare contributions to Romanesque architecture are the typical campanile, such as that of S. Giorgio in Velabro. **47.** The cloisters of St Paul Outside the Walls are characteristic of the work of the Marmorari Romani. **48.** The pulpit in the cathedral of Cagliari (Sardinia) was made by Guglielmo Pisano. **49.** His successor, Gruamonte, together with Adeodato, made the architrave of Sant' Andrea in Pistoia. **50.** That of S. Salvatore in Lucca is the work of Biduino. **51.** Deposition from the Cross, carved in wood, in the cathedral of Volterra. **52.** Bonanno Pisano *c.* 1190 made the bronze doors of the Porta di S. Ranieri of Pisa Cathedral. **53.** The twelfth-century frescoes in S. Giovanni a Porte Latina show a combination of various influences. **54.** Duccio achieved a breakthrough in the Byzantine design. **55.** The decoration of the pulpit in the cathedral of Ravello shows evidence of Islamic influence.

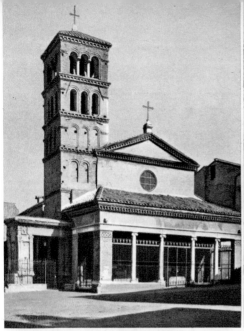

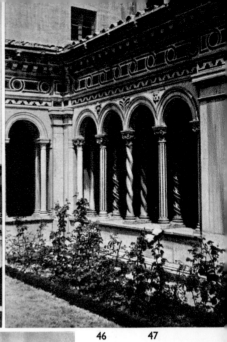

46 47

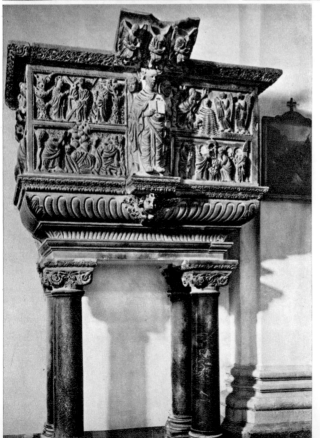

48

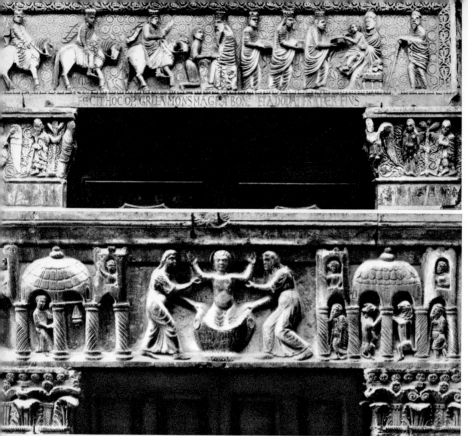

FECIT HOC OP GRELA MONS MAGET BON: ETA DODA FRATER EIUS

49
50

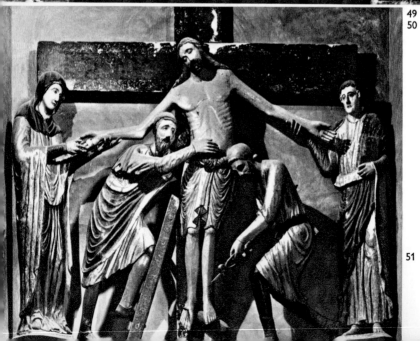

51 52

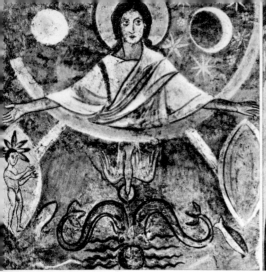

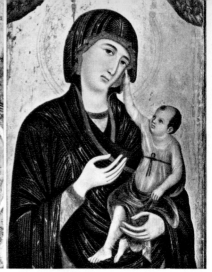

53

54

55

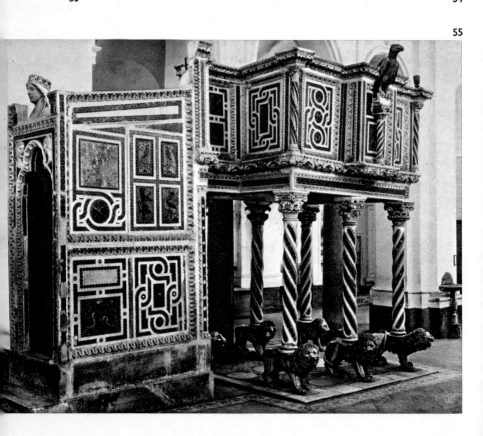

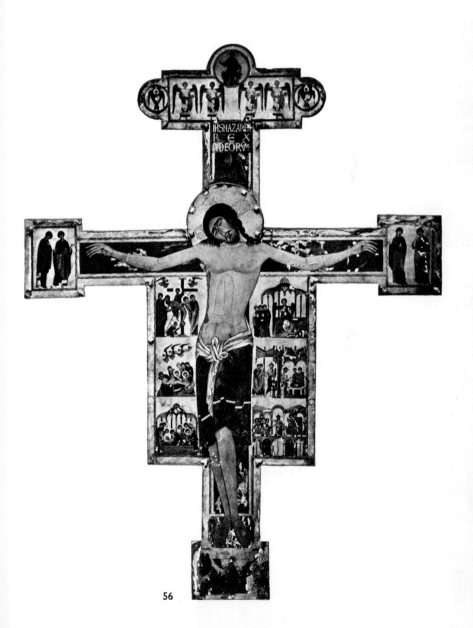

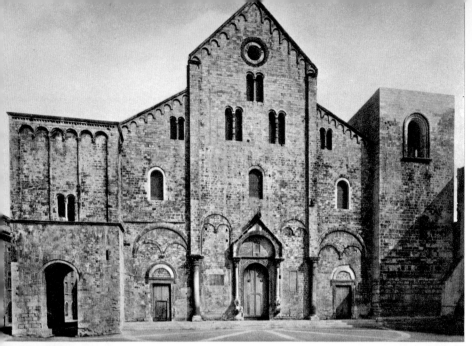

57

58

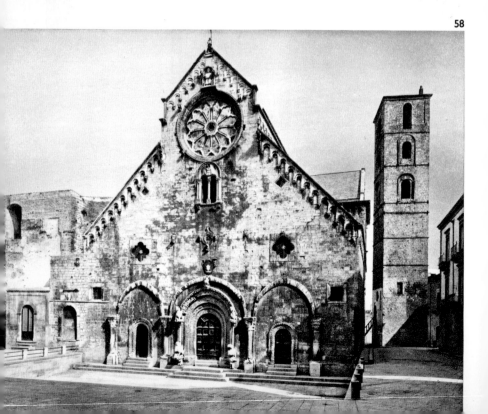

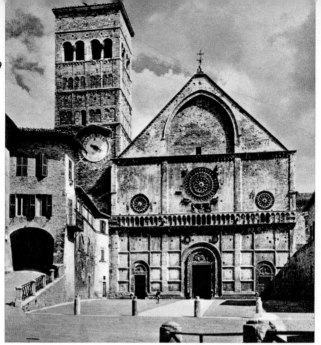

59

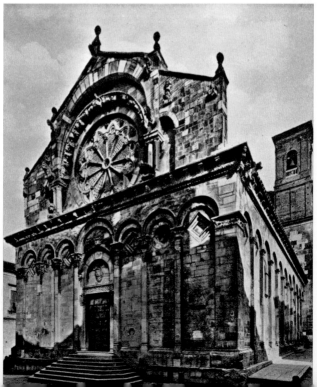

60

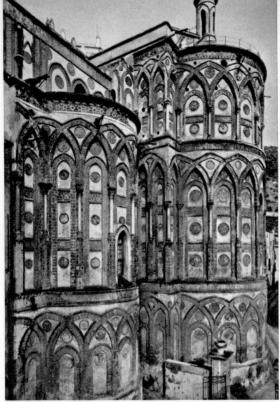

61

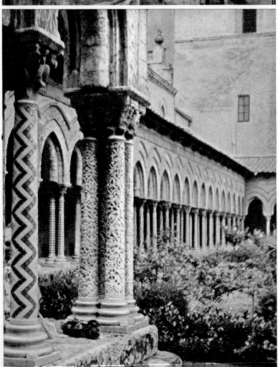

62

had reached Pisa via Byzantium: the *Christus Triumphans* of the West made way for the *Christus Patiens*, the suffering Christ, of the East, for example the magnificent crucifix in the Museo di S. Matteo in Pisa (Plate 56). Here Christ is shown as dead. His eyes are closed and the head reclines on the right shoulder, while the body, which in earlier examples stood erect in front of the cross, is slightly curved. There is not yet any trace of the realism of the sculptors of the late Middle Ages; instead we see an expression of restrained meditative lament.

The same note of quiet melancholy is contained in another work of Berlinghièri; a panel painted in 1235, representing St Francis and episodes from his life for the church of this saint in Pescia, between Lucca and Pistoia. Just as the triumphal crucifixes centre on the large figure of Christ, so the immense figure of St Francis is placed against a gold background, with three smaller scenes, one above the other, to either side. But in spite of its Byzantine character, we see here also a first effort to convey the poetry of the Fioretti.

The Pisan *Christus Patiens* is repeated in a series of crucifixes by Giunta Pisano. The work which he painted in 1236 for the basilica of St Francis in Assisi no longer exists, but another one has been preserved in the church of Sta Maria degli Angeli, as well as a third from a later period in S. Domenico in Bologna. Here the restrained pathos of the neo-Hellenistic movement reaches a climax; at the same time one is no longer distracted by secondary themes.

Let us consider some later paintings. The frescoes of the Cappella di S. Silvestro at Santi Quattro Coronati in Rome, representing the legend of Constantine the Great's miraculous recovery from leprosy, appear to be a substitute for mosaics in the Byzantine style. The undisputed masterpiece of the later Roman school is the cycle of frescoes in the crypt of the cathedral of Anagni, dating from the pontificate of Innocent IV (1234–54). In particular those contributed by the third master are close to the neo-Hellenistic ideal of the period in their moving pathos. The same may be said of the *Madonna di S. Martino* in the Museum at Pisa.

56. Painted crucifixes represent the mystery of the Lord's suffering in a restrained and meditative manner. **57.** S. Nicolo in Bari is one of the masterpieces of Apulian architecture; it was influenced by Lombardy and Emilia, as well as by Normandy. **58.** Ruvo Cathedral is individual in character within the framework of Apulian architecture. **59.** S. Ruffino in Assisi was built in 1140 by Giovanni da Gubbio. **60.** The lower zone of Troia Cathedral is Pisan in style, but in its higher stages it is purely Apulian. It is known also for its bronze doors dating from 1119 and 1127. **61.** The most ornate part of Monreale Cathedral is the exterior aspect of its choir. Purely Moorish decoration has here been adapted to Norman architecture. **62.** The cloisters of Monreale Cathedral are the finest example of Norman architecture in Sicily.

Florence and Siena were to produce flourishing schools of painting, particularly in the subsequent period. The Franciscan friar, Frater Jacopo, who, from 1225 to 1228, decorated the choir vault of the baptistry in Florence with a mosaic, did so, not in the Florentine, but in the Venetian style, at the same time adapting certain Lombard architectural details as ornamental motifs. The large and very complex mosaic in the cupola dates from the second half of the century and was not completed until the beginning of the fourteenth century, the lower stages being the more recent (Plate 38). Especially in the later scenes of the Last Judgement, idiomatic features emerge, rejecting the imposing solemnity of Byzantine art. The mosaics of the baptistry influenced painters, amongst others, the Maestro della Maddalena who in his turn broke with the old-fashioned schematic style; Margaritone d'Arezzo, a sombre artist known for his portraits of St Francis; and, in the second half of the thirteenth century, Coppo di Marco Valdo, who painted majestic enthroned Madonnas and drew the drapery of garments in subtle gold lines against coloured backgrounds.

Guido da Siena appears to have been influenced by Coppa, but lacks the latter's power. His work dates chiefly from the period 1260–70, although his most important painting, the *Madonna Enthroned* in the Palazzo Publico of his native city, bears the misleading date MCCXXII (1222). Most likely this should have read MCCLXXII (1272). The change may be explained by the rivalry between the main centres of Italian painting which in the seventeenth and eighteenth centuries resulted in some works of art being deliberately ante-dated.

Meanwhile the neo-Hellenistic trend also asserted itself in Siena where the situation was complicated by the arrival of French Gothic miniatures. This eventually led to the delicate, spiritual art of Duccio di Boninsegna (1255–1318) (Plate 54). But Duccio belongs rather to the following period, for, in spite of the Byzantine features of his work, his figures stand out from the total design and become realistic human beings.

ARCHITECTURE IN SOUTHERN ITALY

Although by 1100 the whole of southern Italy and Sicily had been conquered by the Norman Hauteville dynasty, the result was no uniformity of architectural style. Unlike their contemporaries in England, the Normans in southern Italy did not launch a wholesale building campaign, nor did they endorse one particular style of architecture. So the regional peculiarities largely reflect the conditions and tastes of their predecessors. As the political situation had been extremely complex, so also were the variations of architecture. The medieval culture of southern Italy may be regarded as an uneven sequence of superimposed deposits: classical, Early Christian, Lombard, Byzantine, Saracen, and French. Although it is convenient to speak of Campania, Apulia, Sicily and perhaps Calabria, as though each possessed a style of its own, the actual picture is far more complicated.

It is probably best to begin with a building which disappeared in the sixteenth century, and which is known only from drawings and descriptions: Monte Cassino. Rebuilt by Abbot Desiderio between 1066 and 1070, it was almost certainly a lavish but straightforward copy of an Early Christian basilica. It is known to have had a T transept, which may have been raised above the roof-line of the nave. But in any case Monte Cassino must have been the model for a number of churches built by the Normans in Calabria, Sicily and Apulia, as well as the inspiration of many buildings both large and small in Campania itself. Of the latter Sant' Angelo in Fourmis is perhaps the best preserved; although Salerno Cathedral, paid for by Robert Guiscard, the founder of the Norman state in southern Italy, still in part betrays its affiliation with Monte Cassino. From an early date, possibly before 1100, pointed arches appeared in Campanian architecture. They survive in the narthex of Sant' Angelo, and throughout S. Clemente a Casauria which, however, belongs to the second half of the twelfth century. It is not entirely certain whether they all were a feature of Monte Cassino, but it has been argued. Pointed arches in this part of the world are generally explained as a consequence of Moslem influence. There was certainly plenty of this in Sicily; and at the cathedral of Caserta Vecchio (dedicated 1153), and the Chiostro del Paradiso at Amalfi in Campania, Romanesque architectural ornament has a decidedly Moslem flavour. This may, however, represent a back-wash from Sicily after the Norman Conquest of the island. An alternative explanation of the more or less simultaneous appearance of pointed arches all over western Europe c. 1100, is to connect it with the West's growing awareness of the Eastern Mediterranean world, both Moslem and Byzantine; and in this process a leading part was taken by the Campanian trading cities of Amalfi, Ravello, Atrani, etc.

It is curious that Apulia, which had much closer and more recent connections with Byzantium than Campania or Sicily, should preserve so few traces of the link. It is in Calabria (e.g. the Cattolica at Stile) that we find the only pure Byzantine buildings in southern Italy. The independence of Apulia in this respect is probably due to the pre-Byzantine influence of the adjacent Lombard Duchy of Benevento. Like that of the Normans who drove them out, the Greek control of Apulia was confined to the level of government. There was little cultural penetration; and what patronage there was after the Norman conquest was largely due to the initiative of the Church and the cities.

Apulian Romanesque falls into two stylistic groups. In the north, i.e. in the vicinity of the Gargano peninsula, and the plain of Foggia, roughly corresponding to the Old Byzantine Capitanata, there is a characteristic type of decoration based on pilaster strips, arcades, and recessed lozenges, which must ultimately be connected with Pisa—either directly, or else through the same Eastern sources. S. Leonardo di Siponto, the cathedrals of Troia, and Foggia, and also that of Benevento (destroyed in 1943) belong to this group.

It should be added that structurally these churches differed as to whether they were vaulted or not. The larger ones (e.g. Troia) were not vaulted and tended to conform to basilican models. (Throughout southern Italy there seems to have been a plentiful supply of antique columns waiting to be re-used. This must have encouraged the building of basilicas.) On the other hand, the smaller churches like S. Leonardo were often vaulted. The full range of Romanesque vault types are found, including ribbed vaults and domes. The most impressive of these monuments are the cathedrals of Canosa and Molfetta.

The other main stylistic group comprises a series of tall galleried basilicas. The prototype is taken to be S. Nicola at Bari, and includes the cathedrals of Bari, Trani, Bitonto, and Barletta (nave only). They all have or were intended to have the T transept of Monte Cassino, and it may be that the formula was evolved by adding galleries to the Monte Cassino type, which was represented in Apulia by the cathedral of Taranto. The result bears a strong resemblance to Modena, and there are also links between the monumental sculpture of Apulia and Emilia. The exact nature of the connection is not, however, easy to understand.

The Romanesque monuments of Sicily are something of a class apart. After 1130 Palermo became the capital of the Northern kingdom and enjoyed the patronage of a dynasty peculiarly aware of the propaganda value of artistic display. The range of style is remarkable, and several secular buildings survive to complicate the overall impression. At one extreme are the pure Moslem S. Giovanni degli Eremiti and the Palazzo della Zisa; at the other the Norman ribbed vaults and capitals of the choir of Cefalu Cathedral (1131). The Capella Palatina, the Martorana and S. Cataldo (all in Palermo) have varying degrees of Byzantine influence. The most ambitious of all, Monreale Cathedral (1174), was a version of the traditional basilican church specially adapted for the huge display of mosaics for which it is celebrated. The exterior of the apse was covered with Moslem arcading and inlays.

Finally, there are a number of buildings which display signs of French influence. The most obvious of these is the ambulatory with radiating chapels, and this occurs at Aversa near Naples, and Venosa and Acerenza on the eastern borders of Apulia. Closely connected with the Hauteville dynasty, and the burial place of Guiscard and his brothers, Venosa would, if completed, have been one of the most sumptuous monuments in southern Italy. Acerenza Cathedral, on the other hand, has an astounding mixture of elements. Apart from the ambulatory and chapels, there are cubic capitals and a ribbed vaulted choir. The latter suggest northern Italy rather than France. No other building better conveys the cosmopolitan aspect of southern Italian Romanesque architecture.

ITALY AND DALMATIA

✝ Church
◎ Church with Romanesque bronze doors
● Church and secular building
⊚ Church with Romanesque bronze doors and secular building

AUSTRIA

SWITZERLAND

Giornico
Chiavenna
Como
Rivalta d'Adda
Bergamo
Brescia
Crema
Verona
Trent
Gemona
Cividale
Aquileia
Grado
Treviso
Murano
Torcello
Venice

AOSTA
VALLEY
OSTA
Ivrea
Cavagnolo
Sagra di
San Michele
Casale
Monferrato
Vercelli
Pavia
Milan
Chiaravalle
Lodi
Cremona
Mantua
Piacenza
Parma
Fidenza
Castell'
Arquato
Modena
Bologna
Nonantola
Ferrara

PIEDMONT
LOMBARDY
VENETO
Po
Adige

LIGURI
Genoa
Albenga
Sarzana
EMILIA

Parenzo
(Poreč)
Rab
DALMATIA

Pistoia
Prato
Lucca
Pisa
San Frediano
a Settimo
San Gimignano
Florence
Arno
ROMAGNA
Ravenna
Fano
Arezzo
Città di Castello
Ancona
Zadar

ADRIATIC

Siena
Massa
Marittima
TUSCANY
Gropina
Perugia
Assisi
UMBRIA
Spoleto
Sovana
Foligno
THE
MARCHES
Ascoli-Piceno
Ferentillo
Tuscania
ABRUZZI
Trogir
Split

SEA

Nebbio
(St. Florent)
Murato
Canonica
(Bastia)
CORSICA
Tarquinia
Civita
Castellana
Castel S. Elia
Rome
Tiber
LATIUM
Anagni
MOLISE
S. Clemente
a Casauria
Monte Sant'Angelo
Siponto
Manfredonia
Troia
Barletta
Trani
Molfetta
Bari

Korcula

Bonifacio
Gaeta
Sant'Angelo in Formis
Benevento
Canosa
Ruvo
Bitonto
Altamura
Matera
Monópoli
A
U

Porto
Torres
Sassari
SS. Trinità
di Saccargia
Olbia
Ottana
Caserta
Naples
Ravello
Amalfi
Atrani
Salerno
CAMPANIA
Venosa
Acerenza
Potenza
BASILICATA
Bitetto
Brindisi
Lecce
Taranto
Otranto

Oristano
SARDINIA
Iglesias
Cagliari

Agropoli

Rossano

TYRRHENIAN

SEA

Tropea
Stilo
Gerace
CALABRIA
IONIAN
SEA

MEDITERRANEAN

Palermo
Monreale
Cefalù
SICILY

SEA

Marcus ut alta fremit uox per deserta leonis

In contrast to the hybrid character of Apulian architecture, sculpture in this region from the beginning went its own, very individual way. Here too, however, outside influences were both numerous and varied. We notice this as early as 1100, when a marble throne, which is now in S. Nicola, was made for Bishop Elia of Bari (*d.* 1105) by an unknown artist. It continued an already existing tradition: cf. for instance the stone cathedra which Romoaldo had made in the second half of the eleventh century for the cathedral of Canosa. The Bari throne has incontestable affinities with Aquitaine, probably through Wiligelmo's work in Modena (see p. 39). Nevertheless there is evidence of a very individual style: the Apulian master's figures are to a greater extent free-standing and are more strongly expressive than those of Wiligelmo.

The cathedral of Monopoli, entirely reconstructed in the eighteenth century, contains a few fragments of its predecessor, which was founded in 1107, among them a decorated arch which has the date carved on it. The sculptures of this fragment are directly reminiscent of Elia's throne at Bari, and may well have been made by the same hand. The region also abounds in sculptured doorways. They are to be found in the cathedrals and churches of Altamure, Ruvo, Trani, Troia, Lecca, Bari, Bitonto, Matera, and elsewhere. One at S. Benedetto in Brindisi is entirely Lombard in style, with rich interlace and fantastically grotesque figures. Something of a similar nature is found in Trani; here classical traditions are strong, moreover, as shown by the acanthus friezes of arches and Corinthian capitals, worked in the late Roman manner with a drill. One of the richest and most harmonious porches in Apulia is to be found in the abbey church of S. Leonardo di Siponto, near Manfredonia, where French, north Italian and classical themes are fused into an admirable whole. Separate mention must be made of the so-called Tomb of Ròtari at Monte Sant' Angelo in the Gargàno peninsula. This was probably erected as a baptistry. Its sculptures are akin to Monopoli and the Bari throne. Special mention must also be made of the half-projecting grotesque animal figures which are everywhere to be found on doorways and window frames: lions, griffons, dragons, elephants, etc. This probably shows Eastern influence. The theme was, together with many others, exported from Apulia to Dalmatia.

No other region in Italy is so rich in cast bronze church doors as Apulia and its neighbouring territories. Troia Cathedral, in fact, has two made in 1119 and 1127 by Oderisio da Benevento. The earlier one is in the main doorway: it contains twenty-eight panels, and is heavily embossed in the surrounding frame, the grotesque heads with rings in their mouths and the handles in the shape of winged dragons. The figures in the panels are not in relief; use has been made of niello work and silver inlay. This is also the case in the doors of S. Michele at Monte Sant' Angelo, commissioned by Pantaleone of Amalfi and made in Byzantium in 1076. The main doorway

The apostle Mark; miniature from the Gospel Book of Susteren, made in the first half of the eleventh century either in Lorraine or in Fulda. Parish church, Susteren (Limburg).

75

of Trani Cathedral has bronze doors dating from 1175. They were made by Barisano, a local artist, who created similar work for the cathedral of Ravello and for the north doorway of Monreale Cathedral in Sicily. The main portal of the latter church has doors made by Bonanno Pisano (1186). There is a distinct relationship between the doors of Ravello and those of Trani, although the former consists of seventy-two decorated panels and the latter of only thirty-two. They contain reliefs which were apparently made with the aid of moulds: some of them are repeated more than once. They are close to Byzantium in style.

A small domed building, perhaps inspired by Eastern models, stands against the southern flank of the cathedral of Canosa. It is the tomb of Bohemund, son of Guiscard who took part in the First Crusade and became the prince of Antioch (d. 1111). One enters through a double bronze door of fairly modest dimensions, cast c. 1111 by the bell-founder Rogerius. This is probably the oldest of its kind to be made in southern Italy. It contains figures reminiscent of Byzantium, with niello work and silver inlay as well as abstract relief, unmistakably Islamic in origin.

Finally, attention must be drawn to a group of bronze doors in the western coastal region. The first, those at Monte Cassino, are lost. But three others survive: those at Amalfi, made in the twelfth century and related to those of Monte Sant' Angelo; those in Salerno, cast in 1099; and those of Atrani, dating from 1087; all cast in Constantinople. The doors in Atrani and Amalfi were donated, like those of Monte Sant' Angelo, by Pantaleone.

In Campania, a strong classical tradition may be detected in sculpture, but though its products are skilfully made, they are generally rather superficial and lifeless. A typical example is the ambo, dating from 1181, in Salerno Cathedral. This classical trend, which was again combined with Islamic elements, proved entirely congenial to the taste of Frederick II, and flourished during his reign and even later. One of the masterpieces of the later period is the magnificent ambo in the cathedral of Ravello (Plate 55), made in 1272 by Nicolò di Bartolomeo da Foggia, and donated by the patrician Nicolò Rùfolo and his wife Sigilgaida della Marra. The latter's marble portrait bust, wholly classical in style, is placed over the entrance to the steps; because of her melancholy smile she has been called the 'Mona Lisa of Romanesque art'. The ambo as a whole is a work of amazing elegance and harmonious perfection. Another example of Campanian classicism is the Easter candlestick in the Cappella Palatina in Palermo. This is surmounted by three figures according to the ancient tradition; but it is nevertheless imbued with a new vitality.

Furthermore, the abbey church of S. Clemente a Casauria in the Abruzzi has a main doorway dating from c. 1180, in which French influences combine with forms reminiscent of the Emilian sculptor Niccolò, who worked half a century earlier.

The influence of France, and in particular that of Provence is predominant

in Sicily. This is evident in the rich capitals of Cefalù Cathedral (second half of the twelfth century), and more especially in the incomparable cloister of the cathedral of Monreale (Plate 62). The fact that the art of Provence exerted influence here is not surprising, nor are the stylistic similarities to Nazareth or Plaimpied (pp 86, 230). But the appearance of Mithras and his bull among the capitals is an unexpected allusion to the remote part of the Mediterranean. In the twelfth and first half of the thirteenth centuries the Sicilian court was the centre of the most cosmopolitan culture of the day; and to some extent it anticipated the role which Florence was to play in the subsequent period. Sicilian poets were to have a particularly important part in preparing for the new style in Italian literature. Among them we may count the Emperor Frederick II and his son Enzo, who was to die in Bolognese captivity. Similar links can be detected between the classicism of the sculpture of Frederick's time and the new style of the Pisani.

ROMANESQUE PAINTING IN SOUTHERN ITALY

Towards the end of the eleventh century a cycle of paintings was executed at Sant' Angelo in Formis near Capua (Campania). The series, which was certainly inspired by Monte Cassino, is one of the most ambitious to have survived in the whole repertory of Romanesque art. Partly attributed to a Byzantine painter of the severe style, the thread of the story was subsequently taken up by indigenous artists, who no longer spoke the solemn language of the Byzantine court, but who expressed themselves in a popular idiom. Thus an almost heraldic tranquility gave way to dramatic emotion. This genre, however, had few followers. Instead we find a return to a humbler Byzantine tradition all over southern Italy, a movement in which the initiative was taken by Basilian monks. The mosaics created in Sicily in the twelfth and early thirteenth centuries, in Palermo, Cefalù and Monreale, also form part of Byzantine art, and are therefore not within the scope of this book.

MINOR ROMANESQUE ARTS IN ITALY

The products of the minor art forms, i.e. metalwork, weaving and needlework, glass and ceramics, ivories, book illumination, etc., reflect the same tastes and attitudes which inspired architects, sculptors and painters. Here, too, there is a fusion of various elements: classical, Early Christian, Byzantine, Lombard, Islamic, Provençal, Aquitanian and Norman. To this mixture were added works imported from abroad. We find this in Venice, which was filled with the riches of Byzantium. But in other places we encounter Rhenishwork, e.g. the *pace di Chiavenna*, the richly ornamented front of a twelfth-century book cover. Works of art from the Mosan region also found their way to Italy as well, c.f. the foot of the Trivulzio candlestick now in the north transept of Milan Cathedral, an illustrious work sometimes attributed to Nicholas of Verdun. These are just a few of the more obvious

examples. The bronze eagle and a figure of an evangelist on the ambo in Sant' Ambrogio in Milan date from the eleventh century and are related to Ottonian art. The famous *Pala d'Oro* in S. Marco, Venice, is an altar frontal later converted into a retable. It consists of eighty enamel plaques, mostly Byzantine, framed in gold and decorated with precious stones. The oldest sections were made in the tenth century, but additions to it were made in both the twelfth and the thirteenth century. Silver altar coverings are found, among other places, in the cathedral of Cividale (chased and gilt silver, dating from the late twelfth century), and in Città del Castello, also of gilt silver, with scenes from the life of Christ—a gift from Pope Celestinus II (1143–44).

In textile design the East set the tone, but workshops were set up in Italy as early as the twelfth century. At first Eastern examples were imitated but an indigenous style was gradually developed, which in subsequent centuries was to achieve beautiful results.

The art of ivory carving was understandably subject to Byzantine influence, although at times Rhenish and Mosan features can be detected. The glass-works at Murano were also at first largely indebted to Byzantium. It was during the Romanesque period that the foundations were laid in Tuscany, Umbria and Emilia of the future Italian ceramics industry.

The art of book illustration was of greater importance. Realism entered this branch of art earlier than in mural or panel painting. A speciality of the southern Italian monasteries were the Exultet Rolls (a liturgical text describing the festival of Easter, written on long rolls of parchment which from the end of the tenth century onwards were illuminated with vivid scenes of the festival). Other manuscripts, too, such as gospel books, psalters, Bibles, sacramentaries, etc., were richly decorated, and these provide a better and more complete idea of the development of painting than do the surviving works on a larger scale. In these illustrations Byzantium exerted far less influence, and this could only encourage the development of a native style, which in the end emerged into maturity.

3. FRANCE

ROMANESQUE ARCHITECTURE IN FRANCE

As in Italy, Romanesque architecture in France did not form a united whole, but consisted of a large number of regional schools, sometimes differing widely one from the other. Nevertheless, these were to display an analogous vitality and to influence in varying degrees the development of architecture in most of the countries in Europe. Thus French styles spread, for instance, far into Spain along the pilgrimage routes (see p. 174), while the Crusades led to the foundation of French Romanesque churches in Syria and Palestine (see p. 229). When the Normans invaded England, they introduced their

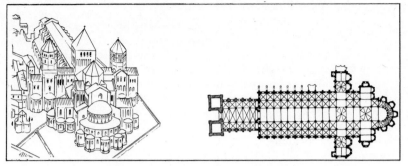

Reconstruction and groundplan of Cluny Abbey.

style of building there (see p. 191), and occasionally other Normans encouraged French styles in southern Italy. The characteristic architecture of the monastic orders (e.g. Cluny and Cîteaux) was often imitated in western, southern and central Europe. Moreover, the sculpture of Burgundy, Languedoc and western France influenced contemporary art in Italy, Spain, England and elsewhere.

On the other hand, French Romanesque did not occur everywhere within the borders of present-day France. Ottonian art left its mark in the north-east; while Alsace and Lorraine belonged to the Rhineland, i.e. Germany. Spanish-Arabian influences occur in the south-west; and Catalan elements turn up in Roussillon. In Provence and in the valley of the Rhône (Digne, Embrun) there are Lombard campaniles and Emilian porches with column-bearing lions. The westwork of Tournus is covered with Lombard bands. In Périgord and adjoining territories, Byzantine motifs are numerous. One could go on like this for some time. Yet even so the Romanesque art of France surpasses that of all other nations or regions, both in quantity and quality.

ROMANESQUE ARCHITECTURE IN BURGUNDY

Of the three important early Romanesque monuments of Burgundy, the second abbey church at Cluny, St-Benigne at Dijon, and St-Philibert at Tournus, the first has entirely disappeared though its plan is known from excavations; while the second has left only the crypt of its rotunda. Tournus, on the other hand, has survived more or less intact. The abbey was damaged or destroyed several times in the tenth and eleventh centuries and its building history is complicated. Essentially it falls into three parts: an early eleventh-century narthex; a somewhat later nave whose vaults are later still; and a choir largely remodelled early in the twelfth century. Although parts go back to the early eleventh, the narthex, the oldest part, is First Romanesque. It has two levels; and in the tower of these, groined and barrel vaults are ingeniously combined. To the two stages of the narthex correspond the

79

whole of the nave elevation. The great height is achieved, as at Sant'
Abbondio, Como, with which it is contemporary, by increasing the height
of the columns. These are of coursed masonry, and Tournus nave was
perhaps the prototype for a later group of Romanesque churches in the
west of England, in which cylindrical piers are prominent (e.g. Tewkesbury).
The ambulatory was derived from that of Clermont Cathedral, and is one
of the earliest surviving examples of this arrangement. The late eleventh-
century transverse barrel vaults over the nave form a unique and curious
solution to a problem which was later solved elsewhere by the use of
groined or ribbed vaults.

It would be interesting to know whether Cluny II or Dijon resembled
Tournus or not. Reconstructions of the former tend to differ considerably
and if correct suggest that Burgundy was the home of great architectural
innovations in the late tenth and eleventh centuries. Thus if Cluny II was
the model for the surviving mid-eleventh-century Cluniac priory at Payerne,
it may have been the first great church in Europe to receive a continuous
barrel vault over its nave. In this respect we would like to know more about
the Lombard William of Volpiano's church at Dijon (1001). To judge from
the traces of the rotunda, it could have been a work of immense originality.

As it is, we know little about eleventh-century architecture in Burgundy
apart from Tournus. At the end of the century the third abbey church at
Cluny set a wholly new standard of architectural scale, structure and decora-
tion. Although it was mostly destroyed after the French Revolution, there
is enough evidence for an accurate reconstruction. When built, it was over
100 feet high and the largest church in Western Europe, rivalling, perhaps
deliberately, the Early Christian basilicas of Rome. The use of classical
pilasters, half-columns, and Corinthian capitals must have imparted a strong
Roman flavour to the nave. The whole east end was contrasted with the
nave. It had two transepts with four towers over them. The capitals of the
chancel were carved with elaborate theological and liturgical allegories, and
a great painting of Christ in Majesty in the apse dominated the choir. Both
parts of the church were barrel vaulted, however, and this involved using
elliptical and pointed arches, and even flying buttresses. Iconographically
the building seems to suggest that the Heavenly Jerusalem and the palace
of the Caesars were one and the same. If so, then the circumstances of the
contemporary dispute between Emperor and Pope, and the classical Roman
features of the Imperial Cathedral of Speyer, form a relevant background to
the design of Cluny.

Cluny was a special effort, and not as such imitated. Individual features
were copied, however. Thus the second transept took root in England (first
at Canterbury *c.* 1100); the octagonal towers in Auvergne; the pointed
arches and classical pilasters in Burgundy itself. In this respect the present
cathedral of Autun and Paray-le-Monial are both smaller versions of Cluny,
and there are several later churches in which the classical elements linger on.

It is therefore surprising to find so few traces of Cluniac influence in the not far away and nearly contemporary abbey church at Vézelay. The independence of Vézelay is further stressed by the appearance there of a more advanced form of groined vaulting. Vézelay was itself the centre of a small, alternative group of Burgundian churches, which included Avallon. The portals of Avallon, which were among the most profusely decorated in Burgundy, belong to the latest phase of stylistic evolution; and the same is true of the largest of all Cluniac priories—La Charité-sur-Loire. This church was drastically remodelled after Cluny was built, and in emulation of the mother house. Its surviving tower and clerestory are encrusted with an exotic array of ornament much of which was imported from Moslem Spain. Apart from its influence in central France, La Charité exercised a vague and distant effect over a certain strand of English taste in the second quarter of the twelfth century, largely through the patronage of the Cluniac bishop of Winchester, Henry of Blois.

ROMANESQUE SCULPTURE IN BURGUNDY

The capitals in the chancel of Cluny, which was dedicated in 1096 (though the capitals are often dated twenty years later), and the tympanum of its west door, mark the opening of a new era in the use of architectural sculpture. Even more elaborate are the capitals and tympanum made between 1125 and 1135 for Autun; they were the work of the sculptor Gislebertus, and they vividly represent scenes from the Bible and from the lives of saints. The well-known fragment from the north doorway dates from the same period. It shows Eve furtively snatching the forbidden fruit, while Satan's claw holds the branch (Plate 67). The climax of this extensive sculptural programme is undoubtedly the tympanum, signed GISLEBERTUS HOC FECIT. This great work is probably later than the capitals. The idyllic nature of the earlier works here gives way to a kind of visionary expressionism. The Divine Judge is supernaturally large and powerful. Accompanied by ethereal angels and saints, he passes judgement on tiny men, who awaken, naked and in full consciousness of their guilt, from the sleep of death (Plate 68). Medieval man's religious fear of death and of the inexorable Judge is here personified in the most moving manner. Gislebertus was one of the greatest artists of the Western world in the Middle Ages.

Naturally the Autun sculptures exercised great influence. This is evident at Saulieu and Perrecy-les-Forges (Plate 81), where Christ in majesty in a mandorla is flanked by insect-like cherubs, who clearly proclaim their Autun origin (Plate 82). The attenuated figures and the somewhat wild composition of the remarkable tympanum in Neuilly-en-Donjon also manifest a mannerism based on the example of Autun (Plate 80). The three wise men bring their gifts to the Christ-child seated on his mother's lap, accompanied by angels blowing elephant-tusk horns, with the reclining figures of a lion and an ox underneath. On the lintel below, Adam and Eve stand under the tree

of sin, and the Magdalene washes the Master's feet at the Last Supper. The two adjoining capitals, of which the right-hand one, showing Daniel in the lion's den, is illustrated, are the work of another, less mannered sculptor (Plate 85). The culminating point of Burgundian mannerism is found in the Cluniac priory church of Charlieu, dating from the middle of the century. The line and shape of the decorative motifs in particular possess an emotional quality reminiscent of the rococo style.

Next to Autun, Vézelay occupies a pre-eminent place in Burgundian sculpture. It is again the tympanum, here between narthex and nave, which demands our attention. This impressive work was made around 1125–30, that is, probably a little earlier than that of Autun. Its theme—the mission of the apostles—is a fairly rare one for the period and for the position it occupies. As at Autun, the great figure of Christ is seated in the centre, flanked by His disciples, while on the surrounding frieze foreign peoples are represented, some of them in a naïve and fantastic manner (Plate 69). Although there are numerous links with Autun and the style of Gislebertus, the moving drama of the latter's work is lacking. The capitals of Vézelay are among the masterpieces of Romanesque sculpture and are comparable to those of Cluny and Autun. On the other hand, the partly preserved tympana of the west doorways of La Charité-sur-Loire, which belong to the middle of the century, are in no way related to Autun, but already point to Chartres.

Finally, mention must be made of the sculpture of Anzy-le-Duc, which is also derived from Autun: a tympanum with high relief, which is now in the *Musée Hieron* in Paray-le-Monial, and a series of capitals with unusual subjects, amongst others one of two bearded men fighting (Plate 77), a theme which is repeated almost identically at Poitiers (Plate 78). Emile Mâle made the point that this is one of many themes which entered Romanesque sculpture by way of the repeatedly copied miniatures from the Apocalypse of Beatus (see p. 120). In the famous specimen of St-Sever the illustration is inscribed: *Frontibus attritis barbas conscindere fas est:* 'when the heads are bald one must pull the beards'.

ROMANESQUE PAINTING IN BURGUNDY

The famous eleventh-century murals of Sant' Angelo in Formis near Capua (Italy), with their Byzantine figures against a blue background, form the starting point of a group of wall paintings referred to in France as *l'ecole au fonds bleus*. Cluny adopted this method of painting before the end of the eleventh century, though it is unfortunate that the principal examples, at Cluny itself, were lost with the church. Fortunately, a subsidiary cycle, painted after those of Cluny by the same artists, has survived in the chapel of the Cluniac priory at Berzé-la-Ville. It dates from between 1103 and 1109. The apse contains a large figure of Christ enthroned in a mandorla, one hand raised as in speaking, the other handing Peter the scroll of the new Law.

82 Fresco in the church of St-Savin-sur-Gartempe; the martyrs Savinius and Cyprian before the judgement seat of Ladicius, *c.* 1100.

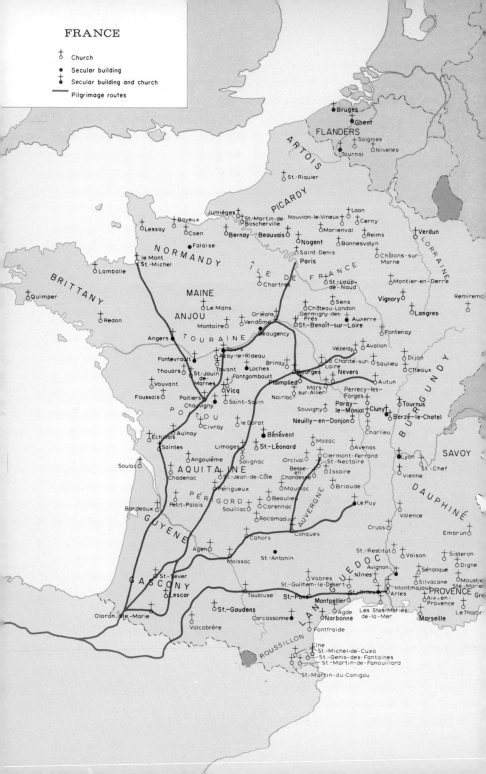

Christ is wearing a purple pallium over a white tunic; the blue background is strewn with stars (Plate 65). On the wall of the choir below the apse are portraits of the martyrs Blasius and Lawrence, and in the spandrels of the arches the Wise Virgins, attired like Byzantine Princesses. Another work of the same school is the great figure of Christ discovered in the apse of Paray-le-Monial. The activities of these artists can be followed all along the pilgrimage routes through southern France and into Catalonia.

ROMANESQUE ARCHITECTURE IN AUVERGNE

The first important Romanesque church in Auvergne of which anything is known is the pilgrimage church of Ste-Foy at Conques. Although this is unlikely to have been the first design of its kind, in the absence of St-Martin at Tours and St-Martial at Limoges, Conques represents for us the earliest stage in France of the evolution of the church with both galleries and vaults. Essentially, it belongs to the second half of the eleventh century. Before about 1050, there were numerous churches in northern France with galleries but no vaults; and in the south with vaults but no galleries. The merging of these two types at Conques was achieved at the expense of clerestory windows. Despite this, the formula was used later in the century for St-Sernin at Toulouse and the cathedral of Santiago de Compostela in Spain. It also remained standard for the twelfth-century churches of Auvergne.

The other source of the twelfth-century architecture of Auvergne was Cluny. In particular the east ends with 'haunched' transepts and octagonal towers rising in a hierarchical triangle from the ambulatory and radiating chapels, owes much to the east end of Cluny. Nevertheless, Auvergne managed to maintain an unmistakable local character. It has a greater love of ornament than Burgundy. There is an exuberant tendency to decorate wall surfaces with patterns in the masonry. The church of St-Austremoine at Issoire is perhaps the most fully developed in the series (Plate 106). Others are found at Brionde, St-Nectaire, Orcival and Notre Dame at Clermont-Ferrand (Plate 104).

Quite separate from this main group of Auvergnat churches is the cathedral of Le Puy. This is one of the most extraordinary designs in all Romanesque architecture. The nave consists in effect of a series of towers raised on transverse arches. In this a distant link with Tournus may perhaps be recognized; but one is driven to the Early Christian churches of Asia Minor, e.g. Alahan, to find anything remotely similar. To complicate matters further, much of the ornament of Le Puy clearly comes from Spain. This can be seen in other churches, e.g. St-Michel d'Aiguilhe (Plate 116). This Spanish-Moorish ornament spread from Auvergne to the region of Limoges. The doorway of the church at Le Dorat, with its undulating, undecorated archivolts is a typical example, also on account of the complete absence of any sculptural ornamentation. The incrustation on the choir walls of Issoire, Orcival and elsewhere, already mentioned, is derived from the

same source. In this connection it must not be forgotten that numerous Frenchmen from the Auvergne and adjoining regions had taken part in the Spanish Reconquest (see p. 177).

(see p. 177)

ROMANESQUE SCULPTURE IN AUVERGNE

The Last Judgement is the theme of the tympana of practically all the churches in Auvergne. There is a preference for architectural or geometrical diversion of the available space. An example is Beaulieu (1130–40) (Plate 100), where the figures of prophets on either side of the entrance and on the central doorjamb are reminiscent of Moissac (cf. Plate 98). The tympanum of Carennac can also be dated between 1130 and 1140. Here Christ is shown in Majesty, surrounded by the four beasts of the Apocalypse and accompanied by the apostles. This work is signed *Gisbertus cementarius*. The large sculpture of the Last Judgement in Conques, composed of eighty-four figures, contains numerous explanatory texts but no signature, although this might have been expected here (Plate 101). In spite of the fact that this work, dated *c*. 1130, has many undeniable qualities which show to advantage in its several details, its unity is destroyed by excessive schematical division. This becomes clear when it is compared with the great Burgundian tympana such as Autun or Vézelay (Plates 68–69). An unusual tympanum, its theme reminiscent of Carennac, is found at Mars-sur-Allier, somewhat further north. Apart from its rather naïve tympanum, this twelfth-century Cluniac church possesses remarkable capitals, almost abstract in treatment. They are clumsy and primitive in shape, but in spite—or possibly because—of this, very descriptive. Their natural simplicity is the more remarkable when compared to the (at times almost too perfect) historied capitals of the great churches of the region: St-Nectaire, Issoire, Besse-en-Chandesse, Mozac, etc.

We have already referred to the influence of the prophet figures at Moissac on the porch of Beaulieu. This is even more the case in the surviving fragments of the sculptures of Souillac, dating from 1130–40, and most of all in the famous figure of Isaiah (Plates 98–99). A particularly remarkable capital, fairly far north, in Plaimpied, showing Christ being tempted by Satan, represents the baroque phase of Romanesque sculpture in this area (mid twelfth century). It occupies a unique position because of its emotional expressionism and its marked interplay with light and shade (Plate 105).

ROMANESQUE PAINTING IN AUVERGNE; METALWORK

The tympanum of Ste-Foy in Conques contains traces of the original colouring, a very rare occurrence. Apart from this and the magnificent St Michael at Le Puy, Auvergne, like most of the southern half of France, is poor in examples of Romanesque painting. Only in the extreme north of this part of the country, near the Loire, can a few series be found, for instance in the church of St-Aignan in Brinay, which possesses a cycle of episodes

from the Lord's childhood, painted shortly after the middle of the twelfth century. The painter tells his story in a naïve and popular manner, but not without skill. The master who painted the choir-screen resembling a pulpit in Vicq (Indre) gives evidence of an emotional temperament which is reflected in his work. Everything seems to move with inner force, and although his delineation is not always perfect, few of his contemporaries equal him in his power of expression (early twelfth century).

Most of the Romanesque metalwork of south and central France has been lost, and it is therefore difficult to estimate the extent to which it shared the styles and techniques that flourished in the Mosan area. One outstanding piece has survived, however—the statuette of Ste-Foy at Conques. This remarkable object was first put together *c.* 980. (It received many later embellishments in the form of cameos, precious stones, etc., which were presented to Ste-Foy as votive offerings.) The head of the figure is a re-used late Antique bronze; the rest is a wooden core of chased gold. Although this kind of figure was always rare, others are known from documents. Four such 'majestates' were exhibited at the Synod of Rodez: St-Marius from Vabres, St-Amand from Rodez, and the Madonna of St-Sernin at Toulouse, as well as Ste-Foy. By remarkable good fortune, the treasury of Ste-Foy survived the French Revolution, and it contains other Romanesque pieces. There is also an eleventh-century silver Majestas of St-Chaffre in Le Monastier-St-Chaffre (Haute Loire).

ROMANESQUE ARCHITECTURE IN LANGUEDOC

St-Sernin at Toulouse is the largest surviving Romanesque building in France. Like Ste-Foy at Conques, it was one of the intermediate stopping places for pilgrims on their way to Santiago. St-Sernin has all the features of a pilgrimage church: double-aisled nave with an aisled transept and an ambulatory with radiating chapels. The entire building is surrounded by tribunes. Its construction began shortly before 1080, and was not completed till the twelfth century.

In Roussillon, the region which borders on Catalonia, of which in fact it originally formed part, there is considerable evidence of the Lombard bands of First Romanesque architecture. Purely Lombardian campaniles are found at St-Martin-du-Canigou (1007–26), and St-Michel-de-Cuxa (Plate 95). At St-Guilhem-le-Désert, which lies on the pilgrimage route from northern Italy, fairly close to the Mediterranean, an eleventh-century nave is linked to a choir of the early twelfth century, which has a dwarf external gallery—a Lombard theme, on the whole rare in France.

Of the Cluniac abbey church of Moissac on the Tarn, north-west of Toulouse, the Romanesque church has disappeared. All that remains are the south doorway in the *clocher-porche* of *c.* 1120–40, which was reconstructed as a fortification; some traces of the nave which had no aisles and was originally vaulted with domes; and lastly a cloister with beautifully carved

capitals of *c.* 1100–20 (Plate 103). It remains important for its magnificent series of Romanesque sculptures.

A rare example of secular Romanesque architecture is the Hôtel Archambault at St-Antonin, subsequently the town hall and now a museum. An open arcade of three arches is surmounted by a series of small pillars carrying a flat architrave. They are interrupted by two piers carved with the figures of Solomon and of Adam and Eve. In the upper stage the threefold division is once more emphasized by three windows with double openings.

ROMANESQUE SCULPTURE IN LANGUEDOC

The sculpture of Languedoc surpasses in quality that of any other region of France during the Romanesque period. Moreover, its influence was widespread. This applies particularly to the sculpture of Toulouse which was to affect much of France, northern Spain and even Emilia, down to the time of its leading master, Antèlami. Moissac was the second great centre in Languedoc, but in contrast to that of Toulouse, its influence remained chiefly regional. We encounter it in Auvergne, at Souillac and at Beaulieu.

The beginnings of Languedoc sculpture have been put back to 1020 by an inscription on the carved lintel of St-Genis des Fontaines in Roussillon. Despite the crudeness of this work (Plate 91) it is unlikely to be quite so early. In any case a new epoch clearly began with the cloister capitals and reliefs at Moissac *c.* 1100, which were followed soon after by the Porte de Miégeville at St-Sernin, and the series of reliefs in the ambulatory of that church.

The golden age of Languedoc began *c.* 1130–35, i.e. when the figures of the twelve apostles were carved on the jambs of the entrance to the chapter house of Toulouse Cathedral. They are the work of two sculptors, one of whom signed himself: Gilabertus. They employ the motif of crossed legs which turns up again in the column figures of St-Denis. At about the same time work began at Moissac on the great doorway with its majestic tympanum which depicts the Vision of St John from Revelation (Plate 97). An enormous figure of Christ enthroned is surrounded by seraphim and the

64. St-Philibert in Tournus; the earliest, western sections are Lombard in style. **63.** Its interior contains circular brick columns and transverse barrel vaulting between diaphragm arches. **65.** The wall paintings in Berzé la Ville are the work of Cluny artists (1103–9). **66.** Cluny Abbey was largely demolished early in the nineteenth century; fortunately the capitals of the choir were preserved. **67.** Eve tempted by Satan; a remnant of the sculptural decoration of the north doorway of Autun Cathedral. **68.** The tympanum of Autun Cathedral, signed by the sculptor Gislebertus, belongs, with that in the narthex at Vézelay (Plate **69**), to the masterpieces of Romanesque sculpture in Burgundy. **70.** The interior decoration of Autun Cathedral was influenced by the Gallo-Roman city gates, of which ruins survive (Plate **71**).

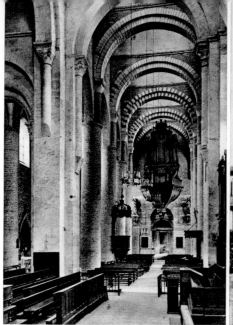

63

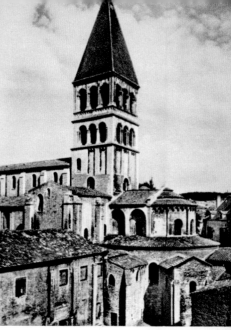

64

65

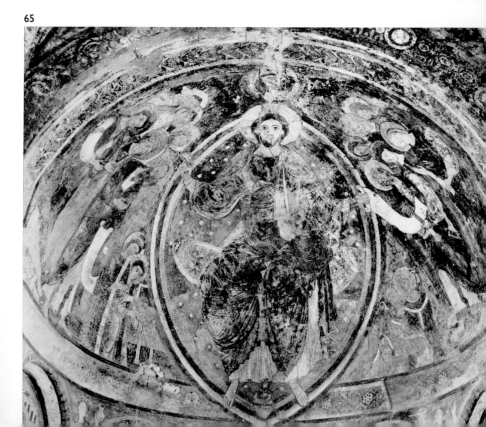

66

67

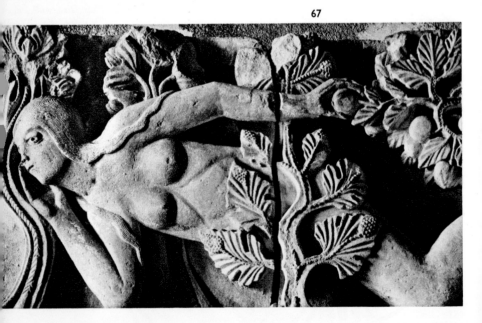

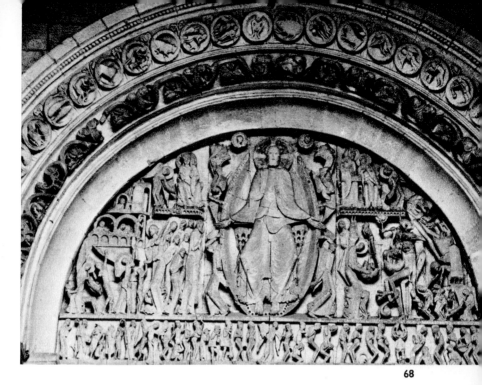

68

69

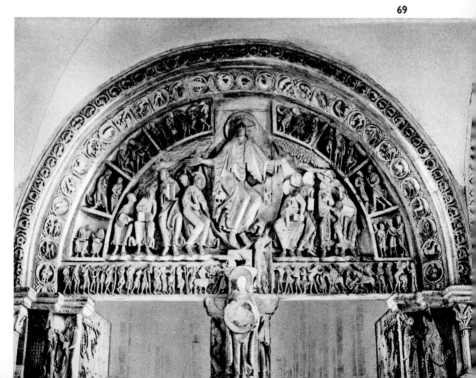

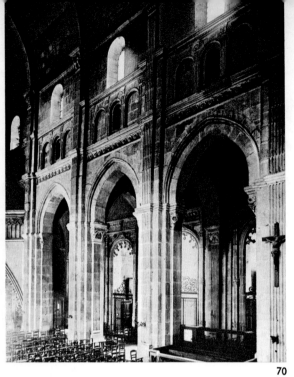

70

71

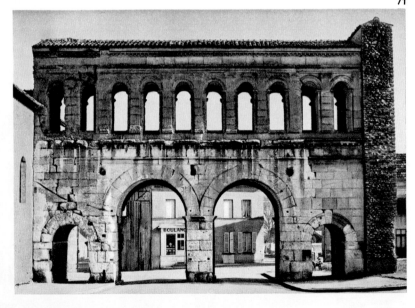

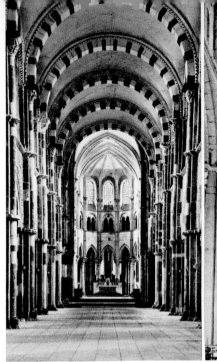

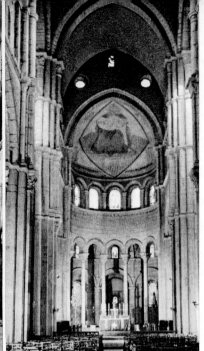

72

73

74

75

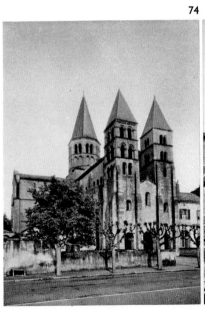

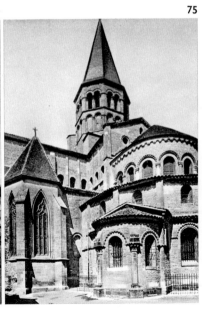

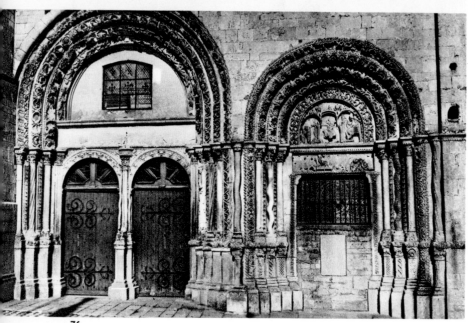

76

77

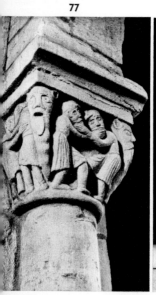

78

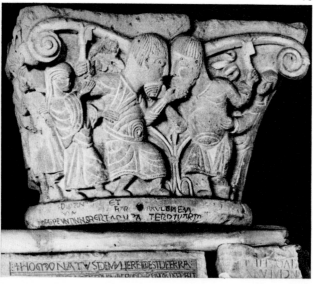

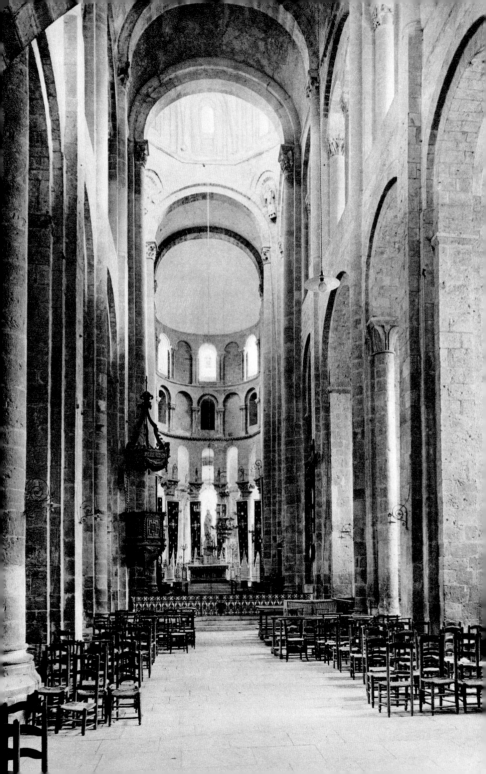

four beasts, while the twenty-four elders look up in veneration. A row of rosettes based on classical tradition encloses the panel below. To the left and right of the doorway are Isaiah and St Peter (Plate 98): the central trumeau is carved with the slender figures of prophets and includes vivid lions and grotesque animal themes. The doorway has a projecting porch, the side walls of which are decorated in high relief with themes from the Gospel. They are later than the sculptures of the doorway: but are reminiscent of the capitals of the cloister (Plate 103). In the same period the famous capitals of the *Daurade* in Toulouse were created, with their mythological and biblical scenes amidst delicate ornamentation reminiscent of orfèvrerie (Plate 96).

Apart from Toulouse and Moissac, the marble doorway of the church of Our Lady at Oloron-Ste-Marie calls for attention. Like Moissac it has a porch, and it is probably because of this that it is so well preserved. Various influences have been active here. In the first place that of Spain: the theme of the Deposition from the Cross on the tympanum was unusual in France in this period, as was the encircled monogram of Christ. The projecting monsters supporting the arches, and the chained Moors carrying the central jamb, are reminiscent of northern Italy or even of Apulia, while the latter motif takes us back to the Spanish Reconquest. These links with Spain and Italy make it necessary to study the Romanesque sculpture of the western Mediterranean as a single problem, and much clarification is still required.

ROMANESQUE PAINTING IN LANGUEDOC

Of the few remaining murals in this region we need mention only those of St-Martin-de-Fanouillar, dating from the middle of the twelfth century. They belong to the Catalan group and were influenced by Italian painting.

ROMANESQUE ARCHITECTURE IN PROVENCE AND THE ADJOINING REGIONS

There are two features of Provençal Romanesque architecture. One is its adherence to the basic church forms of First Romanesque. Thus there is

72. The abbey church of Vézelay was one of the great monastic churches on the pilgrimage routes. **74.** Among these churches, that of Paray le Monial is one of the best preserved. **73.** Its interior is a small-scale copy of the third version of Cluny. **75.** The chancel has an ambulatory with radiating chapels. **76.** The doorways of Avalon represent the baroque phase in Burgundian Romanesque. **77.** On a capital in Anzy-le-Duc, Discord is represented by two old men fighting. **78.** The same theme is found in Poitiers. **79.** The pilgrimage church of Ste-Foy in Conques has a very high nave, lit mainly by way of the cupola. **80.** The remarkable tympanum of Neuilly-en-Donjon is a product of the mannerism emanating from Autun. **81.** The same may be said of the tympanum of Perrecy-les-Forges. **82.** The sculptured capitals in this church also owe much to Autun.

fundamentally no development in structure between an early eleventh-century church like Cardona in Catalonia, and St-Trophime at Arles, which belongs to the middle of the twelfth. This makes it extremely difficult to date many of them. The other is a predilection for good masonry, which betrays the classical past of the region. Many of the churches are extremely simple. Thus we encounter churches without aisles or ambulatories and often without transepts and central towers. In some places they have the appearance of fortifications, as for instance Stes-Maries-de-la-Mer and the cathedrals of Agde and Maguelone. They often consist of an angular, cuboid conglomeration of shapes. A good example is the Benedictine abbey of Montmajour (Plate 87) (mid twelfth century); on the other hand St-Gilles was going to have an ambulatory and radiating chapels. Mention must also be made of the Cistercian monasteries, whose sober style suits the Provençal landscape; e.g. Sénanque (Plate 84), Silvacane and Le Thoronet, all from the second half of the twelfth century. The harmonious proportions of planes, line and space is wholly in Latin tradition in spite of the fact that each of them uses the pointed arch in some form or other (see also p. 119).

ROMANESQUE SCULPTURE IN PROVENCE

Nevertheless it is their sculpture which gives Provençal buildings their special importance, from the primitive Lombard capitals in the eleventh-century crypt at Cruas (Plate 86) to the riches of St-Trophime in Arles and of St-Gilles-du-Gard with their doorways like classical triumphal arches (Plates 88 and 90). At the same time a doorway such as that of St-Restitut strikes us with its pure simplicity. If we did not know that it dates from the twelfth century, we might take it to be classical Roman (Plate 83). On the other hand the influence of Lombardy is clearly evident in doorways such as those in Digne and Embrun which appear to be exact copies of examples in Bergamo and Verona.

The tympanum of St-Trophime in Arles (1180–1200) contains a representation of Christ in Majesty with the twelve apostles, reminiscent of Chartres (Plates 88–89). Against the broad jambs and the adjoining panels of the façade there are large statues in niches behind rows of classical pillars. These carry horizontal architraves which are covered with carved reliefs. Below the Majesty, these depict the twelve apostles; beyond they comprise groups of the elect and of the damned. In style they remind us of late classical reliefs on sarcophagi. The decorative motifs also appear to be derived from classical antiquity. The façade is surmounted by a cornice on corbels; its triangular form recalls a classical pediment. It is the effect of the whole, with its marked contrast of light and shade, and the profusion of ornament which excites our admiration, rather than the execution of the details which seem somewhat hard and uninspired. All the same there is some magnificent sculpture, particularly in the ornamental sections (Plate 89). Two sides of the cloisters adjoining the church date from the second half of the twelfth

century and contain a wealth of historiated capitals, while the corner piers have statues and reliefs.

Across the Rhône lies the former Benedictine abbey church of St-Gilles-du-Gard, famous for its triple west doorway, dating from *c.* 1179, but radically altered at the end of the twelfth century. The original design was based on a Roman triumphal arch, with a frieze which, as in Arles, served as a connecting link. At the time of its reconstruction the central section was slightly raised, thus destroying its coherence. Some of the pillars were left somewhat illogically free-standing (Plate 90). In spite of this, the picturesque effect of the whole is fascinating. Even more than Arles it is imbued with the classical spirit. The capitals are Corinthian and composite, faithful copies of classical examples; some of the pillar shafts are fluted. The influence of Moissac may be discerned in the apostle figures which, like those in Arles, stand behind rows of pillars. At the same time the approach of Gothic is apparent. The three tympana contain representations of the Adoration of the Kings, Christ in Majesty and the Crucifixion. The frieze consists of scenes from the Lord's Passion and reminds us, even more strongly than that of Arles, of Sarcophagus sculpture.

ROMANESQUE PAINTING IN PROVENCE AND
ADJOINING REGIONS

This subject also can be dealt with briefly, although the former abbey church of St-Chef, east of Vienne in Dauphiné, preserves one of the most important examples of eleventh-century mural painting in the whole of France. It is situated in a chapel above the northern transept and dates from *c.* 1070. Themes from the Apocalypse have been decoratively executed in the style of the 'blue school' (see p. 82). The whole is greatly influenced by Italian painting.

ROMANESQUE ARCHITECTURE IN POITOU AND PERIGORD

The Romanesque architecture of western France produced a large number of surviving monuments. Structurally they fall into two main groups. On the one hand there are many churches of the type represented by Notre Dame la Grande at Poitiers, which are essentially derived direct from the single-storeyed barrel-vaulted churches of First Romanesque architecture such as the early parts of the cathedral of Elne in Roussillon (*c.* 1040). In spreading across south-west France and into Spain, this design formula was altered only by the addition of plastic half-columns to the piers, making possible the introduction of carved capitals at the level of the arcade arches, or at the level of the vaults. In these churches rich sculptural decoration tended to compensate for the lack of structural enterprise. The façade of Notre Dame la Grande is particularly ornate, and was perhaps the model from which many others were derived, e.g. St Jouin de Marnes (Plate 110), Echillais, Aulnay, Saintes and Thonars. This type of near hall-church

persisted well into the twelfth century. For instance at St-Pierre, Aulnay, the only difference is that all the arches have become pointed. The type even survived the transition to Gothic.

Slightly apart from this group is St-Savin-sur-Gartempe. Here there are columns instead of piers; and instead of a series of small carved capitals at the level of the vaults connected by transverse arches, there is an abrupt horizontal division (Plate 112). The sense of this deviation from standard practice is provided by the paintings on the vaults, for which this church is famous (see below).

The other group of west French churches are linked together by their use of domes. The presence of these in Périgord and Poitou is not easy to explain. Ultimately they must be derived from the eastern Mediterranean, like so much else in Romanesque architecture. There were famous Byzantine churches with domes at Constantinople and Ephesus, which could have been seen by pilgrims and crusaders; and less spectacular examples in Cyprus. But the adoption of this solution to the vaulting problem in preference to other types indicates that there were perhaps some unusual features of pre-Romanesque church architecture in the region. The domed churches are all without aisles (except St-Front at Périgord), and domes are certainly well suited for vaulting such churches because they require very little lateral buttressing. This was usually supplied by aisle vaults. It is not easy to establish the existence of aisleless halls in western France in the eleventh century, although St-Hilaire at Poitiers may have been one. The series of vaulted churches seems to have begun with the cathedral of Périgueux, St-Etienne de la Cité, just after 1100, and to have been followed in rapid succession by Calors, Angoulême, Souillac and Solignac. They range as far north as Fontevrault near the Loire, and domes may even have been contemplated for Leominster Priory in England. The spans which they covered were quite remarkable: up to sixty feet in some cases. In the early twelfth century this represented a major feat of structural engineering. It was only the fact that domes destroyed the familiar dispositions of a basilican church which restricted their wider use. Even so, they exercised considerable influence on the first ribbed vaults in western France (e.g. the cathedral of Angers *c.* 1150 60).

In most cases, the domes were placed over a sequence of bays in line. Where there were no aisles, the eastern chapels opened directly into the choir. Angoulême has domes over the transepts as well; and St-Front, at Périgord, the most ambitious of them all, adopted the Greek cross plan of the Holy Apostles at Constantinople (*c.* 1120).

St-Hilaire at Poitiers is a curious variant of the usual arrangement. Started in 1049 by an English architect Gautier Coorland, it apparently consisted of a wide aisleless nave, with a timber roof. Into this, aisles were subsequently introduced, and octagonal domed vaults over the narrower nave. The supporting piers, which are quite slender, had to be braced by

transverse arches over the side aisles.

Apart from their structural dispositions, the domed churches shared many of the decoration preoccupations of the other western French group. The drastically restored façade of Angoulême was probably the first in western France to have an elaborate display of monumental sculpture.

Another feature of the church architecture of this region was its towers. Some, like St-Pierre at Chauvigny are square in section throughout (Plate 107). More often, however, the design changes from stage to stage (e.g. Notre Dame la Grande, Plate 108). These towers are stone versions of the staged timber towers of pre-Romanesque buildings (e.g. St-Martin, Augers). A special group of towers on the fringes of the area were the so-called 'clochers limousins', in which the transition from one stage to another was partially masked by a high-pitched gable. The name implies that they originated at Limoges; St-Martin had one, but they spread to Le Puy in Auvergne, and were numerous in the Loire valley. They culminated in the great tower of Vendôme, and the south-west tower at Chartres (see below).

SCULPTURE IN POITOU AND PERIGORD

The sculpture of these regions, particularly that of Poitou, is as extensive as its architecture. There are the usual capitals inside; but the richest displays are found round the choir walls and especially on the façades, where sculpture was used in overwhelming profusion, not only on capitals, but also on the corbels supporting cornices, in the archivolts of doorways, blind arches and windows, in the niches, and in the spandrels above. It is an odd discrepancy that there should be no carved tympana in doorways, although at Angoulême they occur in the flanking arcades. There is a lot of abstract ornament but also foliage decoration. The voussoirs often contain rows of attenuated standing figures, placed radially. These are more often ornamental than graphic. In at least one case, however, at Parthenay, the voussoir figures are arranged tangentially, i.e. like the portals of the Ile-de-France. Another typical feature is the tendency to use figures in high relief, without a frame and standing by themselves against a neutral background; St-Jouin de Marnes in particular provides striking examples (Plate 110).

The iconography of western French sculpture is often original. Thus on several churches in this region we find equestrian statues, with small figures under the horses' hooves. It is generally thought that these are meant to represent Constantine the Great in his victory over paganism. Medieval pilgrims to Rome mistook the bronze horseman, which at that time stood in front of the Lateran and which we now know to be Marcus Aurelius, for Constantine. Others consider these figures to represent St Martin or another equestrian saint.

The iconographical theme of the façade of Notre Dame la Grande in Poitiers (Plate 108) is based on the semi-liturgical *jeu des prophètes*, a mystery play derived from a passage in a sermon by St Augustine, used as one of the

lessons in Matins on Christmas Day. The distribution of the figures on the façade is also eccentric. At Angoulême the Christ in Majesty, which elsewhere usually occupies the tympanum over the central doorway, is placed, immense and impressive, above the central window high in the façade. Christ is represented standing; on the frieze below, the apostles appear in a row of classical portrait busts in round medallions. On either side are angels and prophets (Plate 109).

Finally at St-Pierre in Chauvigny there is a series of historiated capitals, which still retain traces of their original colouring.

ROMANESQUE PAINTING IN POITOU AND PERIGORD

The church of St-Savin-sur-Gartempe possesses the most important cycle of Romanesque painting in the whole of France (Plate 112 and p. 83). It belongs to the *école aux fonds clairs*, which differs from the *école aux fonds bleus* mentioned earlier both in its choice of colours and in its delineation. Unlike the latter it was not influenced by Italian art, but is much closer to the forms of the local sculpture. On the whole, colour is not its primary quality.

The narthex of St-Savin contains a painting of the Resurrection, with episodes from Revelation which have close affinity to the miniatures of the Apocalypse of Beatus (see p. 120). On the tribune of the narthex we find the Deposition from the Cross, the women at the tomb, and Judas hanging himself. The barrel vault of the nave is decorated with four continuous series of paintings illustrating biblical history from the Creation up to Exodus. The paintings in the crypt are deeper in tone. On the walls and the vaults are represented the legend and martyrdom of St Savin and St Cyprian. Although it is obvious that several artists took part in the execution of these cycles there is sufficient affinity between them to show that they belonged to one and the same school. Further north, at Tavant, there are paintings which include the war of the Virtues and Vices, which are related to those of St-Savin. Related works also occur outside Poitou and Périgord, among other places at St-Gilles in Montoire, and in the cloisters of St-Aubin in Angers.

ROMANESQUE ARCHITECTURE OF THE ILE-DE-FRANCE AND ITS ENVIRONS

In these regions, which include Touraine and the Orléanais, and more particularly in the Ile-de-France itself, Gothic was to mature sooner, and achieve greater perfection, than elsewhere, with the inevitable result that little was preserved from preceding periods. This was especially the case in the more important centres. Exceptions to this general rule are a number of abbey churches, for instance the abbey of Benedictine nuns at Morienval, north-east of Paris, where the church in part dates from the eleventh century (Plate 122). The choir is flanked by two towers; at the west end there is one

tower in the midline of the nave. Around 1130 a tiny ambulatory without radiating chapels was added, which contains some early examples of Gothic ribbed vaulting. The choir of St-Martin des Champs in Paris, a former

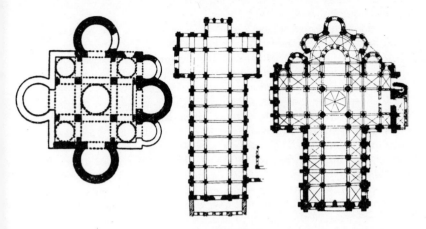

Groundplans of (from *l.* to *r.*): Germigny des Prés, the abbey church of Fontenay, and the pilgrimage church of Ste-Foy in Conques.

Cluniac priory church, has a double ambulatory dating from 1130–40, which perhaps anticipates that of St-Denis. St-Germain des Près was a Benedictine abbey, but unfortunately the church was excessively restored in the nineteenth century. Here too, the tower, dating from the early eleventh century, is placed centrally in front of the nave, which was built in the course of the same century. The early Gothic chancel was added in the middle of the twelfth century. The two towers of the chancel were demolished in the nineteenth century.

St-Pierre de Montmartre was consecrated in 1147 as the church of an abbey of Benedictine nuns. The main chancel and its side aisles, the transept and the adjoining bay of the nave date from about this time. In these, and many other smaller churches of the region it is possible to detect the structural system out of which Gothic eventually emerged.

Further south, at Vendôme, there is a great Romanesque tower (before 1145) adjoining the otherwise Late Gothic church of Ste-Trinité. It was developed from the clochers limousins of the region south of the Loire. The substructure consists of three stages, enlivened by pilaster strips, semi-circular responds and arched windows and niches, as well as·blind arches, alternately round and pointed. The transition from the square substructure to the octagonal superstructure, ending in a pinnacle, is created by means of four small corner spires, partly incorporated within the octagon; these

are circular and consist of open arcading. This style of tower was to be used frequently in Gothic architecture, obviously in a modified form. The south-west tower of Chartres Cathedral, the so-called *clocher vieux*, is of slightly later date (1145–65), but its affiliation to the towers of Vendôme, and Romanesque Poitou is beyond dispute.

St-Benoît-sur-Loire (Fleury) near Orléans was founded as early as the seventh century. The body of St Benedict was said to have been brought there towards the end of that century, after Monte Cassino had been destroyed by the Lombards; hence its medieval name. It became the object of numerous pilgrimages. The two extremities are the oldest sections of this large church. The tower-shaped clocher-porche at the west end may have been the tower known to have been started by Abbot Gauzlin in the year 1026. It is popularly called the *tour de Gauzlin*. The eastwork (Plate 120) with the beginnings of a second transept and an ambulatory with radiating chapels, was built between 1067 and 1107. This may have had some influence on Cluny.

There remains the district to the east of Paris, i.e. Champagne. Here, in the nave of St-Remi at Reims, we have one only surviving example, at least on a large scale, of the so-called Capetian basilicas. Despite their name, the ultimate ancestry of these churches is unmistakably Carolingian. Or in other words, they were the French equivalent of the great Ottonian churches in Germany. They were aisled halls, with galleries and clerestories but no high vaults. Often they were very large indeed. Two more are known in Champagne: Montierender and Vignory; but others were built *c.* 1000 at Orléans, and a few years later at Chartres; and in general the type can be taken as the starting point for nearly all the stylistic developments that emerged in northern European architecture during the eleventh and twelfth centuries.

83. The twelfth-century doorway of St-Restitut might equally well be Gallo-Roman. **84.** The abbey church of Sénanque is a striking example of Cistercian simplicity. **85.** A capital in Neuilly-en-Donjon: Daniel in the lion's den. **86.** Chancel of the church at Cruas. **87.** The church of Mont-majour presents a cuboid conglomeration of shapes. **88, 89.** The sculptures of the doorway of St-Trophime in Arles are in some respects reminiscent of Chartres, but on the whole the spirit of classicism is predominant; it has Corinthian capitals, and the horizontal friezes remind us of ancient sarcophagi. The total effect is due chiefly to the contrast of light and shade. **90′** The original design of the triple west doorway of St-Gilles-du-Gard was a copy of a Roman triumphal arch, with a frieze which served as a connecting link. As a result of subsequent reconstruction, the central section was slightly raised, at the expense of its coherence.

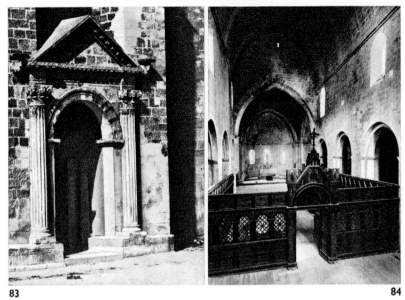

83

84

85

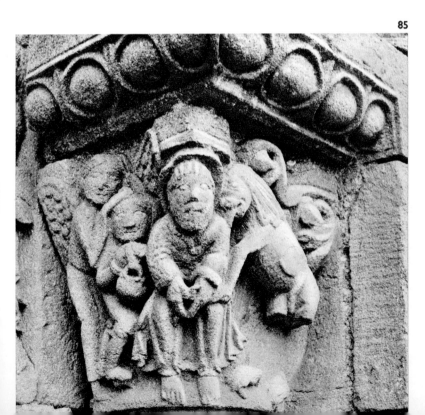

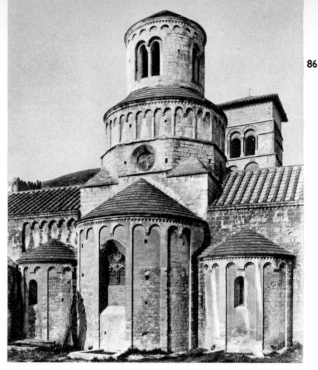

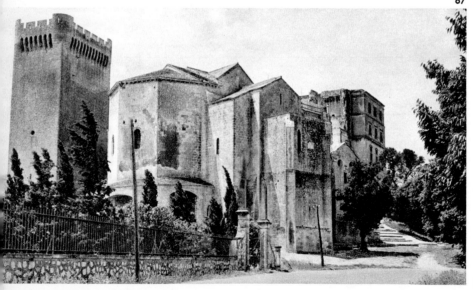

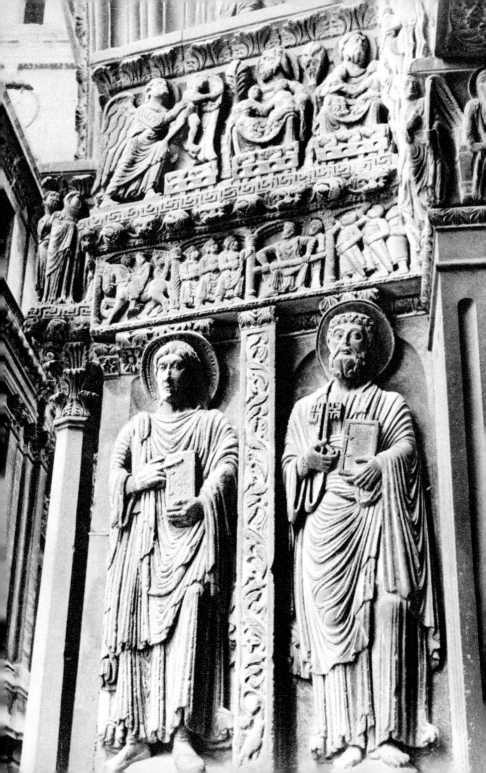

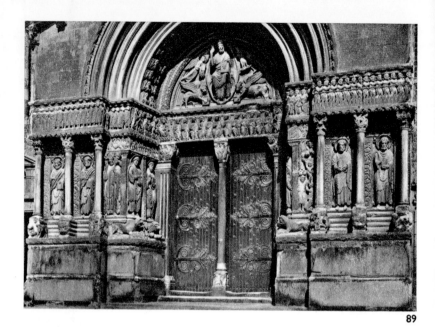

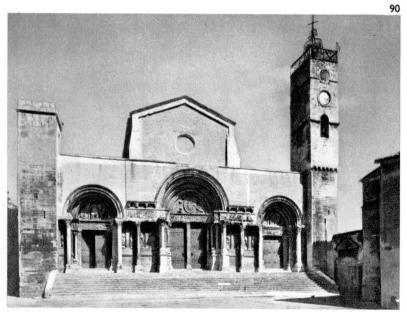

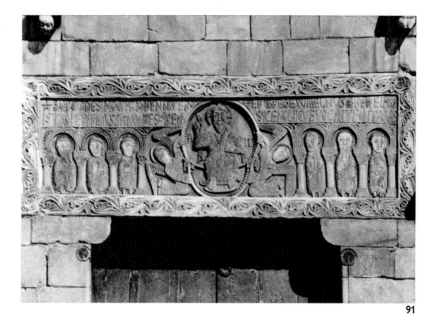

91

92

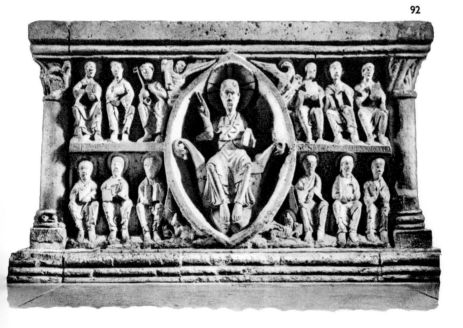

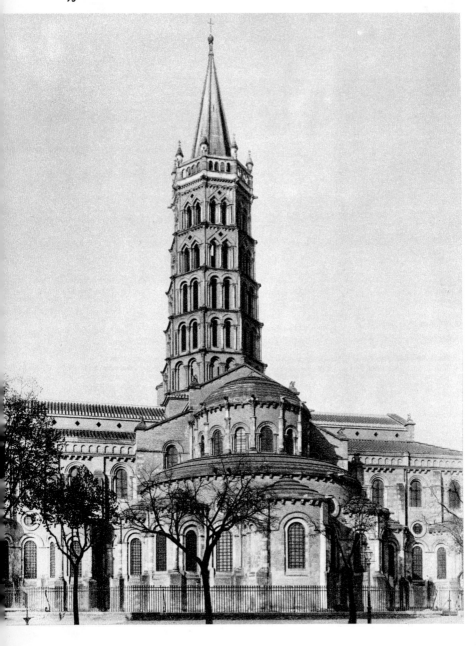

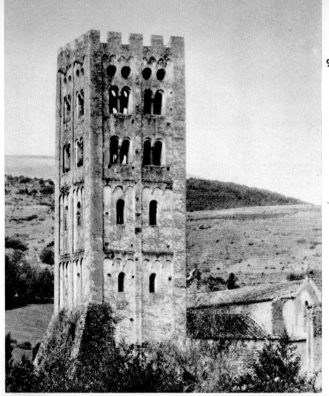

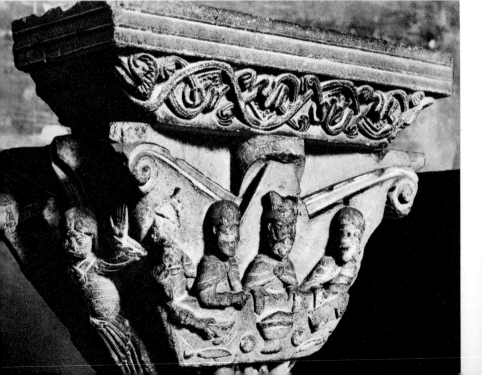

Before the middle of the twelfth century these regions were, as far as
sculpture was concerned, markedly behind the rest of France, and there is
nothing to anticipate the doorways of Chartres or the glorious Gothic
cathedrals that were to follow soon afterwards. Such sculpture as there was,
was restricted to fairly primitive imitations of examples in Normandy. In
the extreme south of the region, at Azay-le-Rideau, in the Loire valley, we
find one of the first church façades (Plate 111), to make use of decorative
sculpture. It dates from the beginning of the eleventh century, and was
subsequently spoilt by the insertion of a Gothic window. The older masonry
is reminiscent of Roman techniques (*opus reticulatum*). It is divided by some-
what clumsily inserted mouldings with two rows of extremely primitive
figures in between, standing separately in shallow arched niches separated
by small columns.

The open narthex and the interior of the abbey church of St-Benoît-sur-
Loire contain impressive series of capitals, in which the development from
the eleventh to the twelfth century can be followed step by step, from an
allusive expressionist style to a closer approach to nature (Plate 120).

The beginning of monumental sculpture in the Ile-de-France is inseparably
connected with the beginning of Gothic architecture. If Suger's new church
at St-Denis is taken to be Gothic, its sculpture nevertheless belongs to the
Romanesque idiom, and is inexplicable without reference to the south-west,
to Languedoc, and even Italy. Nearly everything at St-Denis was destroyed
during the Revolution, and its reconstruction is full of problems. That the
central tympanum was in some measure derived from that of Beaulieu, seems
fairly certain, however; and the voussoirs recall the arrangements at
Parthenay and Châteaudun. The real issue is whether there was a full array
of column figures as at Chartres; and if so, how they came to St-Denis.
Such antecedents as there are, point to Toulouse and Italy; but none of
these examples are adossed to columns, which is the crucial feature of all
northern figures.

91. The earliest dated sculpture in France is found in St-Genis des
Fontaines (1020). It combines Lombard and Moorish influences. **92.** Com-
parison with the altar of Avenas is instructive. **93.** The largest Romanesque
structure in France is St-Savin in Toulouse. **94.** Being a pilgrimage church,
it has a five-aisled nave, a three-aisled transept and an ambulatory with
radiating chapels; it is entirely surrounded by tribunes. **95.** The campanile
of St-Michel de Cuxa was built in the style of the *premier art roman*, as it
occurred in neighbouring Catalonia. **96.** The capitals of Notre Dame de
la Daurade in Toulouse are typical examples of Aquitanian sculpture
which was to exert great influence on other regions, e.g. on Parma and
the school of Emilia, where it is clearly discernible in the work of the
great Benedetto Antèlami.

But whatever the difficulties of St-Denis, the *Portail Royal* at Chartres seems to epitomize all the achievements of the Late Romanesque period (Plate 119). The Christ in Majesty which occupies the centre of the tympanum over the middle doorway, is no longer the supermundane, unapproachable judge, but is represented as a human being. The right-hand tympanum represents Mary, Source of Wisdom, set above a series of episodes ranging from the Annunciation to the Presentation in the Temple. The story of the Coming of Christ which begins here, ends in the left-hand doorway with the Ascension, and culminates in the central doorway with the return, the *parousia* of the Supreme Judge, surrounded by the glory of the apocalypse and accompanied by the twelve apostles as fellow-judges. All this is supported by the Old Testament below, which is represented on the columns of the lower zone by the figures of its leading personalities. Never before had the concept of the Redemption been summed up in such a monumental fashion. The influence of this great work was felt far and wide, for instance in the Late Romanesque doorways of Bourges Cathedral, also belonging to the middle years of the twelfth century. There, however, the expressive simplicity of Chartres had already degenerated to an exaggerated mannerism. There is another curiously Italian tympanum at Bourges, from the destroyed church of St-Ursin. The presence of this style in central France is not at all easy to explain. The south doorway of Notre Dame at Etampes, and the west doorway of the former Benedictine church of St-Loup-de-Naud show the direct influence of Chartres. Close affinity with the *Portail Royal* is also noticeable in the south and west doorways of the cathedrals of Le Mans and Angers respectively, but the borderline between the Romanesque and Gothic has now been crossed: not only does the pointed arch, already present in Chartres, become a dominating feature, but the figures carved on columns, having abandoned the last ties of Romanesque relief, are well on the way to becoming free-standing statues in niches.

ROMANESQUE PAINTING IN THE ILE-DE-FRANCE AND ITS ENVIRONS

The oldest part of the crypt of Chartres Cathedral contains a number of Romanesque murals from the twelfth century.

Examples of glass painting are of exceptional importance. It is certain that the art was already cultivated in the tenth century, possibly even earlier. The earliest glass windows consisted of pieces of glass inserted in a wooden framework; a tenth-century example has been found in the church of Château-Landon (Seine-et-Marne). As early as 1071 mention was made of leaded glass in Monte Cassino, but no examples of this period have been preserved. There are, however, numerous instances of twelfth-century glass: some panels from Suger's choir at St-Denis, *c.* 1144; the Ascension window in the nave of Le Mans Cathedral; and the three west windows of Chartres still contain their original glass. To these may be added Notre Dame de la

Belle Verrière, a twelfth-century figure which miraculously survived the fire of 1194 and was subsequently incorporated into a thirteenth-century window. Finally, there are two windows at Chalons-sur-Marne, and the great Crucifixion in the east window of Poitiers Cathedral.

ROMANESQUE ARCHITECTURE IN NORMANDY AND ADJOINING REGIONS

The Romanesque architecture of Normandy developed in a more forceful and individual way than that of the Ile-de-France. The Norman dukes were great builders and founded numerous abbeys. Their influence pervaded the adjoining districts of Brittany and Maine, and the Ile-de-France owes its rib vaulting to Normandy. In contrast to the enclosed, massive style of building in the south, which implied large wall surfaces and tiny windows, the trend in Normandy was towards spacious, well-lit churches, with long, wide naves. It is not surprising that the Normans were quick to exploit the possibilities of groined and ribbed vaults. Initially, stone vaulting was confined to aisles, crypts and other small compartments. The first ribbed vaults were built towards the end of the eleventh century; the earliest, those in the aisles of the Anglo-Norman cathedral of Durham (p. 192), date from 1096.

The earliest surviving Norman church is at Bernay. It may be argued that this is not yet Romanesque. But the abbey church of Mont-St-Michel, situated on the highest point of a rocky island just off the coast, is entirely Romanesque (apart from its Gothic sanctuary). It was built from 1026 onwards under Duke Richard II. The walls of the nave have a three-storeyed elevation: arcade, triforium and clerestory, a disposition which anticipates some early Gothic buildings such as Sens Cathedral. In spite of the semicircular wall shafts between the bays, the church is and always was timber-roofed (Plate 125).

The abbey church of Jumièges, started in 1037, brought Norman architects face to face with the problems of construction on a large scale. The plan was unusual in having an ambulatory without radiating chapels. To compensate for their absence, the transepts had a floor at gallery level, and two upper chapels. The nave is very tall, yet the walls are thin, and wall shafts were therefore used as internal buttresses. There may have been diaphragm arches, and there was certainly an alternating system. This is somewhat Italian, and there is a distinct similarity between Jumièges and the much later cathedral of Modena. On the other hand, the west walls of the transept were thick enough to contain passages. This idea seems to have reached Normandy from Germany (Trier). On the whole, subsequent Norman architecture was more concerned with the possibilities of these thick walls, than with the thin wall structure of the nave of Jumièges. The latter had much more influence south of Normandy, in the Ile-de-France, e.g. St-Lucien at Beauvais, and St-Germer.

The trend toward thick wall construction is evident in the Conqueror's abbey of St-Etienne, at Caen. This was started just before the conquest of England in 1066. The original choir has disappeared, and the clerestory was rebuilt when ribbed vaults were inserted early in the twelfth century. It may be that the wall passage was introduced then. But the original piers of the nave were already thick enough to carry the later superstructure. Before these alterations, St-Etienne must have been a rather elaborate version of the Capetian basilica. The nave of Cerisy-la-Forêt, started *c.* 1080, perhaps gives us a good idea of what it was like.

The other pre-Conquest foundation at Caen, La Trinité, had an even more complicated building history. There is a crypt that goes back to the 1060s, and the tower part of the choir does likewise. This seems to indicate that a low barrel vault was intended. Later, in the 1120s, a transept was built with provision for ribbed vaults, and the choir was then altered to match it. When the choir was vaulted, however, it received a groined vault, presumably for structural convenience.

Apart from the projected barrel vault for the choir of La Trinité, there is no evidence of vaulting in Normandy before the end of the eleventh century. There is some reason to suppose that the first ribbed vaults appeared in the Duchy at the abbey of Lessay *c.* 1100, i.e. at the same time as at Durham. For some time ribs and groins seem to have been equally acceptable (there is another early groined vault in St-Nicholas at Caen). By the time St-Georges de Boscherville was built, however (*c.* 1125), the preference for ribs was well established, presumably because they fitted better into the decorative schemes of Norman architecture.

Later Norman churches show a strong sense of ornament. This reached its climax in the nave of Bayeux Cathedral reconstructed after 1150.

The other feature of Norman church architecture that left a deep mark on the surrounding regions, was its handling of towers. Both the crossing tower and the two-towered west front were developed in Normandy in characteristic ways—the latter in particular being transformed from something akin to the early German westwork into a prototype for the west fronts of the French Gothic cathedrals.

ROMANESQUE SCULPTURE IN NORMANDY

Contrary to the general impression of its bare functional masonry, Norman architecture of the eleventh century made considerable use of carved capitals. Granted that the standard form of capital was a simplified Corinthian of no great artistic merit, there were some interesting exceptions. At Bernay, in the choir aisles, there are some very early eleventh-century capitals which suggest northern Italian influence (perhaps via William of Volpiano and Fécamp). The series in the nave were defaced in the eighteenth century and plastered over. Other early examples occur in the crypt of Bayeux. Animal subjects were already in use by the Conquest of England and Norman

116 Cover of the Codex Aureus of St Emmeran, made *c.* 870 at Reims or St-Denis. Staatsbibliothek, Munich.

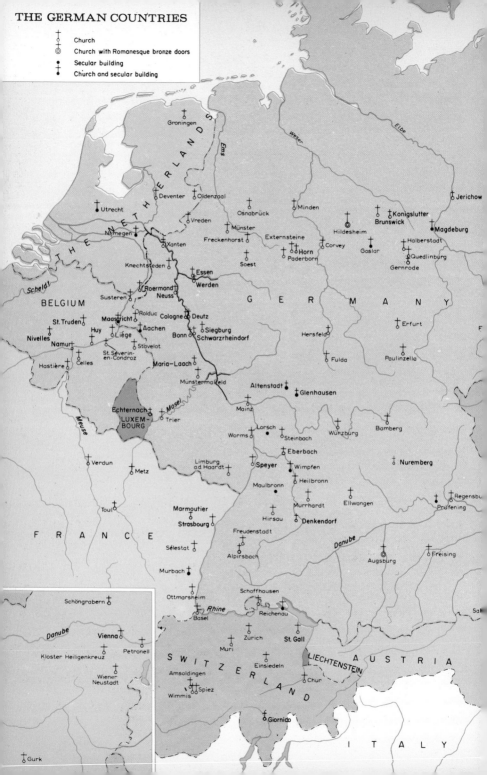

THE GERMAN COUNTRIES

- ✝ Church
- ☺ Church with Romanesque bronze doors
- ● Secular building
- ✝ Church and secular building

THE NETHERLANDS

Groningen

Deventer Oldenzaal

Utrecht

Vreden

Nijmegen

Xanten

Osnabrück

Münster

Freckenhorst

Knechtsteden

Essen

Werden

Soest

Roermond Neuss

Susteren

Rolduc Cologne Deutz

BELGIUM

St. Truden Maastricht

Huy Aachen

Nivelles Liège

Namur Siegburg

St. Séverin- Stavelot Schwarzrheindorf

Hastière en-Condroz

Celles Maria-Laach

Munstermaifeld

Scheldt

Minden

Externsteine

Horn

Paderborn

Jerichow

Königslutter

Brunswick

Hildesheim

Corvey

Goslar

Magdeburg

Halberstadt

Quedlinburg

Gernrode

GERMANY

Erfurt

Hersfeld

Paulinzella

Fulda

Bonn

Altenstadt

Glenhausen

Mainz

Echternach Trier

LUXEM-

BOURG

Verdun

Metz

Toul

Meuse

Mosel

Worms

Lorsch

Steinbach

Eberbach

Limburg

a.d. Haardt

Speyer Wimpfen

Maulbronn Heilbronn

Marmoutier Murrhardt Ellwangen

Strasbourg Hirsau Denkendorf

Sélestat Freudenstadt

Alpirsbach

Murbach

Ottmarsheim

FRANCE

Würzburg Bamberg

Nuremberg

Regensbu

Prüfening

Danube

Augsburg Freising

Schaffhausen

Rhine Reichenau

Basel

SWITZERLAND

Zurich St. Gall

Muri

Amsoldingen Einsiedeln Chur

Spiez

Wimmis

Giornic

LIECHTENSTEIN

AUSTRIA

ITALY

Ems

Weser

Elbe

Schöngrabern

Danube

Vienna

Kloster Heiligenkreuz Petronell

Wiener

Neustadt

Gurk

capitals were apparently imported into England in the 1070s for use in Durham Castle. There were few historiated capitals—some occurred at Graville Ste-Honorine but their subject matter is secular. In the twelfth century, at La Trinité, new influences become evident. These emanated from the south, i.e. Maine and the Ile-de-France; in some cases from even further afield. By the time the nave of Bayeux was built, and the chapter house of St-Georges de Boscherville (1160–80), Norman sculpture, like Norman architecture, was on the threshold of Gothic.

ROMANESQUE ARCHITECTURE OF THE CISTERCIANS
In contrast to the Benedictine abbeys, which are often situated in or near towns, the Cistercians chose remote and desolate sites for their foundations. The abbey of Fontenay near Montbard (Côte-d'Or), founded in 1118 by St-Bernard, but built c. 1140, is of the design followed by practically all Romanesque Cistercian monasteries, e.g. Noirlac (Cher), Silvanès (Aveyron), Silvacane (Bouches-du-Rhône), Le Thoronet (Var), Sénanque (Vaucluse) (Plate 84). The Cistercian rule condemned splendour and sculptural riches, particularly in churches and cloisters. These were regarded as empty opulence, whole-heartedly and severely condemned by Bernard in his well-known letter to abbot Guilielmus of St-Thierry. The Cistercian style of architecture, therefore, aimed at the greatest possible simplicity, and the decorative element was restricted to the minimum. The cloisters of Fontenay achieved beauty not by means of richly decorated capitals, but by their magnificent and perfectly executed masonry and balanced proportions. As a result of the spread of the monastic reforms of Cîteaux this type of church plan, originally restricted to France, was repeated all over Europe, from Scandinavia to as far south as Sicily and Greece. Towers are usually lacking, and so is the sculptural decoration of doorways or windows. Stained glass windows give way to abstract patterns in grisaille. The church of Fontenay, consecrated in 1147, has a nave with a barrel vault on pointed arches. The aisles are in effect a series of chapels with transverse barrel vaulting, facing the nave. The transept is lower than the nave, and on each arm there are two square eastern chapels flanking the rectangular compartment of the main choir. The church is lit solely through the end walls and the transept. Here again it is the beautiful proportions and fine masonry which makes the beauty of this form of architecture (see p. 98). In the thirteenth century the style of the Cistercian churches was to influence the design used for their churches by the mendicant orders (Franciscans, Dominicans, Carmelites and Augustines).

ROMANESQUE BOOK ILLUMINATION IN FRANCE
Illuminated manuscripts contributed a great deal not only to the development of mural painting, but also to that of sculpture. In France the tradition of the Carolingian school of miniature painting had become extinct in the

tenth century, and from then onward until the beginning of the twelfth century, the work of the monastic scriptoria shows an uncontrolled trend towards experimentation. The examples produced in this period by the schools of Paris and the Ile-de-France give as yet no indication whatsoever of the approaching golden age of the art.

The situation was somewhat better further south. The Bible of St-Martial of Limoges, which dates from the late eleventh century, was illustrated by skilled illuminators of the Cluniac abbey. A fair amount of their work has been preserved. The famous copy of the Commentary by Beatus, bishop of Liebana in Asturias (c. 780), on the Apocalypse which was written and illustrated at St-Sever by Stephanus Garcia Placidus between 1028 and 1078, when the Spaniard Gregory of Montana was abbot, was inspired by Mozarabic versions. Monumental sculptors in Languedoc took themes such as Christ in Majesty, and Christ in the mandorla, supported by angels, from this and other copies of Beatus (Plate 132).

At the beginning of the twelfth century the abbey of Cîteaux witnessed a flowering of the art of miniature painting. At the time of the English abbot Stephen Harding, a Bible in four volumes was written there. It was completed by 1109, and the third and fourth volumes in particular give evidence of a new control of form, delineation and composition. In accordance with the Cistercian rule no gold was used in this or other Cîteaux manuscripts. The drastic prohibitions issued in 1134 effectively put an end to any Cistercian art of book illumination. In the meantime, however, the influence of the books already completed proved so strong that manuscripts copied elsewhere in Burgundy adopted the style of Cîteaux. Outside the Order this was now enriched, by the use of gold. A good example is the Bible of Souvigny, in which figures and initials are placed against a gold background (second half of the twelfth century).

ROMANESQUE METALWORK IN FRANCE

Mention has already been made of the early Romanesque metalwork of Auvergne. This appears to have been precocious and isolated. Paris and the Ile-de-France had no tradition of their own in this branch of the arts, before 1140; and when Abbot Suger of St-Denis wanted bronze doors and other works of art in metal for his abbey church (including an impressive crucifix, nearly 24 feet high and decorated with enamel), he commissioned *aurifabri lotharinghi*, i.e. goldsmiths from the Meuse region. Godefroi de Claire may have been one of these. The cross of St-Denis no longer exists, but there is a small-scale copy of the base and the column which carried the crucifix proper, the *croix de St-Bertin*, in the museum of St-Omer. Most other surviving works of Romanesque metalwork in St-Denis, Laon, Reims Cathedral, etc., were made by craftsmen from the Meuse valley.

The other great centre of the art of enamelling, Limoges, grew up around the great abbeys of this region: St-Martial in Limoges itself, Grandmont

and Solignac. The earliest works, small, coffer-shaped reliquaries, with an incised vertical decoration on the apex, date from the first half of the twelfth century. The sides are decorated with figures in champlevé enamel against a neutral background. From 1160 onwards these were enframed in enamel semi-circles, and further decorated with foliate ornament. The main colour used was dark blue, sometimes enlivened with pale blue, green or red. In later examples the figures are left unenamelled and sometimes stand out in low relief against an enamel background. The manufacture of all sorts of objects in this technique became something of an industry, and examples are found everywhere in France and abroad: reliquaries, candlesticks, pyxes (caskets), processional crosses, crosiers, censers, indeed even grave plates, such as that of Geoffroi Plantagenet, Count of Anjou (d. 1151) in Le Mans, and that of Bishop Ulger of Angers (d. 1160). One of the masterpieces of later Limoges enamel work is the large reliquary of SS. Calminius and Namadia in the church treasury of Mozac (Puy-de-Dôme), where the influence of the great Mosan reliquaries is evident (Plate 128). A theme often used on the smaller caskets is the murder of St Thomas à Becket. This happened in 1170 and is therefore only found on very late examples.

ROMANESQUE FABRICS AND NEEDLEWORK

Mention must first be made of the fabrics imported from Byzantium, Persia, the Middle East and the Islamic parts of Spain. These reached the West partly in the course of trade, but more particularly as a result of the Crusades and the close ties between France and Spain. Although they were not indigenous to France, their pattern left a deep mark on Romanesque ornament; and numerous capitals and decorative sculptures contain details derived from these fabrics. They were also used for covering relics and for liturgical vestments; consequently they are found chiefly in the treasuries of the older churches. The most important single collection is that of Sens Cathedral.

With the famous Bayeux Tapestry we move into an entirely different world. This tapestry is a long strip of linen, about nineteen inches wide, consisting of eight joined sections, and embroidered in wool in eight colours. It depicts the history of Harold's visit to Normandy and the invasion of England by William the Conqueror (1066). The strip is edged by two decorative bands representing various grotesque animal figures, themes from fables, landscape details and battle scenes. According to tradition, the tapestry was made by Queen Mathilda and her ladies, but it seems more likely that it was commissioned by William the Conqueror's stepbrother, Odo of Conteville, who was bishop of Bayeux and plays an important part in the story. Probably it was originally intended for the cathedral of Bayeux. The narrative is vividly and imaginatively told with very simple means, and shows undeniable talent in design. It provides numerous realistic details of contemporary life and warfare. Its place in Romanesque

art might be compared to that of Trajan's column in Roman art (Plate 130). We know from written sources that there were more needlework histories of this kind. One is described in a poem by Baudri de Bourgeuil, dedicated (before 1102) to Williams' daughter Adèle, countess of Blois. The monastery of Alpirsbach in the Black Forest also possessed a tapestry. This depicted the First Crusade. A fragment of another, incomplete, is in the treasury of Sens. The two latter works were made towards the end of the twelfth century.

ROMANESQUE ARCHITECTURE IN THE SCHELDT REGION

In the Romanesque period the basin of the River Scheldt, now Belgium, was the meeting place of a number of architectural trends. To the east was the Mosan area and Germany; to the south France; and to the west the British Isles, and Normandy. The precise relations between these component factors is not easy to unravel, for most of the monuments have been destroyed. Politically the Scheldt area was closer to France than Germany at this time, although most of the area fell within the frontier of the Empire. This was symptomatic of a general situation in which new architectural ideas, i.e. Romanesque, gradually encroached on the older established styles and traditions of the region, i.e. Carolingian and Ottonian.

This becomes evident if we compare the two phases of Romanesque style which can be distinguished. The first, which persisted until *c.* 1125, is typified by the great church of St-Bavon at Ghent. Although this was demolished in the sixteenth century, its plan and building history have been reconstructed from excavations. It had two aisles, the inner one with a gallery over it; uniform square piers, and in its final form a complicated westwork and eastern retrochoir. All the architectural antecedents of this design were Carolingian or Ottonian rather than Romanesque. Another church of the same type is St Gertrude at Nivelles (Plates 142–143).

Apart from its Romanesque westwork, St Gertrude is in fact one of the

97, 100, 101. The magnificent tympani of Moissac, Beaulieu and Conques are among the masterpieces of Romanesque art. The first presents a theme from the Revelation; both the others represent the Last Judgement. **98, 99.** The apostle figures at Moissac exerted influence on those of the prophets at Souillac. **102.** The famous Majesté de Ste-Foy in Conques is a rare example of a free-standing Romanesque figure. It consists of a wood core covered in chased gold and richly decorated with precious stones. **103.** The cloisters at Moissac, built *c.* 1150, contain capitals related to those of Notre Dame de la Daurade in Toulouse. **104.** Notre Dame du Port in Clermont-Ferrand shows Cluniac influence. **105.** The capital representing the Lord's Temptation in Plaimpied is remarkable because of its emotional expressionism and its marked clair-obscur.

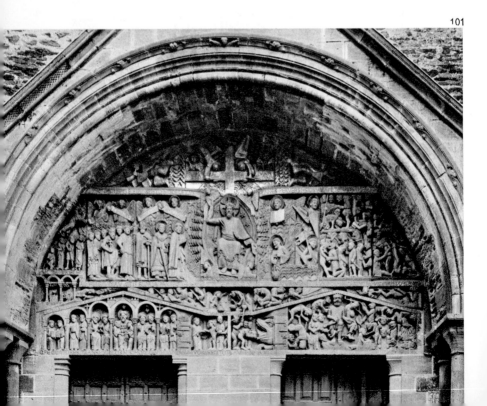

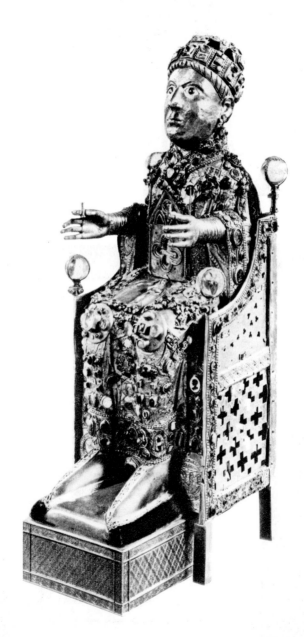

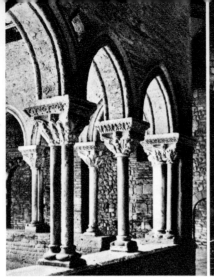

103

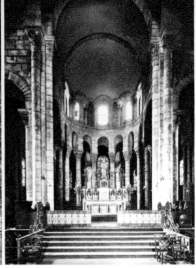

104

105

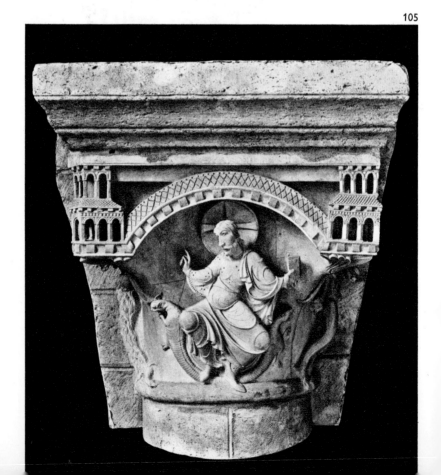

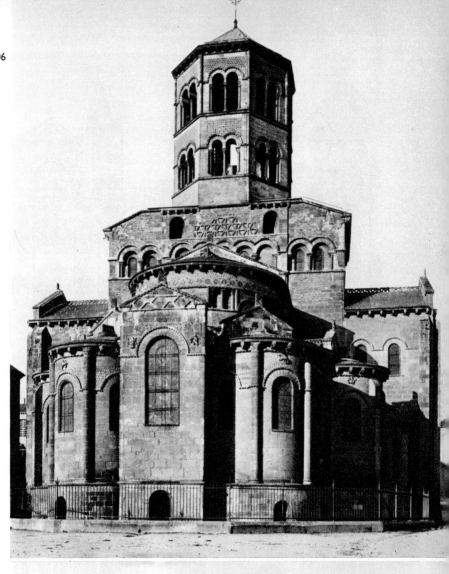

106

107

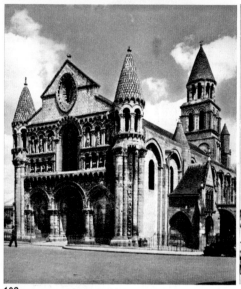

108

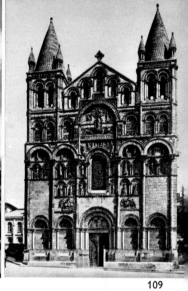

109

110

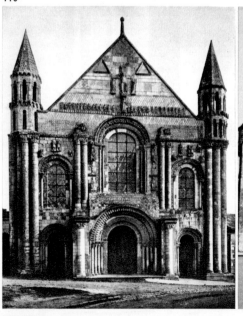

111

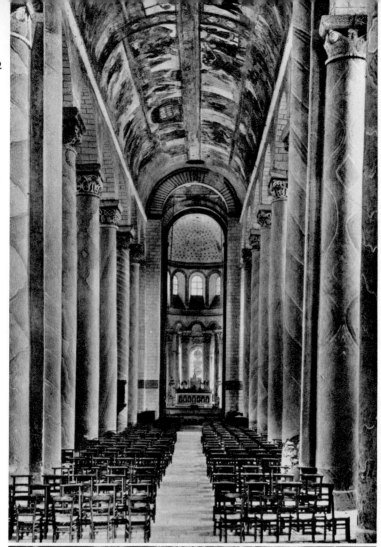

112

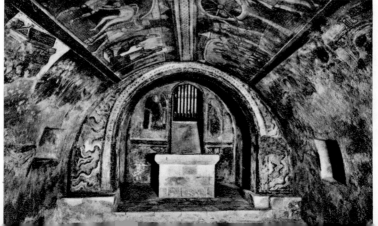

113

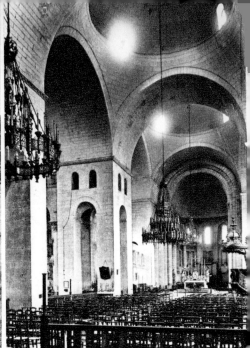

114

115

116

117

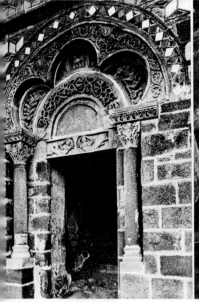

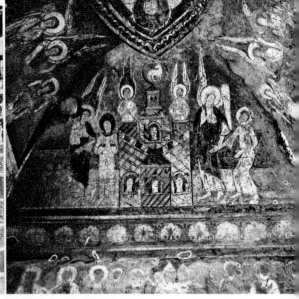

most perfect remaining examples of an Ottonian church, although its choir is slightly too late (*c.* 1060). It has a low transept (see below) and east and west transepts of unequal size. Its external decoration with pilaster strips and broad arches recalls numerous Mosan and German buildings. The existing westwork was preceded by another, smaller one, Ottonian in design. In 1046 the first part of the church, probably the nave, was consecrated. It is carried on square piers; and there are eight arches divided into two groups of four by a diaphragm arch. The spandrels above the low transepts contain small windows, more usual in the Mosan region.

Signs of Romanesque penetration appear in the nave of St-Vincent at Soignies. This is also a galleried basilica basically German in its affiliations; but there is now an alternating bay system which is reinforced by internal wall buttresses. The date of this nave is not easy to determine. It has been attributed to the late eleventh century, but also as late as the middle of the twelfth.

The second phase of Scheldt Romanesque architecture is associated with the rebuilding of Tournai Cathedral. This was begun *c.* 1110; but although the church was consecrated in 1171, the vaulting of the transept was still uncompleted in 1199. The central tower and the corresponding four corner towers were finished in the early thirteenth century. The internal walls of the nave consist of four stages: arcade, tribunes, triforium and clerestory. In this respect it is the forerunner of several early Gothic cathedrals in north-east France. The original choir may have formed part of a trefoiled east end, like Sta Maria im Kapitol at Cologne; or it may just have had apsidal transepts like St-Lucien at Beauvais—a more suggestive affiliation. It was replaced by the present Gothic choir in the thirteenth century. The nave of Tournai is the important part from a Romanesque point of view. In construction it resembles the thick wall buildings of the Normans, especially the Normans in England. There is a passage at clerestory level, though it is outside instead of inside. More significant, however, is the use of shafts in large numbers to articulate the piers and walls of the church.

106. St-Austremoine in Issoire is typical of the Romanesque style of Auvergne. **107.** Picturesque Chauvigny, with St-Pierre. **108.** Notre Dame la Grande in Poitiers is the classical example of the style of Poitou. St-Pierre in Angoulême and the church of St-Jouin de Marnes are related structures (**109, 110**). **111.** One of the earliest sculpted church façades is found at Azay le Rideau. **112.** At St-Savin-sur-Gartempe the barrel vaulting, supported by tall columns, is decorated with Romanesque paintings, as is the crypt (Plate 113). **114, 115.** St-Front in Périgord, reconstructed after 1120 on a cruciform groundplan with five domes, is reminiscent of S. Marco in Venice. **116.** The doorway of St-Michel d'Aiguilhe in Le Puy contains Moorish elements. **117.** In the paintings in a side chapel of the church of St-Chef (*c.* 1070), apocalyptic motifs have been employed after the manner of the Italian-influenced 'blue school'.

These were made of local Tournai marble, which was highly valued for its colour, and exported both to northern France and England. It is the shafts and uncarved capitals that go with them that give the building its Romanesque character.

So far as its towers are concerned, Tournai was equally in line east and west. Apart from the five towers on and around the crossing, two west towers were planned, and probably a further two flanking the choir, which would have brought the number up to nine. The style of the cathedral was imitated in several parish churches in Tournai, for instance St-Piat (*c.* 1150) and St-Brice (*c.* 1175).

The Tournai style spread to the county of Flanders, where, as a result of the economic boom of the twelfth century, stone from quarries in and around Tournai was imported by way of the Scheldt. Tournai stonemasons prepared the capitals before despatch, so that the style forms prevailing in the region penetrated into Flanders and were imitated there.

Mention must be made of a number of Romanesque houses surviving in Tournai. These have double opening windows, divided by small colonettes and set between horizontal mouldings (*c.* 1175). Ghent also possesses a number: the *Korenstapelhuis* (*c.* 1175), the *Borluutsteen* (*c.* 1200) and the *Huis Tspijker* (early thirteenth century). The oldest part of the *Gravensteen* dates from the tenth or eleventh century; the surrounding walls and the gateway from 1180. The lower storey of the double chapel of the Sacred Blood in Bruges consists of a three-aisled nave on circular piers, with an adjoining choir; it was built in the third quarter of the twelfth century.

ROMANESQUE SCULPTURE IN THE SCHELDT REGION

Tournai was also the chief centre of sculpture. French influence (e.g. Languedoc, Provence) intermingled with Lombard themes, as is evident in the two surviving doorways of the cathedral: the northern doorway, or *Porte Mantile*, and the slightly simpler south doorway. Only a few fragments remain of the original west doorway. The shape of the *Porte Mantile* is an unusual one: the single opening, without lintel or tympanum, is surrounded by a continuous sculpted border. Two free-standing columns carry voussoirs in high relief, and a third row of voussoir merges into a slender pointed arch enclosing a small window (Plate 127). Some of the details might suggest influence by Vézelay, but one would have to go as far afield as Apulia to find parallel examples of the sculpted framework surrounding the doorway, uninterrupted by capital or impost; cf. for instance, S. Nicola, Bari, and the cathedral of Trani; the former being the earlier. The Norman connection with Bari may be significant.

Tournai Cathedral further possesses an impressive series of carved capitals, better preserved than the weathered sculptures of the doorways. They show an almost Lombard preference for grotesque animal figures and foliate themes; the human figure seldom appears. In the westwork of St Gertrude

at Nivelles, there are two doorways, probably survivals from an earlier structure. The story of Samson is the theme of one; the archangel Michael that of the other, of which only the lintel survives. These sculptures are generally attributed to the Mosan school in view of the unmistakably Mosan shape of the lintels with their triangular finish, and of the equally Mosan feature of profile moulding; there, however, the affinity ends. The narrative style of the sculptures themselves differs greatly from the always lyrical and solemn art of the Meuse valley, and both in form and aspect is much more like that of Tournai. The influence of Tournai is also discernible in the fragments of a carved lintel in St-Bavon, Ghent, and in the doorway of the chapel of the Sacred Blood in Bruges (c. 1175).

The wholesale manufacture of Tournai marble fonts, which found markets as far away as northern France and England, made use of somewhat rigid Lombard designs. These also appeared in the Mosan region.

ROMANESQUE PAINTING IN THE SCHELDT REGION
Again it is the cathedral of Tournai which provides a number of examples of Romanesque mural painting, dating from between 1171 and 1178. They consist of episodes from the life of St Catherine and an impressive representation of the Crucifixion. Of slightly later date are a painting of the Holy City of Jerusalem, and a series of episodes from the legend of St Margaret. All these paintings are ultimately derived from Italy, like others which we have already encountered elsewhere.

4. OTTONIAN ART

HISTORICAL BACKGROUND
When Otto the Great was crowned in Aachen in 936, he took Charlemagne as his model. After a troubled start to his reign, he gave the dukedoms in fief to members of his family and to ecclesiastical dignitaries; in the latter case they were, of course, not hereditary. In 951 he married Adelaide, the widow of King Lothar of Italy, and was crowned in Pavia. In 955 he decisively defeated the Hungarians at the Lechfeld and settled the frontiers with the Slav peoples. In 962 he was crowned Roman Emperor by Pope John XII. He died in 973.

His successor, Otto II, married a Byzantine princess Theophanu. His army was defeated by the Saracens at Crotone in Calabria, and the frontier with the Slavs receded to the line of the Eider and Elbe. In 983 he was succeeded by his young son Otto III, who hoped to make Rome the centre of the new Empire. To this end he closely co-operated with Pope Silvester II (999–1003). Otto III died early, in 1002, and was succeeded by Henry II, who reigned until 1024. He attempted to safeguard the eastern frontiers against the Poles by forming alliances, and to halt the reviving power of Byzantium in southern Italy.

His successor, Conrad I (1024–39), the first ruler of the Salian dynasty to occupy the imperial throne, continued this policy. In 1033 he incorporated the Burgundian kingdom into the German Empire. Under Henry III (1039–56), imperial power reached its zenith: Bohemia, Poland, and Hungary became German fiefs. Five consecutive popes were Germans: Clement II (1046–47), Damasus II (1048), Leo IX (1049–54), Victor II (1055–57), and Stephen IX (1057–58). All save the last owed their office to the emperor; and the last three in particular were outstanding personalities. Together with the emperor they worked for the re-establishment of church discipline and encouraged the reform movement which had its centres in Lotharingia and Cluny.

OTTONIAN ARCHITECTURE

This is in some ways an ambiguous term. The revival of Germany in the tenth and eleventh centuries was the first phase in a general revival of European prosperity, which elsewhere is associated with Romanesque. It is basically a backward-looking style, with Carolingian buildings forming its most obvious inspiration. Behind these were the Early Christian models of the Carolingians themselves. Another factor, however, was the personal influence of the Empress Theophanu, who may have been responsible for the occasional Byzantine features that occur. And the close connection with Italy, established after 951, opened the way for the eventual penetration of Germany by Italian Romanesque forms and ideas. The emperors themselves, insofar as they took the pretensions of their title seriously, were always liable to require specific allusions to Imperial Roman architecture. Then, also, there were the changed liturgical conditions of the reformed church, which, although not responsible for drastic architectural innovations, lent weight to certain developments, e.g. hall crypts. Finally, there were the vague, but none the less real sentiments of the Germans themselves, which in Saxony in particular, took the form of a stubborn, conservative attachment to an inherited tradition.

Chronologically, the Ottonian period is usually taken to have lasted from c. 950 to c. 1050, i.e. from the first visit of Otto I to Italy to the end of the reign of Henry III (1056). Already before this, however, the founder of the fortunes of the Ottonian dynasty, Henry the Fowler, had built for himself an Eigenkirche at Quedlinburg (c. 929), the crypt of which still survives. The connection of the dynasty with Saxony was responsible for a number of major buildings of that province during the period in question. Perhaps the most impressive of all was Otto I's cathedral at Magdeburg. Although this was replaced in the thirteenth century by the present church, the fact that it was decorated with ornate marble shafts brought from Italy, proves that it was intended to be something out of the ordinary. Moreover, this gesture was clearly modelled on that of Charlemagne himself at Aachen. At about the same time, Otto's marshal, Count Gero, who had subdued the

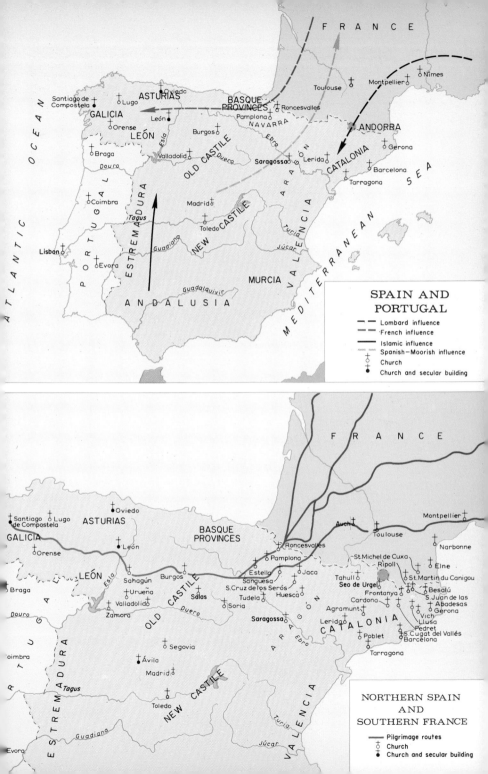

SPAIN AND PORTUGAL

--- Lombard influence
--- French influence
— Islamic influence
Spanish–Moorish influence
☩ Church
● Church and secular building

F R A N C E

Nîmes
Montpellier
Toulouse
ANDORRA
BASQUE PROVINCES
Roncesvalles
Pamplona
NAVARRA
Gerona
CATALONIA
Lérida
Barcelona
Saragossa
Tarragona
Santiago de Compostela
GALICIA
Lugo
ASTURIAS
Orense
León
LEÓN
Braga
Valladolid
OLD CASTILE
Duero
Burgos
Ebro
ARAGÓN
PORTUGAL
Coimbra
Tagus
Madrid
NEW CASTILE
Toledo
Guadiana
ESTREMADURA
Lisbon
Evora
Guadalquivir
ANDALUSIA
MURCIA
VALENCIA
Turia
Júcar
ATLANTIC OCEAN
MEDITERRANEAN SEA

NORTHERN SPAIN AND SOUTHERN FRANCE

— Pilgrimage routes
☩ Church
● Church and secular building

F R A N C E

Montpellier
Narbonne
Auch
Toulouse
Elne
St.Michel de Cuxa
Ripoll
St.Martin du Canigou
Besalú
S.Juan de las Abadesas
Gerona
Llusá
Pedret
Vich
S.Cugat del Vallés
Barcelona
Tahull
Seo de Urgel
Frontanya
Cardona
Agramunt
Poblet
Tarragona
Lérida
CATALONIA
ARAGÓN
Ebro
Saragossa
Roncesvalles
Pamplona
Jaca
Estella
Sangüesa
S.Cruz de los Serós
Tudela
Huesca
Soria
BASQUE PROVINCES
Santiago de Compostela
GALICIA
Lugo
Orense
Oviedo
ASTURIAS
León
LEÓN
Braga
Sahagún
Burgos
OLD CASTILE
Salas
Uruena
Valladolid
Zamora
Duero
Segovia
Ávila
Madrid
NEW CASTILE
Toledo
ESTREMADURA
Tagus
PORTUGAL
Coimbra
Guadiana
Evora
Turia
VALENCIA
Júcar

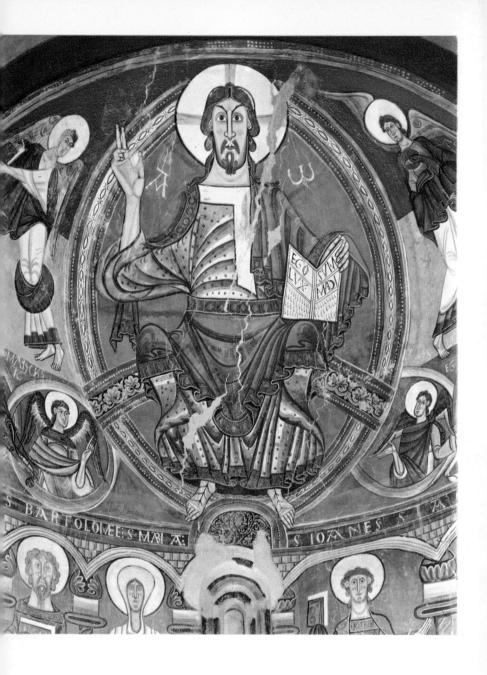

border provinces east of the Elbe, started a family church at Gernrode (961) (Plate 133) which seems to have been influenced by the galleried churches of Early Christian Rome. On the whole, however, galleries remained exceptional in Ottonian churches and the more usual practice was for a simple arcade to be surmounted by a continuous wall broken only by a row of clerestory windows. The classic instance of this type of design is St Michael's at Hildersheim founded in c. 1001 by Bishop Bernward. St Michael's at Hildersheim is sometimes taken to mark the beginning of a new period in German architecture. It is true that it contained a number of features which were not exactly common among Carolingian buildings—for instance, the square crossing in which the transepts meet the nave and choir on equal terms. Another distinctive feature was the alternation in the arcade of square piers with two columns, although a variation of this scheme was already present in the earlier nave of Gernrode. Outside, both Gernrode and St Michael's have characteristic blind arcades, reminiscent of the walls of the Mausoleum of Galla Placidia at Ravenna. This foreshadows a rash of Lombard bands that appeared all over the outside walls of German churches a few years later. Otherwise, however, neither Gernrode nor St Michael's Hildersheim display in their masonry the characteristic plastic qualities that are indispensable features of true Romanesque architecture. Moreover, the symmetry in plan of St Michael's, which is a very obvious feature, clearly belongs to the Carolingian tradition of double ended churches of which St-Riquier/Centula is the most celebrated instance.

The plainness and bareness of Saxon church interiors such as the Abdinghof at Paderborn (c. 1016) strikes one as decidedly retardataire. It may be presumed that in so far as these churches were decorated at all, this took the form of wall paintings. In Saxony itself no Ottonian examples survive; but in southern Germany (St Georg, Oberzell on Reichenau) there are frescoes in a church of similar type which provide a good impression of what they may have been like. There is, however, one very puzzling exception to this generalization. This is the Bartholomeuskapella at Paderborn (1017), a small hall church designed around four columns and vaulted with low shallow domes. Bishop Meinwerk, for whom it was built, is known to have employed Greek workmen, and this suggests a specific if somewhat untypical link with southern Italy, where a number of Greek monasteries were established during the early years of the eleventh century.

In the absence of architectural features like galleries, it is not usual to classify Ottonian churches into sub-species. An attempt has been made to do this in terms of the kinds of transepts that were used: in some churches, for instance, the transept cuts across the nave—the so-called T transept; in others, however, the nave cuts through the transept, which is usually lower than the nave and forms separate compartments; finally there is the type with a clearly defined crossing (*croisée définie, Ausgeschiedene Vierung*) where the crossing space is separated from nave, transept and choir by four equal

Fresco from the apse of S. Clemente in Tahull (Catalonia). The church itself was built c. 1123; the fresco cannot be of a much later date. Museum, Barcelona.

arches. The outstanding instance of the last, St Michael's at Hildersheim, has already been mentioned. The first type, i.e. with a T transept, occurs in Lower Saxony at Gernrode, at Hersfeld (1037) (Plate 137), and in the episcopal church of Walbeck. Originally it was found also in most cathedral churches, amongst others Würzburg (c. 1042), Worms (c. 1015), Bamberg (c. 1010), Mainz (c. 1000), Toul (between 963 and 994).

The low transept was known in Carolingian architecture, e.g. the church of SS. Peter and Marcellinus at Steinbach in the Odenwald, built by Eginhard (821–7). The type originated, however, not in Germany, but probably in Lombardy, where it appeared very early. Outside the Rhineland, the scheme was applied more generally and consistently in the Mosan Region, i.e. the bishopric of Liège. It is a striking fact in the Ottonian Romanesque period that although the architecture of the Archbishopric of Cologne was closely interrelated, the dioceses of Cologne itself and Utrecht favoured the high T transept, whereas Liège favoured the low transept. The starting point was St-Denis in Liège, built by Bishop Notger (972–1008). Two perfect examples are provided by the churches of Celles near Dinant and of Hastière-par-Delà (c. 1035).

In spite of the many losses, Grodecki was right when he referred to the Mosan area as *une des régions les plus inventives au début du onzième siècle*. The size, variety and complexity of the known churches reflect the special importance which this region began to assume during the Ottonian period. The most populous part of the German kingdom, and the centre of whatever industries it possessed, it was also the focal point of numerous trade routes. Moreover, it was more deeply affected by the church reform movement than other parts of Germany. Stavelot and Liège were nurseries of reformed clergy. This must have helped to make the Mosan area the greatest centre of Romanesque decorative art from c. 1100 onwards. By the same token its Romanesque architecture ought to have been equally impressive. Yet we know very little about it and what we do know suggests that it was more cautious in adopting Romanesque innovations than the region further west, i.e. the Scheldtlands and northern France. If this impression is correct, the explanation may lie in the fact that western Belgium got its Romanesque from the west, i.e. from France, and perhaps even England; whereas in the Mosan area it came directly from Italy.

Nevertheless in the eleventh century there were some impressive churches built in the Mosan area. In Liège itself Bishop Notger, who died in 1015, rebuilt his cathedral, dedicated to St Lambert, on a most ambitious scheme. This was probably the first large Ottonian church to have a western as well as eastern transept, preceding both Hildesheim and Nivelles in this respect. Unfortunately, very little is known about it. Two other great churches which also disappeared are Stavelot and St Truden. St Servatius at Maastricht still retains some features of the Ottonian church that was dedicated in 1039, but it has been much altered in subsequent ages. Susteren, on the

other hand, has survived fairly well in spite of a drastic modern restoration. Here the alternating system of columns and piers with a set of blind arcades in the chancel anticipate the arrival of Romanesque forms. Its chief interest, however, lies in the *Aussenkrypta*, a Carolingian feature which was to undergo a fascinating metamorphosis, first in the Low Countries and later in England where it eventually became the Gothic retrochoir. Another Ottonian example survives at Essen.

In Utrecht, the church of St Peter and the less well preserved church of St John show more direct affinities with Cologne than with Liège. Other churches such as St Lebuinus at Deventer and Emerich form a group with the Utrecht churches named after Bishop Bernulph or Bernold. They have deep choirs, polygonal on the outside and entirely separate from the side chapels. The choir and chapels are raised over hall crypts below, which are characterized by columns decorated by spiral or fluted grooves. These were to find their way into English Romanesque architecture at the end of the eleventh century.

Cologne itself played a prominent part in both Ottonian and Romanesque architecture. During the reign of Otto I his brother was Archbishop of Cologne, and it was during this period that the church of St Pantaleon was built (957). In its original form this church had low transepts and no side aisles. The nave was articulated with a version of the giant order based on the hall of Charlemagne's palace at Aachen and ultimately on the Roman basilica at Trier. The influence of this church on the eleventh-century cathedral of Speyer makes it one of the forerunners of German Romanesque. At the very end of the Ottonian period another, even more influential church was built in Cologne: Sta Maria im Kapitol (*c.* 1049). The east end of this church is centrally planned, i.e. with three identical apses opening from the square of the crossing. On the fourth side, to the west, there is a nave of seven bays and a westwork. The centrally planned east end is clearly reminiscent of a number of Early Christian churches in the eastern Mediterranean. Just how the idea came to be adopted in the Rhineland in the middle of the eleventh century is not clear, but Italian intermediaries such as those that inspired the later S. Fedele at Como, have been invoked. Several Cologne churches of the twelfth century adopted the trefoiled east end of Sta Maria Im Kapitol, and apsidal transepts extended even further afield, i.e. to Tournai and St-Lucien at Beauvais. Another important original group of Ottonian churches is that which takes its name from Einseideln in Switzerland, which included Muri, Schaffhausen and St Gall, the last of which was probably the prototype for the rest. It is likely that all these had crossings like St Michael's at Hildersheim. Another group which shared this feature was located in Upper Lorraine between the Meuse and the Rhine. It included Trier, Metz and Verdun. The most impressive monument of this group is the ruined abbey of Limburg an der Haardt, which was built for the Emperor Conrad II between 1025 and 1042. This church had a

two-tower façade and a nave carried on columns—in which respect it seems to have been dependent on the slightly earlier cathedral of Strasbourg. The east end and transepts had pilaster articulation which related it to another of the big Rhenish cathedrals, namely Speyer.

Of the great Rhenish cathedrals of the Ottonian period, nothing remains at Mainz (c. 1000) or Strasbourg (1015) other than the plan, which in both cases determined the dimensions of the buildings which replace them. These are sufficient, however, to indicate the great size to which Ottonian churches aspired. At Worms there are small fragments of masonry dating from the early eleventh century; but the only building which preserves considerable parts of the eleventh-century structure is Speyer. The Imperial Cathedral of Speyer was started by Conrad II in 1031. The plan, crypt and the aisled walls of this building, which was dedicated in 1062, survived to be incorporated into the extensive Romanesque rebuilding undertaken in the years following 1081. When built, Speyer was by far the largest church in northern Europe. The walls of the aisles and nave were given the flat, giant order pilasters of St Pantaleon at Cologne, and no doubt carried the same imperial connotations. The capitals of this first building were, however, of the plain cubic form, no doubt introduced from Italy. It is generally agreed that the nave of Speyer was originally covered by a flat wooden roof, although the choir had a barrel vault from the start. The west end of the building was totally destroyed at the end of the seventeenth century; but its original form is known from earlier engravings. While it had the characteristic Ottonian group of towers and an extensive narthex, there was no attempt to preserve the double-ended character found in earlier Ottonian churches; and from this point of view Speyer has some claim to be regarded as the first great monument of German Romanesque architecture.

When Speyer was built, German architecture was in no way lagging behind that of the rest of western Europe; and if German prosperity had not been interrupted by civil wars and the Investiture Contest, no doubt architecture would have continued to develop in pace with that in France,

118. The tympanum of St-Ursin in Bourges, made by Girauldus, contains northern Italian features. **119.** The famous doorways of Chartres Cathedral are close to Gothicism. **120.** St-Benoît-sur-Loire has two transepts, as had Cluny. **121.** The nave was reconstructed in the thirteenth century. **122.** The abbey church of Morienval has one western tower; two other towers flank the chancel. The ambulatory, dating from c. 1130, contains the earliest known Gothic vaulting in France. **123.** Ste-Trinité in Caen, consecrated in 1066, was founded by William the Conqueror. The clerestory is flanked by galleries, and ambulatories on two levels surround the choir. **125.** The threefold division of the walls of the nave in the Romanesque part of Mont-St-Michel is in advance of the Gothic style; this dates from after 1026. **124.** Fontenay Abbey is another example of the simplicity of Cistercian architecture.

118

119

120

121 122

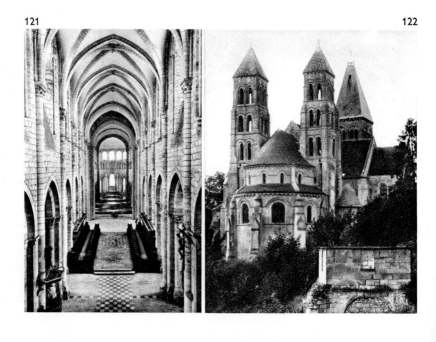

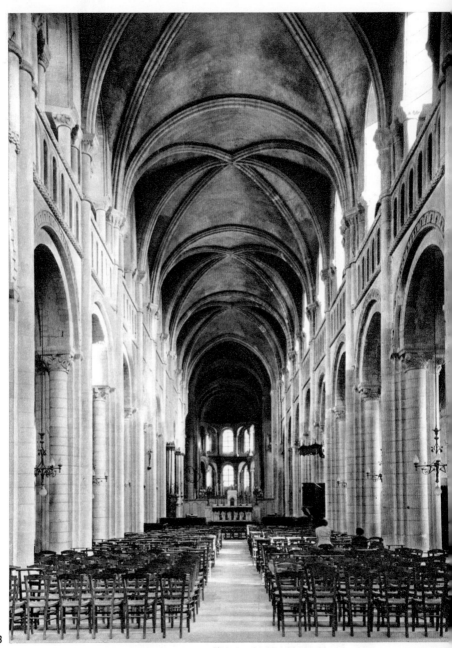

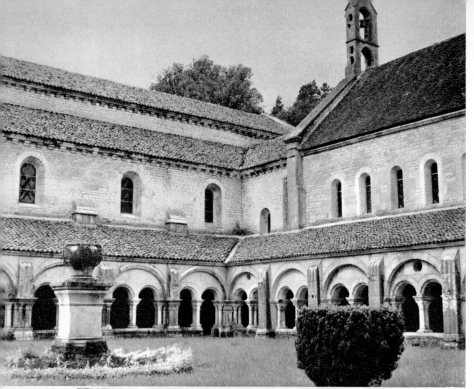

124

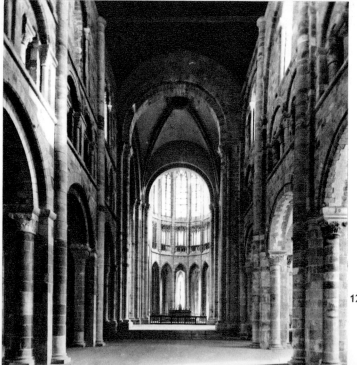

125 126

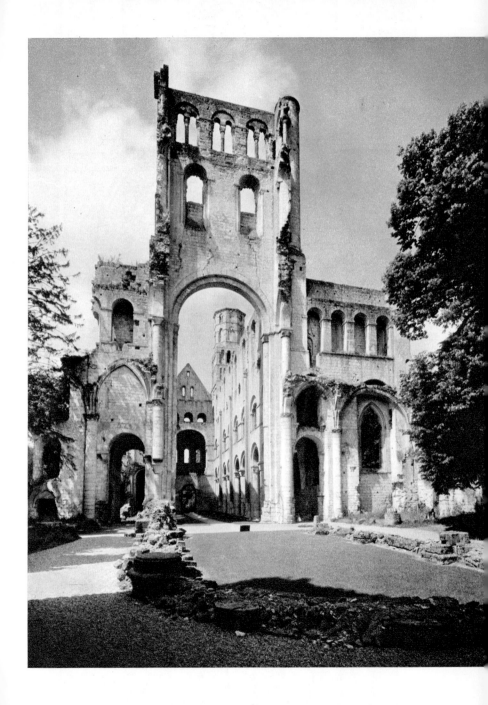

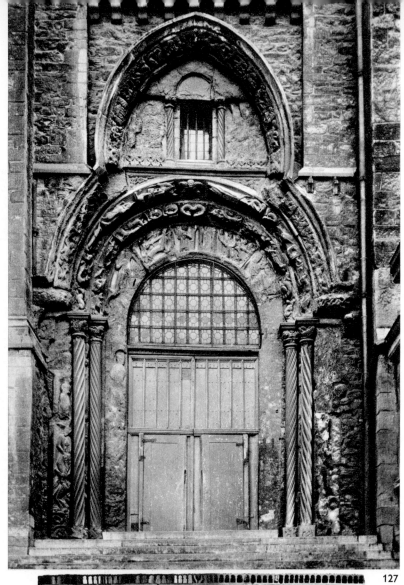

127

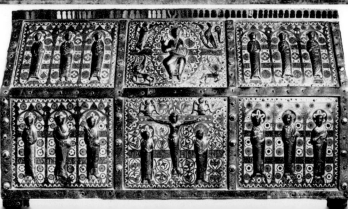

128

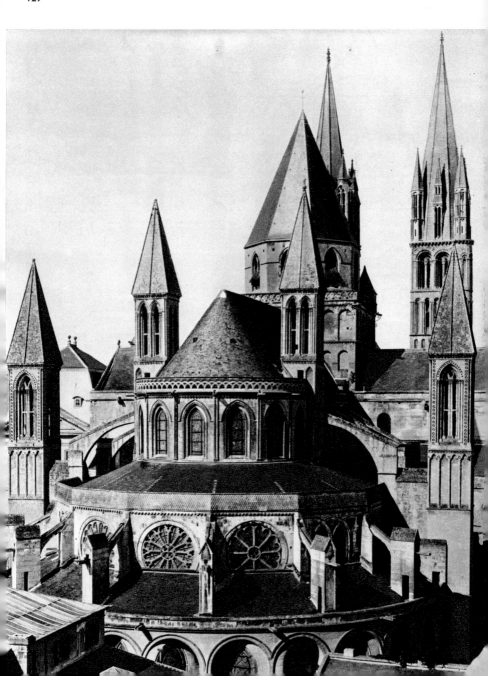

Italy and England. As it was, however, comparatively little was built in the years following the completion of Speyer, and apart from rebuilding operations in the twelfth century nothing on the same scale was attempted before the arrival of High Gothic *c.* 1250. In many ways German Romanesque takes the form of a perpetuation of the much more precocious achievements of the Ottonian period. That is why it is necessary to devote so much space to a style that admittedly stands somewhat outside the main lines of Romanesque development elsewhere in Europe. Thus there is little interest in vaulting other than on a small scale for crypts and aisles. Thick walls appear in Germany, e.g. in the early eleventh-century parts of the cathedral of Trier, before they were incorporated into Norman architecture, but the structural possibilities which the Normans were quick to exploit were left undeveloped. The same is true of the alternation of columns and piers in Ottonian church arcades. This was in effect the starting point of the double bay system; nevertheless the history of the bay as such in German architecture is concerned with the importation of alien ideas from Italy and perhaps France. It is as though the Germans were the first to reach the threshold of Romanesque, but they stood aside and let others get in first.

OTHER FORMS OF ART

Little has survived of the paintings which must at one time have decorated the walls of numerous Ottonian churches. Only St Georg, Oberzell on Reichenau can give us an idea of the riches which once existed. On the other hand, a fairly complete judgement and valuation may be made of another form of painting, namely miniatures, the more so as, in contrast to mural painting, the full freshness of the colour has, on the whole, been well preserved in book illustrations. The chief centres of this art were Reichenau, Cologne and Regensburg, with Trier, Echternach, Fulda and Hildesheim making their contributions. Some of the manuscripts produced in these places are world-famous, for example the *Codex Egberti* (Stadtbibliothek, Trier), made at Reichenau in 980 by Keraldus and Helibertus. The Gospel

126. The Norman scheme was fully developed in the abbey church of Jumièges, now an imposing ruin. **127.** In the Porte Mantile of Tournai Cathedral, French and Lombard elements are combined. **128.** The reliquary of St Calminius and St Namadia of Mozac (it was made in Limoges) provides clear evidence of the influence of the great Mosan reliquaries. **129.** The exterior of St-Etienne in Caen is fairly simple, but the east end contains the first elements of Gothicism in its rich detail. **130.** Detail of the famous Bayeux Tapestry, approximately $1\frac{1}{2} \times 234$ feet; a wool embroidery in eight colours, relating Harold's voyage to Normandy and the Norman Conquest of England. The scene depicts a battle between French and English. **131, 132.** Miniatures from the Apocalypse of St Sever (middle of eleventh century) and the Gospel of Avesnes (second quarter twelfth century).

Book of Otto III (Reichsbibliothek, Munich) was also executed at Reichenau (Plates 155–156), as was the Book of Pericopes of Henry II (ibid.); and many others.

In distinguishing the main scriptoria, one agrees with Hans Jantzen, who notes that in Cologne it was the colour, in Reichenau the gesture, and in Regensburg the concept, which played the dominating role. Reichenau in particular created an entirely new art form, uninfluenced by ancient tradition. Figures and scenes detach themselves from the context of reality. Colour, gesture and composition place them on another, transcendental plane. Reichenau in particular exerted enormous influence. The style of Regensburg illuminators, on the other hand, is intellectual and full of symbolism. They contain numerous texts and theological subtleties. The most typical example is in the Gospel Book of Uta (also in Munich). Here colour was reduced to the status of a purely decorative element. In Cologne, on the other hand, colour forms both the basis and the accompaniment of the conceptual content.

A very special place in Ottonian art is occupied by the works in bronze commissioned by Bishop Bernward of Hildesheim. The most important of these were the famous doors for the cathedral, 15 feet high and dating from 1015 (Plate 145). It is probable that on his visit to Italy the bishop saw the wooden doors with narrative panels at Sant' Ambrogio in Milan, or those at Sta Sabina in Rome. He could also have seen the *Pala d'Oro* of Wolvinius in Milan. But this does not lessen the impressiveness of Bernward's achievement. A new type was created in Hildesheim in which a number of scenes from the Old and New Testaments were combined in a monumental way, adapting the forms of expression appropriate in miniatures to the particular conditions of metal relief. The result was a naïve, but very direct and individual idiom. The bronze Column of Christ was clearly inspired by another antique example, namely Trajan's column in Rome, of which it is a smaller-scale copy. A frieze containing twenty-four scenes from the life of Christ forms a spiral up the shaft (Plate 146).

The wood reliefs of the doors of Sta Maria im Kapitol in Cologne are imbued with an entirely different spirit from that of Hildesheim. The groups with their numerous figures narrate the biblical stories in a more popular and epic manner; colour contributed to its exuberance (Plate 147).

There is practically no architectural sculpture of the Ottonian period, and this is one of the features which makes it necessary to distinguish Ottonian from Romanesque. On the other hand there is quite a lot of free-standing sculpture of very high quality, both in metal and wood, which was not without influence on the early stages of Romanesque sculpture. There are two outstanding works dating from late in the tenth century. One is the seated Virgin and Child at Essen, made of wood with strips of gold beaten over the core. The other is the Gero Cross in Cologne Cathedral. This is a truly monumental work made of wood, over six feet high, and filled with a

tremendous expressive power. There is another, also in wood, at Gerresheim, and two more, this time of bronze, at Milan (the Aribert Cross), and at Werden. Although the last example dates from the time of Henry IV (*c.* 1080), it is still entirely Ottonian in conception.

Finally, there are the magnificent, richly jewelled Gospel Book covers, exquisite settings for Holy Writ. Many of them have ivory carvings inserted front and back, works of art in themselves and excellent introductions to the reviving art of sculpture (Plate 149). Most of these ivory carvings were made in Upper Lorraine (Metz, Trier, Echternach) and in the regions of Rhine and Meuse, where Cologne and Liège were the main centres. Aachen, too, remained a focus of the applied arts, cf. its golden antependium and the ambo donated by Henry II, as well as the wonderful ivory situla of Otto III in the cathedral treasury (Plate 152). All these works of art achieve an almost barbaric splendour, combined with extreme refinement of shape.

5. THE GERMAN COUNTRIES

ROMANESQUE ARCHITECTURE IN THE RHINELAND

The most ambitious building in Germany during the later years of the eleventh century was the remodelling of the cathedral of Speyer for the Emperor Henry IV in the years after 1081. It was discovered that the foundations of the early eleventh-century cathedral were being undermined by the River Rhine and this necessitated considerable strengthening of the foundations. The opportunity thus presented was taken to remodel the entire cathedral. Apart from thickening the walls, new windows with elaborately carved frames were introduced in the transepts; while the whole

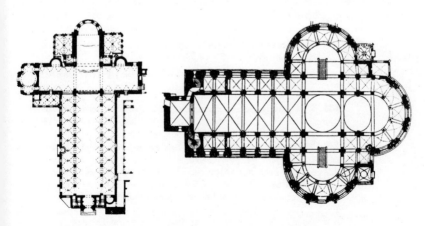

Groundplan of (*l.*) Würzburg Cathedral, and (*r.*) Sta Maria im Kapitol.

church was vaulted. This entailed raising the walls of the nave and the modification of the piers of the main arcades inside. The result of this remodelling was to make the height of the church over 100 feet, and until the third abbey church at Cluny was built, it was the highest as well as the largest Romanesque building in Europe. The heightening of the walls was effected by the construction of an external 'dwarf gallery' in the thickness of the wall. This was the first example of its kind in the Rhineland, although wall passages had been used earlier in the eleventh century at Trier. The external gallery was to prove one of the most influential features of German Romanesque buildings. It spread all over the Low Countries and into Italy (Plate 162).

It is likely that this work was done by imported Italian masons and sculptors. In the case of the sculptured decoration it is possible to connect the windows at Speyer with those of the late eleventh-century choir in Sant' Abbondio at Como. The same patterns recur in the south transept at Quedlinburg which was remodelled at the same time as Speyer. The implication is that the craftsmen concerned moved from place to place in Germany, seeking employment wherever there was work in hand. These craftsmen seem to have come in waves and evidence of their work can be found in Germany throughout the twelfth century. Although the original vaults no longer exist, there is reason to believe that Lombard masons were responsible for these also. Speyer was one of the first great churches in northern Europe to receive a vault other than a barrel vault over its nave. It almost certainly precedes Durham in England which is the other main contender for this honour. This precocity was almost certainly due to the patronage of the Emperor Henry IV. While Speyer was being re-endowed the Emperor was in the throes of his great quarrel with the Pope for control of the Church in Germany, and there is little doubt that Speyer was intended as a grandiose symbol of imperial prestige, and a veritable re-affirmation of the Emperor's rights over the Church. It is only with this in mind that we can appreciate the numerous Corinthian capitals which imbue the building with a strong classical flavour.

Speyer in its rebuilt form served as a model for the nearby cathedral of

133. Westwork, nave and transept of St Cyriacus at Gernrode. **134.** The interior: westwork and tribunes. **135.** St Michael, Hildesheim, is the best example of a church in which westwork and choir are practically identical. **136.** The interior of this church has Saxon alternation: square piers alternating with two pillars; and a timber roof richly decorated with Romanesque paintings. After the Second World War all later additions were demolished. **137.** Ruins of the abbey church of Hersfeld near Kassel. This church, built in 1037, has an imposing hall transept in imitation of Early Christian examples. **138.** The church at Celles-lez-Dinant has the low transept characteristic of the Mosan region, and a westwork in the shape of a large tower flanked by two circular staircase towers.

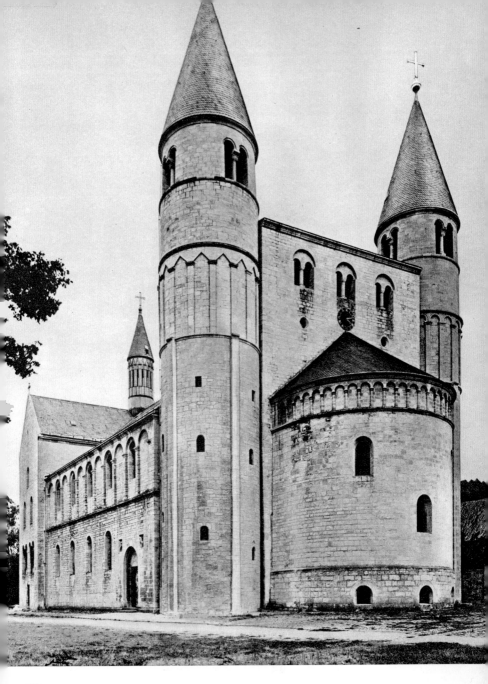

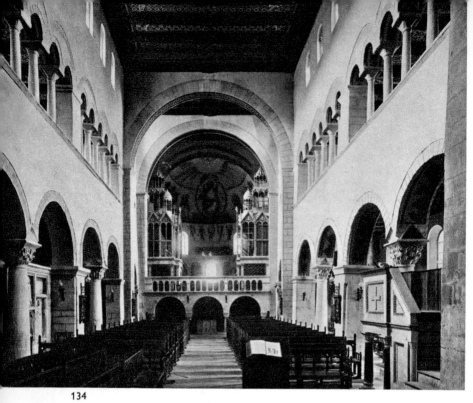

134

135

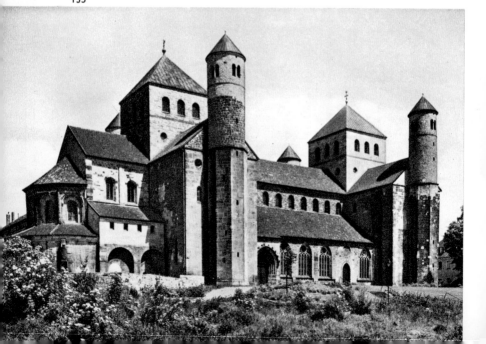

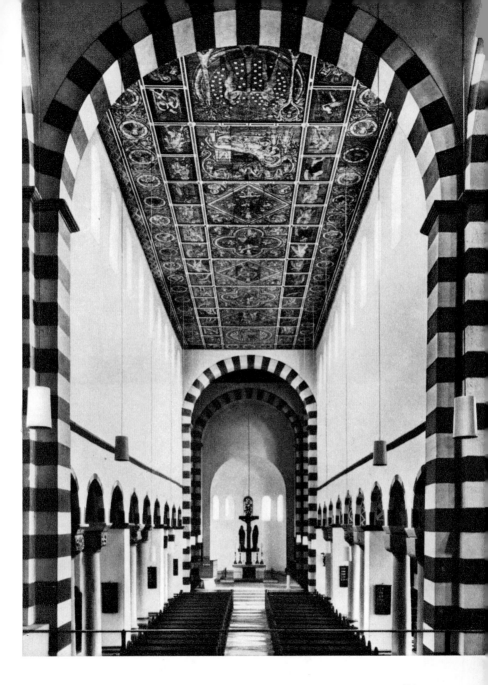

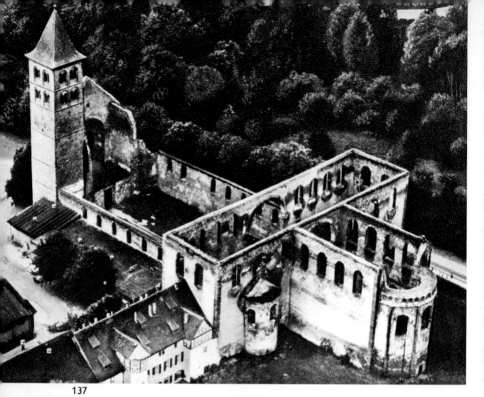

137

138

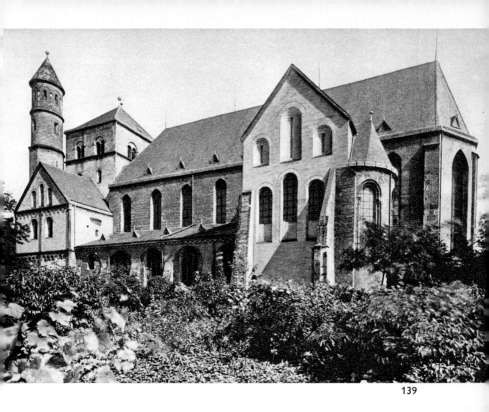

139

140

141

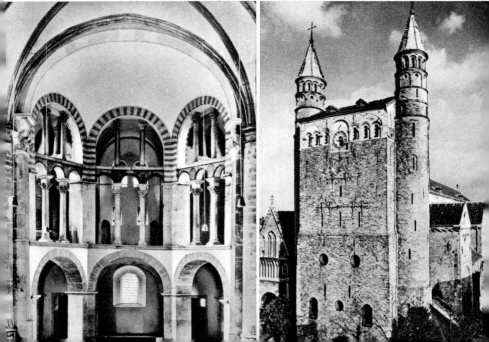

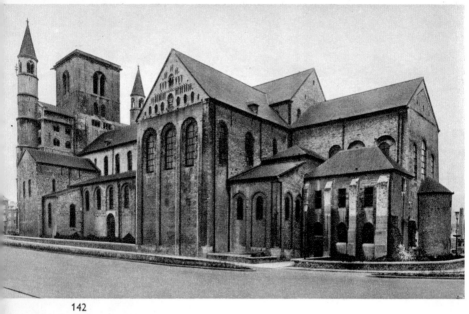

142

144

143

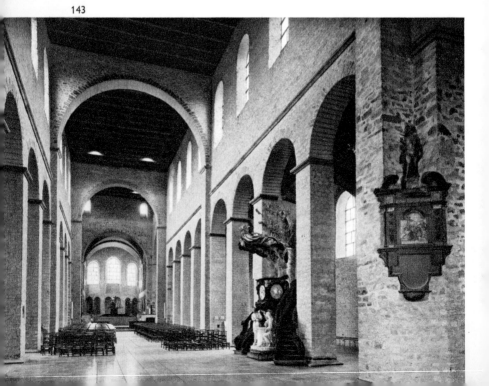

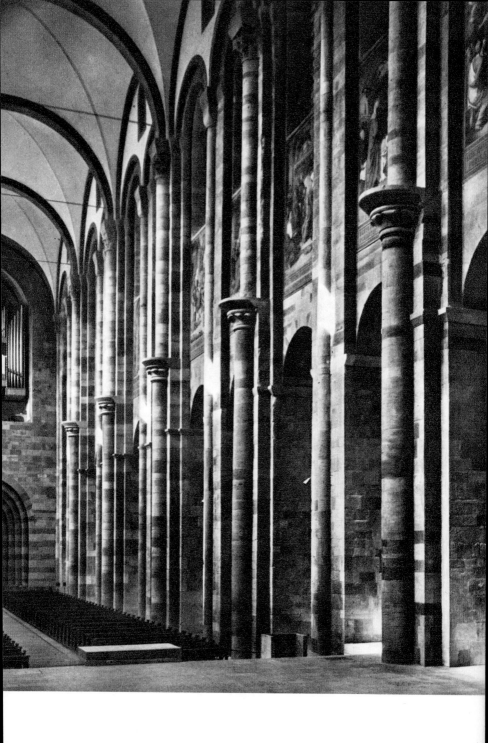

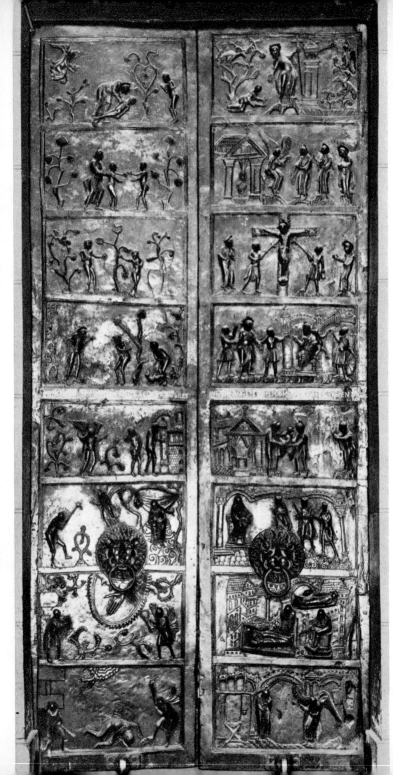

Mainz, the construction of which began shortly after Speyer itself (Plate 163). The vaulted roof was completed before 1137. The later stages of the work, i.e. the centrally planned structure at the west end, was not completed until well into the thirteenth century. As at Speyer, there are Lombard details in the decoration but unlike Speyer the building retains traces of its Ottonian predecessor's double-ended plan.

The third great Rhenish cathedral, Worms, was not reconstructed in its present form till after 1150. Parts of the preceding Ottonian church are in fact incorporated into the present building. It is unusual in having different elevations for each side of the nave. Apart from this peculiarity the nave has ribbed vaults with pointed arches, and this has been taken to indicate French as opposed to Italian influence. If so, Worms was one of the first buildings in Germany to reflect the gradual shift of influence from Italy to France, which culminated with the introduction of Gothic in the thirteenth century. The same point can be made by comparing the two choirs of the building. The eastern choir has an apse internally, and a flat wall outside. The latter includes a great deal of Lombard sculpture. It was presumably finished by the dedication of 1181. The western choir, on the other hand, which dates from the early thirteenth century, includes a rose window and much chevron ornament that has been taken to have come from France.

The rebuilding of the cathedral of Strasbourg which was even later than Worms, i.e. *c.* 1180, has a similar east end, and its north transept shows unmistakably the influence of a north Italian building such as Piacenza Cathedral. The south transept and the nave which date from well into the thirteenth century indicate the transition of German architecture from Romanesque to Gothic.

Apart from the Rhenish cathedrals, vaulted churches remain rare in German Romanesque architecture. An important exception is the abbey church of Maria Laach which was started in 1093, and designed to have groined vaults over its nave. However, there is no guarantee that these were completed much before 1156, and the church itself was not finished

139. St Pantaleon in Cologne originally had a one-aisled nave; the choir was reconstructed in the Gothic style. **140.** The western choir of Essen Minster is a copy of the Palatine Chapel in Aachen (see Plate 5). **141.** The westwork of the church of Our Lady in Maastricht, dating from *c.* 1000, has a Romanesque superstructure from the late twelfth century. **142.** St Gertrude in Nivelles is the best preserved of the great Ottonian churches in the Mosan region. Here also, the transepts are lower than the nave. The impressive westwork was reconstructed in the Romanesque period. **143.** Internally, the nave is divided by a transverse arch. **144.** The walls of the nave of Speyer Cathedral are divided by half-columns and blind arches. **145.** The bronze doors of Hildesheim Cathedral, created for Bishop Bernward and dating from 1015, are the earliest of their kind; they are decorated with scenes from the Old and New Testaments.

until the beginning of the thirteenth century. The Upper Rhineland, especially Alsace, also provides a number of exceptions. There are some fairly early ribbed vaults in the choir of the abbey of Murbach; and the church of St Johann bei Zabern can be taken to represent a number of Alsace churches with ribbed vaults over double bays, decidedly Lombard in their general character. In fact the term 'Lombardo-Rhenish system' has been coined to indicate the ramifications of this kind of church design.

In Cologne itself there was an important school of twelfth-century architecture, whose monuments can be found in the east end of the church of St Gereon, in the additions to Sta Maria im Kapitol and in the two churches whose plan follows that of Sta Maria im Kapitol: the Holy Apostles and Gross St Martin. It was a characteristic of the Cologne School to use decorative shafts for purposes of articulation; this gives Cologne architecture a much more Western flavour than the rest of German architecture of the time.

ROMANESQUE ARCHITECTURE IN THE MOSAN AREA

This was closely connected with the Rhineland and more particularly with Cologne. Thus the east end of St Servatius at Maastricht was obviously inspired by the east end of Speyer, and the Minster at Roermond reflects the influence of Cologne.

In Liège itself the west end of the church of St-Barthélemy survives to represent an interesting type of Romanesque west front in which the two-tower façade was combined with the simple block form of earlier westworks. The appearance of St-Barthélemy is quite distinctive; but the idea underlying its design was taken up and developed as far away as Lincoln in England, St-Denis in France and Wimfen in Germany.

Another church in this part of the world which calls for comment, even though it has been totally destroyed, is the church of Sta Maria at Utrecht. This is known from seventeenth-century paintings and engravings, and it was clearly a straight import from northern Italy. Probably the cathedral of Novara (which is also totally destroyed) was the inspiration.

ROMANESQUE ARCHITECTURE IN SWABIA AND
SOUTHERN GERMANY

The dominant factor in south German architecture during the eleventh and earlier twelfth centuries, was the so-called School of Hirsau. Abbot William of Hirsau (1069–91) made Hirsau the centre of a reformed monastic congregation whose rule *Consuetudines Hirsaugenses* was based on that of Cluny. Hirsau developed its own church design consisting of a three-aisled chancel without a crypt, sometimes square ended although apses are known. At the west end there were usually two towers and a narthex. Unfortunately both the churches at Hirsau itself have been destroyed, but their design is known and surviving representatives of the Hirsau group occur at Paulinzella (Thringia) and Alpirsbach (Plate 153) in the Black Forest. These churches

use columns instead of piers and heavy cubic capitals; but apart from these they show remarkable similarities to the flat-roofed basilicas of Ottonian architecture. It is hard to tell whether a Saxon church like Königslütter (founded in 1135 by the Emperor Lotha) was influenced by the Hirsau formula or whether it was simply a continuation of the conservative Saxon tradition. On the other hand the decoration of Königslütter (Plate 159) was much influenced by Lombard sculpture. In fact all over southern Germany one senses the proximity of Italy. The decoration of the *Schöttenthor* at St Jacob, Regensburg, provides perhaps the best known instance, while the east end of the church of Schöngrabern in Austria (Plate 161), which dates from well into the thirteenth century, shows how far the style travelled and how long it persisted.

<p align="center">*　　*　　*　　*　　*　　*</p>

In northern Germany Romanesque architecture, such as it is, shows the tenacity of the Carolingian/Ottonian traditions. Its characteristic monuments are a number of spectacular westworks such as that of Söest (1200–20) or that of Freckenhorst (Plate 168). The cathedral of Paderborn provides another example of a westwork in the form of a great single western tower.

The Neuwerkkirche at Goslar (late twelfth century) has round its apse some familiar Lombard ornamentation which resembles the columns of the cloister at Königslütter. Behind this architectural ornament it is perhaps possible to detect the persistent influence of the Helmarshausen workshop, which was still influential in the time of Henry the Lion, Duke of Saxony. The cathedral of Brunswick (1173) is the most important piece of architecture connected with the patronage of Henry the Lion. Here at last the Ottonian tradition which had prevailed in Saxony for so long was finally abandoned. The cathedral had an alternating system in groined vaults.

It is necessary to mention the cathedral of Bamberg which was rebuilt in the half-century between 1190 and 1240. The east end is particularly rich in Romanesque decoration, while the rest progressively underwent transformation into Gothic.

Finally, there are groups of buildings which stand somewhat apart from the traditions that predominated in the rest of Germany. In the north, brick architecture began to assume local prominence, especially along the Baltic coast which was incorporated into the German kingdom, largely thanks to the enterprise of Duke Henry the Lion. Of the twelfth-century churches built in this material that of the Premonstratensian monastery at Jerichow is the only important surviving example.

The other exceptional group of buildings comprises the churches of the Cistercian order. These followed the *plan Bernardin* but in other respects the Cistercians in Germany seem to have been content to use the local types of elevation. The outstanding Cistercian church in Germany that has survived from the twelfth century is at Eberbach, not far from Wiesbaden.

Among the very earliest Romanesque stone sculptural monuments are the remarkable Externsteine. When early in the twelfth century the monks of Abdinghof in Paderborn, near Horn in the Teutoburger Wald, hewed a chapel from the rocks, which was consecrated in 1115, they decorated the exterior with large reliefs chiefly on the theme of the Deposition from the Cross—a life-size copy of ivory representations.

The bronze lion erected in 1166 by Henry the Lion in front of his castle Dankwarderode in Brunswick, is one of the few free-standing sculptural monuments produced by the Middle Ages. In design it is an enlarged *aquamanile* in the shape of a lion, a form which occurred fairly frequently in the minor Romanesque arts. The monumental bronze Wolfram, a standing male figure, over five feet high without its base, which serves as a candle-stick in Erfurt Cathedral, dates from approximately the same period.

Apart from these, Lombard influence is predominant, especially in later German sculpture. The so-called *Galluspforte* of Basle Minster (*c.* 1185–90) is one of the oldest sculptural doorways in the German provinces. While the shape, which resembles a triumphal arch, points to Provence, the style of sculpture is reminiscent of northern Italy. Even more closely akin to the latter are the columns in the crypt of Chur Cathedral in Switzerland. They are supported by recumbent lions and carry apostle figures. Possibly they originally formed part of a *pontile* like that in the cathedral of Modena. Some scholars have traced in them influence of the school of Antèlami. A tympanum from the Catherine chapel in Würzburg, representing the Virgin enthroned between two saints, is related in style to Wiligelmo of Modena. A striking feature is the predilection for inscriptions and texts, not only in the surrounding frame, but also on manuscripts held by the figures. This practice, which originates in northern Italy, turns up also in the Meuse valley: i.e. in the tympanum showing Christ in Majesty and the Romanesque retable in St Servatius in Maastricht; in reliefs and historied capitals in the church of Our Lady in the same city; in the *Vierge de Dom Rupert* and the unusual tympanum of the *Mysticum Apollinis*, both in Liège (Plate 170); in

146. Detail of the bronze Column of Christ in Hildesheim Cathedral, which was clearly inspired by Trajan's Column in Rome. **147.** Relief on the wooden doors of Sta Maria im Kapitol, Cologne. **148.** The Golden Virgin of Essen dates from the late tenth century. It is a wood figure covered in gold (cf. Plate 102). **149.** Detail of a Gospel Book cover, probably from St Servaas, Maastricht. The symbols of the Gospel have been executed in cloisonné enamel on a gold background. **150.** The 'pendant cross of St Servatius', Maastricht. Strips of cloisonné enamel have been incorporated in the border decoration. The Christ figure is carved in ivory. **151.** Miniature from the Codex of Lebuinus in the Archiepiscopal Museum, Utrecht: the Last Judgement. **152.** Situla of Otto III in the treasury of Aachen Cathedral; the Emperor is portrayed in the upper left-hand section.

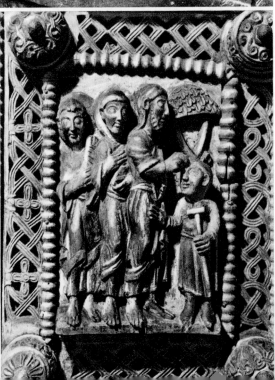

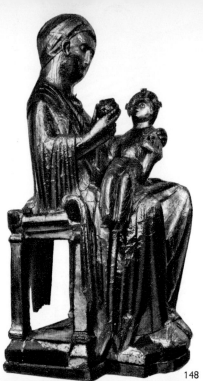

148

149

150

151

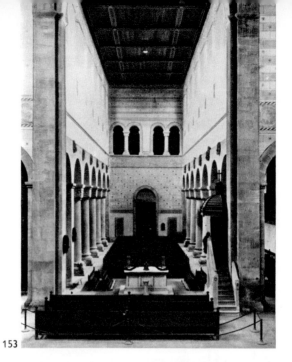

153

154

SCLAUINIA · GERMANIA · GALLIA · ROMA

157

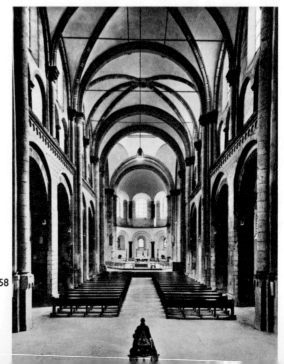

158

the apostles of the Odilienberg, etc. In Cologne the tympanum of St Cecilia deserves mention. All these sculptures were produced between *c.* 1160 and 1180.

From the same period a number of important wood carvings survive, amongst others the famous lectern with the figures of the four Evangelists, originally in Alpirsbach, but now in Freudenstadt (Plate 173), the Christ figure made by Imerward in Brunswick Cathedral, which is based on the *Volto Santo* of Lucca, and the *Sedes Sapientiae* in St-Jean, Liège (Plate 172).

ROMANESQUE PAINTING AND METALWORK IN GERMANY

As regards murals, the Rhineland provides a number of masterpieces, for instance the Knechtsteden paintings, dating from *c.* 1150, and in particular the paintings in the remarkable two-storeyed Romanesque church at Schwarzrheindorf. Those in the lower church date from before 1150, those in the choir of the upper church from around 1170. The artists have broken through the rigid Byzantine tradition, and thematically they are related to the ideas of the contemporary painter Rupert of Deutz. Elsewhere Byzantine influence is much stronger, as for instance in Westphalia. From the twelfth century date the first surviving historied windows, amongst others the *Five Prophets* in Augsberg Cathedral. Secular themes gradually invaded book illustration, creating a more lively, direct and personal style.

In this period the region of Meuse and Rhine became one of the chief centres of the art of goldsmiths and bronze casters. The masterpiece of the latter is without any doubt the wonderful bronze font which Rainier of Huy made around 1115 for the baptistry of Liège Cathedral (it is now in St-Barthélemy, Liège), and which he decorated with baptismal themes in high relief (Plate 171). The goldsmith Godefroi de Claire also worked at Huy; he made large reliquaries in the shape of sarcophagi, richly decorated with figures in chased relief. The most important reliquaries to have survived from the enormous output of the Mosan School are those in Visé (the St Hadelinus reliquary, which contains earlier sections), in Maastricht (St Servatius) and in Aachen (the *Karlsschrein*). The reliquary bust of St

153. The church of the monastery in Alpirsbach in the Black Forest is as yet close to the Ottonian style in shape. It belongs to the Hirsau school of architecture. **154.** The former Premonstratensian church of Jerichow is a striking example of northern German brick building. **155, 156.** Two miniatures from the Gospel Book of Otto III: the personifications of Roma, Gallia, Germania and Sclavinia pay homage to the Emperor, majestically enthroned. **157.** The church of Our Lady in Maastricht, buttressed by blind transepts, was influenced by northern Italy. The choir is related to La Trinité in Caen (see Plate 123). **158.** Choir and transept of The Holy Apostles, Cologne, are built on a trefoil-shaped groundplan; it has an octagonal cupola. The shape is characteristic of the Romanesque churches in the Cologne area.

Alexander (1145, Cinquantenaire, Brussels), and the Pentecostal retable (Musée de Cluny, Paris), are sometimes attributed to this school as well. We have already mentioned the Cross of St-Denis (p. 120).

Godefroi de Claire's slightly younger contemporary, Nicolas of Verdun, exported his work to several countries and established a centre of the art in the Rhineland. His most famous work is the altarpiece of Klosterneuburg near Vienna (1181), consisting of fifty-one scenes in enamel (Plate 175). In 1205 he completed the Maria reliquary (*châsse de Notre Dame*) in Tournai, in which the first elements of Gothic are discernible. The figures on this casket are practically free-standing. Subsequently the master worked in Cologne, where his influence was considerable: it is evident in the reliquary of the Three Kings in the cathedral (1180–1220), in the Heribert reliquary in Deutz (Plate 175), the reliquaries in Siegburg, the Maria reliquary in Aachen (completed in 1238), and others. A late flowering of the art is revealed in the work of Hugo d'Oignies, whose chief products are in the treasury of the *Sœurs de Notre Dame* in Namur. In his work the figurative element plays a minor part; it consists of exceptionally delicate foliage ornamentation in filigree and niello. With him the thirteenth century is definitely reached.

6. SPAIN

HISTORICAL BACKGROUND

In 711 Roderic, the last of the Visigoth kings, was killed in battle against the Arabs, and the greater part of Spain came under Moslem rule. From 929 onwards, the Omayyad dynasty, whose capital was Córdoba, presided over a brilliant civilization. In the north a number of smaller regions remained under Christian rule: Asturias-León, Castile, Aragon and Navarre. Eventually they were destined to overthrow Arab power in the south, and to reconquer practically the whole of the peninsula. French knights took an active part in this struggle. Toledo was captured as early as 1085; but the decisive battle of the reconquest was not fought until 1212 near Las Navas de Tolosa, after which Córdoba was taken in 1236 and Seville in 1248. Until 1492 a remnant of Arab power survived, centred around Granada. It follows from this course of events that examples of Romanesque art are only to be found in the northern provinces.

The pilgrimage to Santiago de Compostela constituted an important factor in the development of Spanish art during the Romanesque period. This Galician town (in the north-western corner of Spain), was founded on the spot where the body of the apostle James the Great was reputed to have been found in 812. This led to the development of the so-called pilgrimage routes from the north and east, of which the *camino francés*, the French route, in particular, was to attain great cultural importance, not only for Spanish, but also for French art. Apart from architectural and sculptural influences,

Cluniac foundations were made in Spain along the camino francés. They centred on Sahagún. Numerous Frenchmen settled on the route especially towards the end of the eleventh century. In turn, Spanish art exerted influence on that of France. Catalonia, on the other hand, remained somewhat apart. There northern Italian influence was predominant.

CATALONIA

In the Iberian peninsula, examples of First Romanesque architecture only occur in profusion in Catalonia, and it was a Catalan art historian, J. Puig y Cadafalch, who in 1928 introduced this term to denote the renaissance in architecture which, in the tenth and early eleventh century, spread from northern Italy to the adjoining regions and constituted the earliest phase of the developing Romanesque style.

In Catalonia First Romanesque architecture dates from the early eleventh century onward. At first masonry tended to be fairly rough—flat stones between thick layers of mortar—as already noted elsewhere. This form of masonry created rough wall surfaces, which were enlivened by pilaster strips and arched friezes, sometimes extending up the sloping edges of church façades (Plate 176). The characteristic cruciform window openings in the upper zones, frequently found in northern Italy, are met here also. It is probable that, as in Carolingian times, the walls of these churches were plastered both inside and out, so that what we see nowadays is only the exposed core of the structure. As yet there was no question of sculpture, and the wall surfaces were pierced only by small windows.

The development of the liturgy called for more space around the altar; the semi-circular apse therefore no longer immediately adjoined the transept, as was the case in Early Christian basilicas, but a chancel bay was inserted, although the earlier design survived here and there. As a result of the growing cult of relics, crypts too became more spacious, and this naturally encouraged the development of vaulting techniques. Stone-vaulted small churches, probably based on the Roman building tradition, were in any case not rare even in the pre-Romanesque period. Occasionally this technique was applied to larger structures, for instance in the transept of St-Michel-de-Cuxa in that part of Catalonia which is nowadays French. In the crypt of St-Martin-du-Canigou, dating from shortly after 1000, attempts were already made to solve the problems of lateral thrust and buttressing.

With the eleventh century, a new element was introduced in Catalan architecture, namely the combination of a transept with a dome or central tower. Probably architects knew examples in the Byzantine East, but structures with a cupola over a Greek cross nevertheless remained rare (Montmayor, San Sebastian); usually they were combined with a basilical nave (San Jaime de Frontanyá, Plate 178). One of the most successful examples is San Vicente en el Castillo in Córdoba (1029–1040), which is,

moreover, one of the churches with an apse surrounded by an (as yet rudimentary) 'dwarf gallery'. In San Nicolas in Gerona, a trefoil-shaped solution has been applied; it is a single-aisled structure with three apses surrounding the domed space. The design of the choir of San Sadurni de Tavérnoles at Anserall is akin to this, but it is more complicated; here also the presbytery is trefoil-shaped.

The bell-towers of early Romanesque churches in Catalonia are almost identical to those of their precursors in northern Italy; an example is that of Tahull (Lérida) (Plate 177). Circular towers are exceptional, but that of San Sadurni de Tavérnoles mentioned above provides an instance.

The most prominent patron of architecture in the early eleventh century was Oliva, Bishop of Vich and Abbot of both Ripoll and St-Michel-de-Cuxa. On his death he was lauded as an 'inspiring influence in matters ecclesiastical, and the founder of buildings of admirable design'. He was an avowed adherent of the new style from Italy and enlarged his two abbey churches accordingly. The impressive east end of Ripoll with its seven apses, though unfortunately drastically restored, provides eloquent testimony (Plate 183). The church, which was consecrated in 1032, was intended to match St Peter's in Rome; hence its five aisles, its wide transept and imposing choir.

After the fall of the caliphate of Córdoba, this entire region, once so backward and thinly populated, enjoyed a brisk economic revival. Among other manifestations of this was the building of numerous new churches and monasteries. Most of the surviving churches possess a fairly wide nave without aisles, and are externally decorated with Lombard bands and arches. These are interspersed by churches of Augustinian canons, which tend to have transepts with three adjoining apses and towers over the crossing. The sudden prosperity of Catalonia was not confined to that region alone, but soon spread to the remote valleys of the Pyrenees. There, however, the naves of the churches were generally timber-roofed. This is the case for instance in the two churches in Tahull, with their purely Italian campaniles (Plate 177). Much further west, San Caprasio in Santa-Cruz-de-los-Serós (Huesco) deserves mention, and even in Castile there is one church, in Urueña (Valladolid), which adopted the Italian style.

In spite of its natural simplicity, this architecture did not entirely ban decorative sculpture. This may have been partly due to the influence of Omayyad art, which is discernible in the capitals of the earliest sections of Ripoll and in the crypt of Vich Cathedral. Nevertheless, the Catalan stone-masons asserted their own character when they adopted the Islamic version of the late classical Corinthian capital. They enlivened the acanthus leaf ornament with tendrils and flower motifs. The influence of Languedoc may also be recognized, understandably so, since Catalonia was subordinate to the archbishops of Narbonne. Beautiful capitals, some of the Corinthian type, others decorated with interlace, are to be found in San-Pedro-de-Roda

(Gerona). Nevertheless, Catalan sculpture was not to achieve its greatest flowering until the early twelfth century.

ROMANESQUE ART ALONG THE PILGRIMAGE ROUTES

Until the mid eleventh century Spain lagged behind in the general development, the more since this region at the end of the tenth century suffered invasions by the Arabs under Almanzor. One consequence was that Mozarabic refugees (i.e. Christians who had lived under Moorish rule) found shelter in these parts, and they settled there permanently. In this way Moorish influences penetrated Christian art, especially in León and Old Castile. When the empire of the Omayyads collapsed (1031), and Christian rulers once more became powerful, the Saracens in their turn had to pay tribute, and this helped to improve the economic situation. Relations with the rest of Christian Europe became closer and as a result Cluniac influence spread into northern Spain, putting an end to its religious and cultural isolation. The monks of Cluny are often credited with the promotion of the pilgrimage to Santiago de Compostela, which brought not only numerous pilgrims, but also artistic influences from France to these hitherto backward regions. In many respects the *reconquista* was a French affair. It was not just a local war of liberation, but an international crusade against unbelievers. This interaction between north-western Spain and France culminated around 1100.

It is hardly surprising that the earliest manifestations of Romanesque art along the *caminos francés* bear the stamp of their French origin. The economic revival and the pilgrimage made possible the reconstruction of Santiago Cathedral itself. It was begun in 1075 by Bishop Diego Gelmires, when Alfonso VI was king of Castile, and with the support of Alfonso's son-in-law Raimond of Burgundy, count of Galicia. More than anywhere else it is in this magnificent cathedral that the French contribution to the development of Romanesque art in Spain can be recognized. Elsewhere along the pilgrimage routes, both in France and Spain itself, architects had repeatedly tackled the problem of building churches spacious enough to accommodate large numbers of pilgrims. At Santiago it was possible to benefit from the lessons already learnt. Essentially it is the same design as St-Sernin at Toulouse. The choir and the extensive transept are surrounded by aisles and ambulatories with projecting chapels. Over the aisles, tribunes help to buttress the sideways thrust of the barrel vaulting of the nave. There is no clerestory. The nave consists of ten bays, each transept arm of five. Some of the builders' names are known: Bernardo the Elder, Robert, Estéban, Bernardo. Probably the first two were Frenchmen.

Among the sculptural decoration of the famous *Puerta de las Platerias* (Plate 198) are fragments of at least two older doorways from the early twelfth century. The influence of the Porte Miégeville at St-Sernin is so obvious that it has been suggested that the same sculptor worked in both

places. On the other hand there is affinity with the sculpture of S. Isodoro in León, where Tolosan influence was also active.

The latter church was rebuilt in 1063 by King Fernando I of Castile. In the course of the twelfth century it was enlarged and altered, but a chapel at the west end, called the 'Pantheon of the Kings', survives from the eleventh-century church. Its capitals are important for being among the earliest dated pieces of Romanesque carving. They have been connected with similar capitals at St-Benoît-sur-Loire in France. (Plate 202.) In the early twelfth-century doorways the influence of the *Puerta de las Platerias* and through it that of the *Porte Miégeville* is clearly discernible.

The chancel of the third important product of northern Spanish Romanesque, the cathedral of Jaca, dates from 1063, the year of its foundation, when Ramiro I of Aragon commissioned the building. The nave is an early example of the alternating system, which seems to indicate north Italian influence. Similar influence appears in the sculpture of the capitals and is evident in the lions in the tympanum of the western doorway, where they flank the monogram of Christ (XP) which so frequently occurs in Spain. Kingsley Porter dated it from before 1094 (Plate 186).

TWELFTH-CENTURY DEVELOPMENT

In Catalonia the great difference between eleventh-century and twelfth-century architecture lay in the fact that the rough wall surfaces, produced by the Lombard technique of building, gave way to the smooth, well trimmed walls of dressed stone (ashlar), both inside and out. Sta Maria in Vilabertrán (Plate 180) may serve as an example. Links with northern Italy continued to exist. This is typified in the cathedral of Seo de Urgell. Its construction began in 1131, and in 1175, when it approached completion, the Chapter commissioned a certain Raimundus and four other 'Lombards' to finish the roofs, the cupola and the towers. Not surprisingly, we find in this church a Lombard dwarf gallery surrounding the choir (Plate 182).

Apart from the effect of France on sculpture, there are also links with that country as regards groundplans, particularly in the typically French use of ambulatories. Three churches may be mentioned: S. Pedro de Roda, S. Pedro de Basalú and S. Juan de las Abadesas (Plate 181).

One of the most ornamental specimens of Spanish monumental sculpture is the doorway of Ripoll, dating from the third quarter of the twelfth century (Plate 185). The doorway is set in a wide façade entirely covered with seven consecutive sculptured friezes, reminiscent of northern Italian doorways, such as that of S. Zeno in Verona (Plate 26). The impression is strengthened by the lions on either side of the door. They do not, however, support pillars, as tends to be the case in Italy. The majority of the themes of the friezes are based on the Old Testament, with the exception of the upper band, which represents Heaven. The same motifs are found in Catalan bibles of the period, such as that of Farfa.

In Catalonia also, cloisters form a separate and fascinating chapter in the history of architecture. In Ripoll only the southern wing is Romanesque; as in Llusá and Queralbs, close affinity with Elne (Roussillon) is discernible here. A second group is formed by the cloisters of Gerona Cathedral (Plate 179), and of the Benedictine monastery of S. Pedro de Galligáns in the same city. In the former, the capitals of the pillars and those of the adjoining corner and centre piers appear to form a continuous historied frieze. Something similar is found in S. Cugat del Vallés, where the sculptor Arnaldo Catell worked towards the end of the twelfth century.

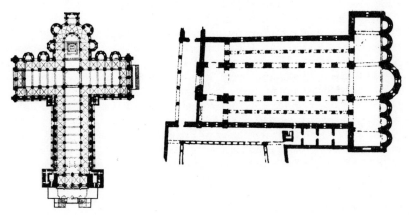

Groundplans of (*l.*) the cathedral of Santiago de Compostela and (*r.*) the abbey church of Ripoll.

In Aragon, further away from the main routes, and consequently less accessible to foreign influence, sculpture was mainly produced by local artists. They interpreted, with greater or lesser success, themes which they had seen in the great cathedrals. The Christ monogram in the doorway of Jaca Cathedral (Plate 186), for instance, occurs at least fifty times in the provinces of Huesca and Navarra. Later, when relations, including those of the Church, with adjoining French districts became increasingly close, the influence of French art had more opportunity to assert itself.

Navarre and the Basque provinces, on the other hand, were traversed by the pilgrimage route, with the result that French influence, in particular that of Poitou, was considerable in many ways. But not only that of Poitou. Take the doorway of Sta Maria la Real in Sangüesa (Plate 188). Poitevin influence is evident in the blind arches surrounding the statues in the zone over the doorway proper. But the tympanum is reminiscent of Burgundy; the statues against the flanking pillars, of Chartres; and the grotesque animal motifs, interlace, and distorted human figures in the spandrels, of northern Italy. The doorway is the work of at least three different sculptors. Similarly

mixed influence is noticeable on the façade of S. Domingo at Soria (Plate 191), of which the sculpture is reminiscent of Poitou, shape and lay-out of Italy. The same applies to the doorway of San Miguel at Estella, where possible connections with Ripoll are also discernible (Plate 190).

It is understandable that Spanish art in general, and its Islamic element in particular, was in its turn to influence that of France (see p. 79), the more so as in the regions adjoining France, and especially in Soria, the impact of Moorish and Mozarabic art was considerable. This is very obvious in the cloisters on S. Juan de Duero (Plate 194). Another fine example is the *Puerta del Obispo* of the cathedral of Zamora (Plate 196).

Castile also profited from the pilgrimage routes, particularly in the north. Moreover, the country prospered under the vigorous rule of Alphonso VI (1072–1109). In that period, the late eleventh century, the construction began of the Romanesque cathedral of Burgos, which no longer exists, and of the famous monastic complex of Silos. S. Domingo, Abbot of Silos, died in 1073, and his tomb, originally in the monastery and later in the church, became the object of numerous pilgrimages. Only fragments survive of the late twelfth-century church; but the famous cloisters are intact. These may justifiably be regarded as the climax of Romanesque sculpture in Spain, the more so as they give an excellent idea of the development in style from the start to the completion of their construction, a development extending over a large part of the twelfth century (Plate 193).

CLOSING PERIOD OF THE ROMANESQUE

As in Italy, so in Spain, Romanesque art survived for a long time, even when here and elsewhere the Gothic style was already gaining ground. It was the Cistercians in particular, enjoying as they did the special protection of the Spanish kings, who brought the latter style across the Pyrenees. Gothic elements are noticeable, for instance, in the west doorway, dating from 1188, of the cathedral at Compostela: the *Puerta de la Gloria* (Plate 199), by Master Mateo. His work shows that he was familiar with Burgundy, Aquitaine, Chartres, and even St-Denis, which might indicate that he was a

Numerous examples of Lombard influence are to be found in southern Germany and Austria, for instance in the choirs of (**159**) Königslütter and (**161**) Schöngrabern, and in (**160**) the Schöttenthor in Regensburg. **162.** The choir of Speyer Cathedral had the first 'dwarf gallery' in the German countries. **163.** It was copied amongst other places in Mainz. **164, 165.** The eastern choirs of the cathedrals of Worms and Bamberg are examples of the final phase of the Romanesque style. **166.** Cologne also was strongly influenced by Lombardy via Speyer. The coffered frieze under the 'dwarf gallery', as shown here on the trefoil-shaped eastwork of The Holy Apostles, is characteristic of Cologne. **167.** The Galluspforte of Basle Minster is French in shape and construction, but northern Italian influence is clearly apparent in the theme and the execution of the sculptural ornamentation.

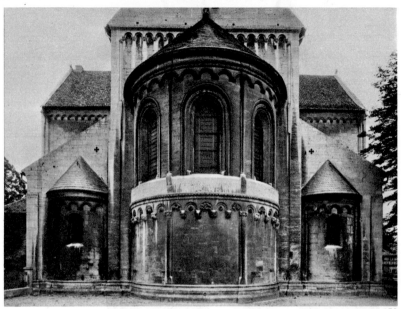

159

160

161

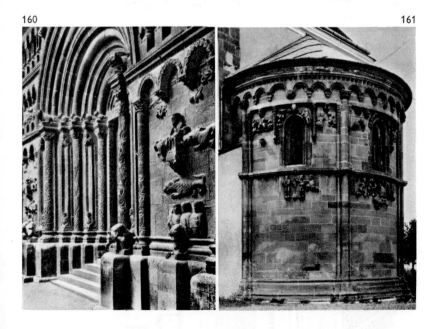

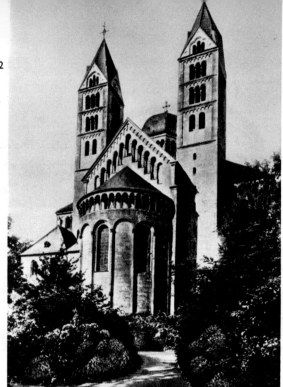

162

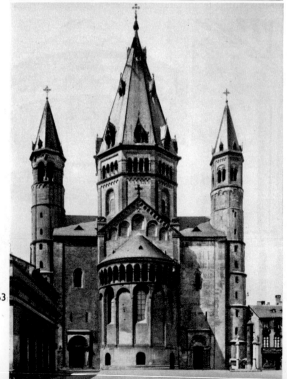

163

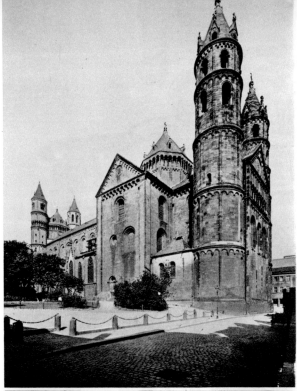

164

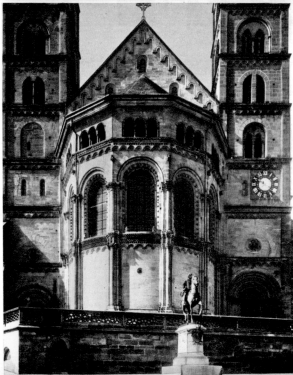

165

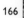

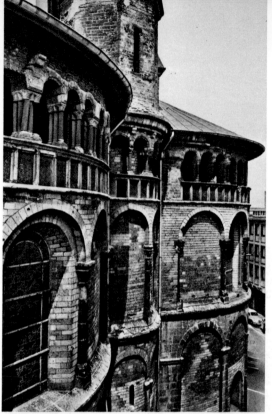

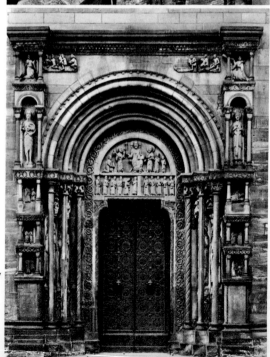

170

171

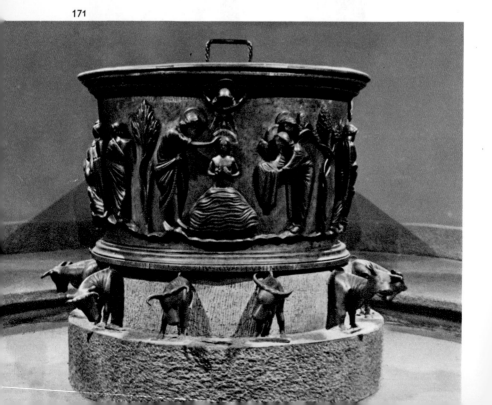

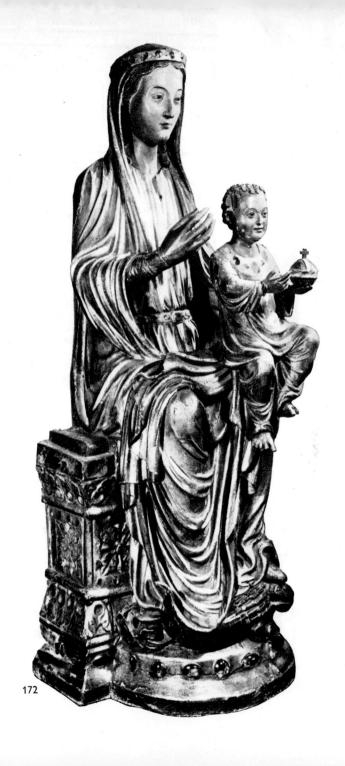

172

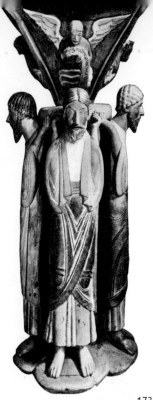

173

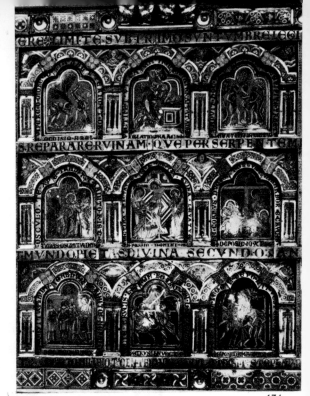

174

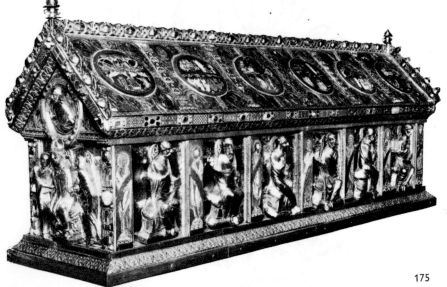

175

Frenchman, although this is by no means certain. Whatever his nationality, his work is one of the culminating points of Romanesque sculpture as such.

At the time when the first Gothic elements, including rib vaulting, entered the Iberian peninsula from France, through the influence of the Cistercians and along the pilgrimage routes, another feature gained ground. After the battle of Las Navas de Tolosa in 1212, a large part of the territories inhabited by Moslems came under the rule of Christian kings. The indigenous sections of the population, the so-called Mudéjars, remained, or even moved to originally Christian regions, with the result that Spanish art received yet another injection of Islamic influence. This manifested itself in a group of brick-built churches in and around Sahagún. Elsewhere also, late Romanesque art is hardly imaginable without Mudéjar influence. The cloisters of S. Juan de Duero at Soria (Plate 194), already mentioned, provide a convincing example. In the conquered cities, churches and cathedrals were built. Tarragona, which was sacked and occupied by Christians in 1096, was rebuilt in the twelfth century. Its cathedral was designed in the Romanesque, but completed in the Gothic style. A similar development can be traced in the adjoining cloisters (Plate 184). The *Majestas Domini* over the doorway leading from the cloister to the church, presents a Romanesque theme in Gothic form (Plate 187). The construction of the cathedral of Lérida commenced in 1203 and was completed in 1278; here too, a similar development took place, though here the sculptural decoration is entirely Late Romanesque. The predominantly abstract decor of the fine doorway of Sta Maria in Agramunt (Plate 189) shows Mudéjar influence. It dates from as late as 1283, and is akin to the doorway of the *Fillols* in Lérida. That of San Vicente in Avila is reminiscent of Burgundian examples as to its sculptural style, and of churches in the French Pyrenees where the subdivision of its tympanum is concerned.

PORTUGAL

The majority of the Romanesque churches in Portugal have either been entirely reconstructed, or have been decorated to such an extent in the style

168. In Westphalia the westworks attain the aspects of sturdy western towers, flanked by two staircase towers, for instance at Freckenhorst. **169.** In Alsace, Lombard, Burgundian and Rhineland elements combine, cf. the westwork at Marmoutier. **170.** The tympanum at Liège is unusual because of its allegoric secular theme: the *Mysticum Apollinis*. **171.** The magnificent bronze font by Rainier of Huy in Liège dates from *c.* 1115. **172.** The shape and ornamentation of the large *Sedes Sapientiae* in St-Jean, Liège, appears to have been influenced by goldsmith's art. **173.** Figures of the apostles support the wooden lectern, originally in Alpirsbach, now in Freudenstadt. **174.** Nicolas of Verdun was foremost among the Mosan school of goldsmiths, which was also responsible for (**175**) numerous reliquaries.

of later periods that they retain little of their original character. Others, in Lisbon for instance, suffered as a result of earthquakes. Lisbon Cathedral was founded in 1147. The larger part of the Romanesque nave, as well as the two western towers and the doorway between, survive. Coimbra Cathedral is better preserved; its construction began in 1162 and was influenced by Compostela. The same applies to the cathedral of Evora, begun in 1186, consecrated in 1204, but not completed until much later. It was also influenced by early French Gothic. The Templars' church at Tomar is an octagonal central structure, with a likewise octagonal core which originally rose high above the rest of the building. It is closely akin to the church of Vera-Cruz in Segovia in Spain.

MURAL PAINTING

Catalonia is particularly rich in Romanesque wall paintings, though the majority are no longer *in situ* but have been transferred to the museums of Barcelona and other towns. Some of the Catalan masters also worked in Castile. In general it is difficult to date these paintings, although we possess a clue in the two churches of Tahull: S. Clemente and Sta Maria (Plate 204 and p. 135), which must have been built around 1123. Two different artists worked here. The more gifted was the painter of San Clemente, who, especially in his Christ in Majesty in the apse, created a work of impressive and spiritual quality, with a wealth of decorative detail. In the paintings in Sta Maria, the delineation is pure, tranquil and monumental, but the artist's decorative skill is inferior. Apart from these two masters, the work of numerous others survives, but they either stagnated in the local traditions or in a naïve impotence. Often the influence of contemporary manuscripts is discernible; at times there is a connection with examples from beyond the Pyrenees or from Italy. The former is evident in the paintings originally in S. Pedro in Seo de Urgel. At Sigena (1185) even an English hand has been recognized. Other paintings such as those from Pedrét, were subject to the influence of Byzantine movements similar to those in Italy. Outside Catalonia, Byzantine influence predominated, although the paintings in the Pantheon of the Kings of San Isidoro in León remind us rather of western France (Plate 202).

PANEL PAINTING AND WOOD CARVING

Paintings on wood of this period are to be found chiefly on and near the altars, where the antependia and baldachinos were decorated by the same masters who were responsible for the wall paintings. At times they repeated themes already elaborated in the apses; at others they narrated the legends of saints in a popular idiom. Around 1200 a new Byzantinizing movement began, distinguishable amongst other things by a facial type: a slightly curved nose, and large, melancholy eyes (Plate 204).

Romanesque wood carving also is better represented in Catalonia than elsewhere in Spain. The most frequently occurring themes are: Christ on the Cross, the Deposition, and the Virgin Enthroned with the Child on her lap, the so-called *Sedes Sapientiae*. Figures of saints also occur. A most impressive crucifix is the so-called *Majestad Batlló* in the Museo de Arte de Cataluña in Barcelona. The representations of the Deposition from the Cross, in Tahull, S. Juan de las Abadesas and elsewhere, are reminiscent of similar works in Tuscany. A very early example of a *Sedes Sapientiae*, dating from the first half of the twelfth century, came from Tahull and is now in the Fogg Art Museum. Nevertheless, the churches of Catalonia, both great and small, still contain a wealth of fine Romanesque wood carvings, for not all have gone to museums (Plate 204). Their fascination is due partly to their colourful polychromy, which blends with the paintings on altars and church walls.

7. THE BRITISH ISLES

ROMANESQUE ARCHITECTURE IN ENGLAND

The exceptional importance of Anglo-Norman architecture in the Romanesque period was not realized until fairly recently. It is, however, now recognized that the Gothic style which developed in Ile-de-France in the middle of the twelfth century owed much to the earlier achievements of the Anglo-Norman School—especially in respect of ribbed vaulting.

Beginnings of Romanesque architecture in England go back to the reign of King Edward the Confessor (1042–65). There is no evidence to suggest that the monastic reform movement which began in England in the second half of the tenth century, had any important architectural consequence—unlike its counterpart on the Continent. However, King Edward was responsible for introducing into England a number of reformed Norman and Lotheringian clergy who were familiar with Romanesque developments on the Continent, and his own Abbey at Westminster is known to have been modelled on Jumièges in Normandy. Although this is only known from descriptions it is generally recognized to be the first Romanesque monument in the country.

Whether or not England would have developed its own Romanesque style if the Norman Conquest of 1066 had not taken place, there is no doubt that the whole process was speeded up as a result of that event. Canterbury Cathedral was rebuilt after the fire in 1067; Lincoln was begun after the removal of the Bishopric to that city in 1073; Old Sarum followed in 1075; Winchester in 1079; Worcester in 1084; Durham in 1093; and Norwich in 1096. In addition to these cathedrals many of the great abbeys were also rebuilt at this time: St Albans (1077), Gloucester (1089) and Peterborough (1117).

The style of these buildings was largely determined by the current architectural practice of the Duchy of Normandy, although it would seem clear that such features as wall passages and cushioned capitals came to England from the Low Countries. Norman churches in England tended to be consistently larger than their Norman counterparts, and especially in the matter of length. In this respect they not only exceeded all other Romanesque churches in Europe, but have seldom been surpassed in the history of church building. Apart from their overall size, nearly everything of importance in Anglo-Norman churches stems from the fact that they used very thick walls. This technique arose from the practice of facing relatively thin rubbled walls of pre-Romanesque architecture with skins of ashlar. The result was gigantic piers which required immensely complicated articulation to make them visually interesting; and the main preoccupation of Anglo-Norman architects was to produce satisfactory decorative effects by the use of applied shafts, roll-mouldings, etc. Later, c. 1100, a wave of abstract patterns reached England, and these were applied to the hitherto bare surfaces of masonry to enhance their decorative complexity. It is possible to trace the development of Anglo-Norman ideas about church decoration through a series of buildings from St Albans which was excessively severe, through Winchester and Ely, to reach a climax at Durham.

Durham occupies a place apart in the history of Anglo-Norman architecture insofar as the famous ribbed vaults over its nave (1128–33) have survived. It is known that the vaults over the choir were planned from the outset, although these had to be replaced in the thirteenth century. On the other hand, the nave vaults which have survived are now known to have been an afterthought. As a result of this recent reappraisal of Durham, its historical importance is perhaps not as great as was at one time thought. Nevertheless, the success with which the Anglo-Norman formulas were adapted to the special needs of a vaulted church makes it aesthetically the most satisfying building of its time.

There were few buildings constructed in England during the twelfth century which were able to follow the example of Durham, and its influence

178. S. Jaime de Frontanyá is a typical example of the *premier art roman* imported from northern Italy. **176.** The same applies to the church of Tarassa. **177.** The campaniles at Tahull are identical with their predecessors in northern Italy. **179.** The capitals in the cloisters of Gerona Cathedral appear to form part of the sculpted friezes. **180.** In contrast to the *premier art roman*, Sta Maria in Vilabertrán is constructed in dressed-stone masonry. **181.** In S. Juan de las Abadesas the French theme of ambulatories with radiating chapels is used. **182.** The cathedral of Seo de Urgell has a Lombard 'dwarf gallery'. **183.** The reconstructed abbey church of Ripoll has a very wide transept and seven apses. **184.** The cloisters at Tarragona are Romanesque in design, like the cathedral itself; they were subsequently completed in the Gothic style.

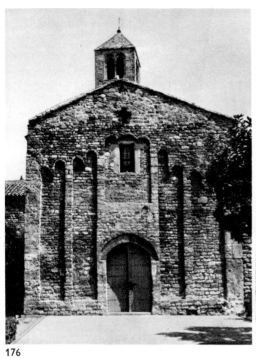

176

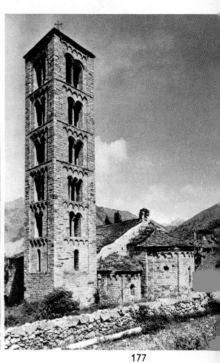

177

178

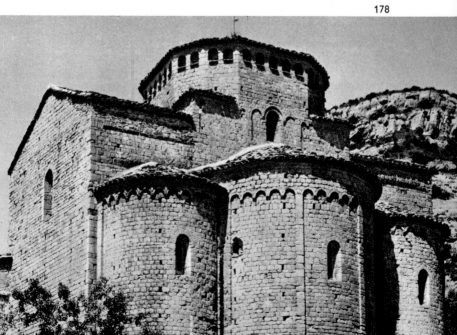

179

181

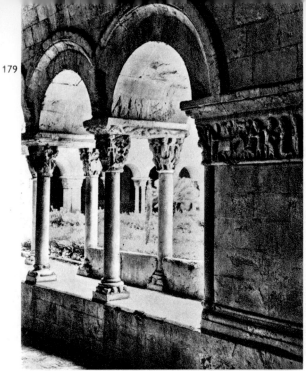

180

182

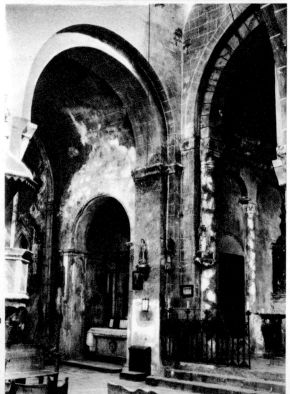

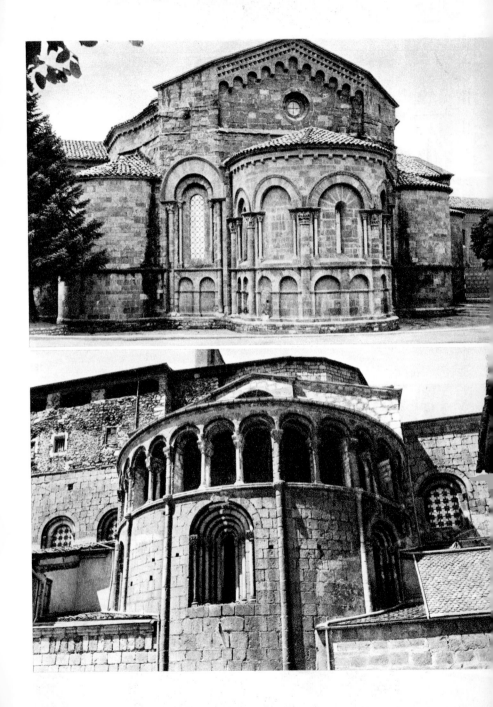

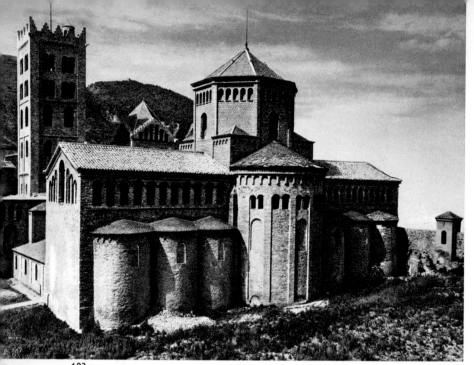

183

185

184

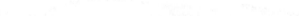

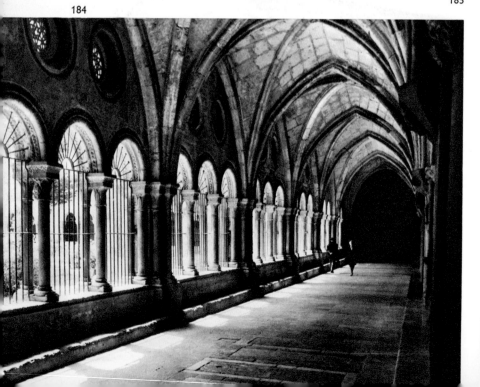

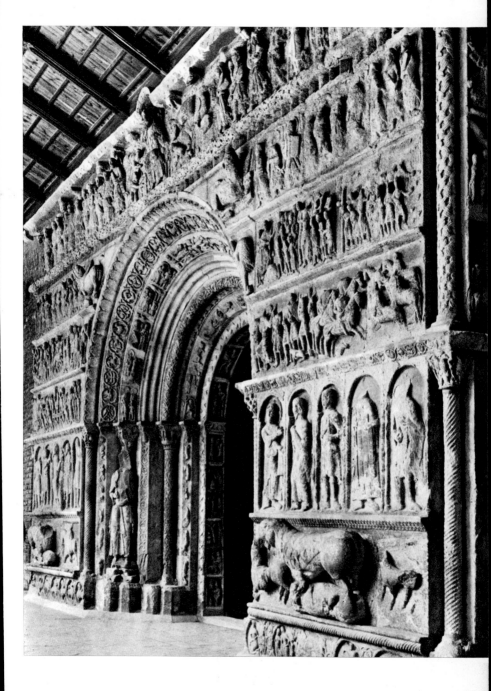

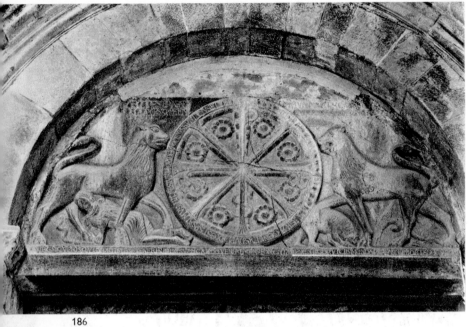

186

188

187

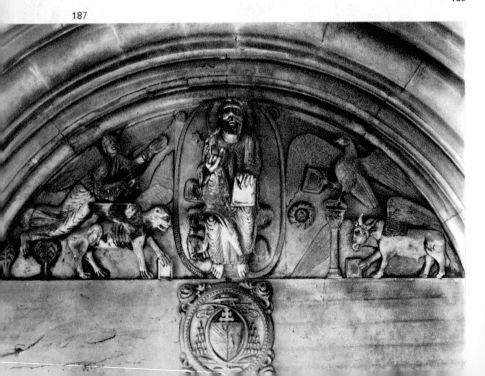

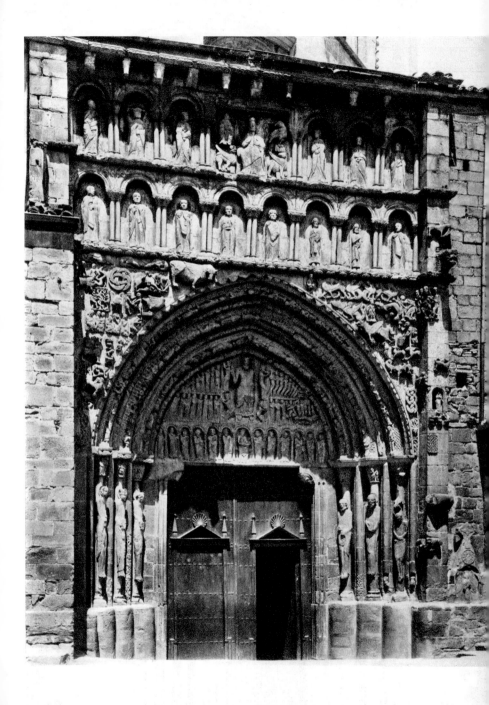

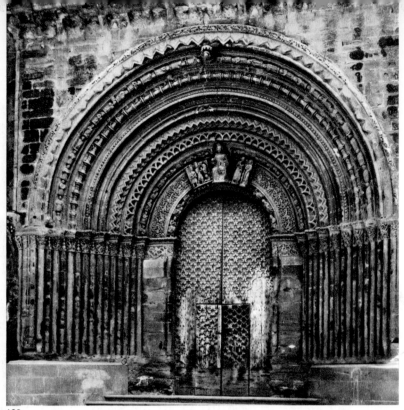

189

190

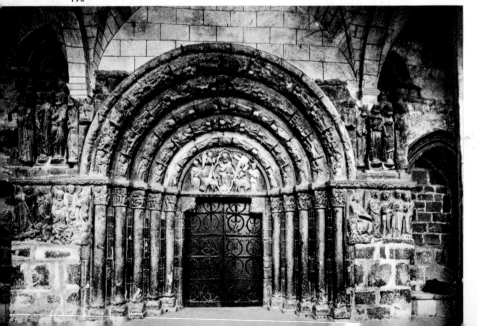

was largely confined to the spread of architectural ornament. Thus the chevron is thought to have made its appearance at Durham *c.* 1110; while the incised patterns on its great cylindrical piers were copied all over the country until well into the second half of the twelfth century.

The building which set the aesthetic standards for twelfth-century English architecture was the new choir of Canterbury Cathedral, rebuilt from *c.* 1100 onwards. This was partially destroyed in the fire of 1174, but it is known from descriptions to have been intensively coloured, and the crypt with its set of finely carved capitals survives as testimony of its rich decoration.

One other group of English Romanesque buildings call for comment: namely the so-called West Country group which includes Gloucester and Tewkesbury. These churches are distinguished by the use of tall cylindrical piers instead of compound piers—a feature which connects them with Tournus in Burgundy; or Sant' Abbondio at Como in northern Italy. A development of these cylindrical piers was the giant order articulation found in two nave bays of Romsey Abbey (*c.* 1135) and in a more sophisticated form in the cathedral of Oxford (*c.* 1160).

Apart from internal elevations, Norman architecture in England gradually developed a series of insular peculiarities which distinguished it from Norman architecture on the Continent. The two aspects of church design in which this showed most prominently was in the predilection for square east ends in place of the apsidal or curved ambulatory types favoured elsewhere. It may be surmised that this had something to do with the English passion for orientation. Even when radiating chapels occur, for instance at Norwich or Canterbury, attempts have been made to place their altars as nearly towards the east as possible, with the result that the chapels no longer converge radially on the centre of the apse. In some of the larger churches such as Romsey where the ambulatory was retained, this became rectangular in plan and the chapels instead of opening at regular intervals, were grouped together into three parallel chapels opening eastward. This eventually led to the formation of extensive retrochoirs of a kind occasionally found across the Channel, e.g. at St-Bavon, Ghent (*c.* 1150).

185. The ornate doorway at Ripoll shows the influence of northern Italy (Verona); it dates from the third quarter of the twelfth century. **186.** The tympanum of Jaca Cathedral, probably dating from before 1094, contains the Christ monogram which frequently occurs in Spain. Apart from this, the animal figures and the numerous texts give evidence of northern Italian influence. **187.** The high relief of the Christ in Majesty in Tarragona marks the approach of Gothicism. **188.** In the doorway of Sta Maria la Real in Sangüesa influences from Poitou, Burgundy, Chartres and northern Italy may be found side by side. **189.** The abstract decoration of the doorway of Agramunt shows Mudéjar influence. **190.** At Estella we note the same combination of influences as at Sangüesa; in this case that of Ripoll might be added.

The other main English idiosyncracy was in the design of façades. The straightforward Norman two-towered west front was known in England, e.g. at Canterbury and Durham; but from an early date a taste for extensive western blocks akin to westworks can be observed. The remarkable eleventh-century façade of Lincoln was one of these, distinguished by the use of tall semi-circular niches on its three exposed sides. Elsewhere, e.g. at Bury St Edmunds, a similar western block was subsequently transformed into a veritable screen façade. At the same time a great single western tower occasionally took the place of the two smaller ones. None of these have survived, however, presumably because their foundations were inadequate. Of the great central towers over crossings of Anglo-Norman churches, however, three examples survive: St Albans, Tewkesbury and Norwich. Akin to these are the great transept towers of Exeter.

Perhaps because of the great decorative richness of English Romanesque architecture the early buildings of the Cistercians in England stand out in stark opposition. For this reason they have sometimes been regarded as forerunners of Gothic. It would, however, be better to regard such buildings as Fountains (c. 1135) or Kirkstall (c. 1150) as manifestations of a conservative reaction, toward a simpler style, rather than as anticipations of something new.

ROMANESQUE SCULPTURE IN ENGLAND

The history of Romanesque sculpture in England is closely connected with the development of church decoration. While it is true that Anglo-Saxons had a flourishing tradition of carving in stone this was seldom applied to buildings in the systematic and logical way that is characteristic of true Romanesque. This meant that there was a repertory of indigenous forms always liable to recur in a Romanesque context; and in the case of many small twelfth-century churches there is abundant evidence of the recrudescence of Anglo-Saxon taste in Anglo-Norman forms.

As elsewhere in northern Europe, when patterns or subject matter were needed for the use of sculptors, these were mostly found among the illuminations of easily accessible manuscripts. Thus it is evident that many of the carved capitals in the crypt of Canterbury Cathedral (early twelfth century) were based on drawings from the adjacent monastic library. The group of sculptors trained at Canterbury seem to have spread across much of southern England. Thus similar work occurs at Romsey and Christchurch in Hampshire.

Later in the century, however, there is considerable evidence that motifs were imported from abroad. A West Country school of Romanesque sculpture has been identified largely on the basis of themes brought from western France and the pilgrimage routes to Santiago.

On the whole, however, English Romanesque sculptors do not seem to have been encouraged to produce the elaborately carved doorways that

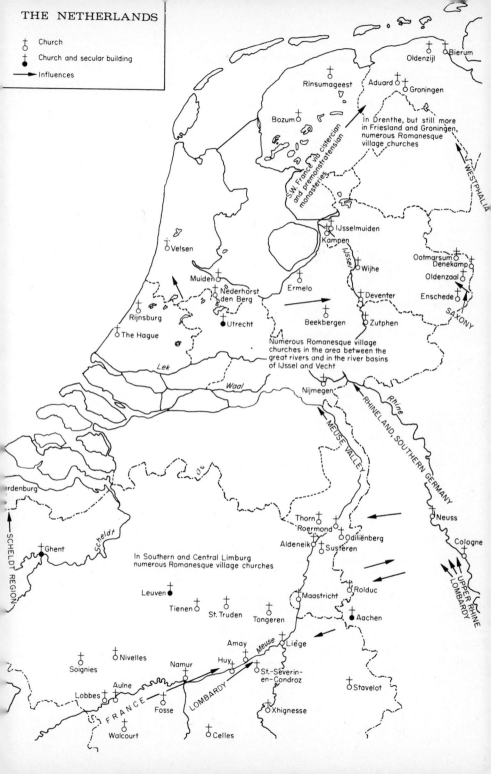

THE NETHERLANDS

- ✝ Church
- ⊙ Church and secular building
- → Influences

Bierum ⊙
Oldenzijl ✝
Rinsumageest ✝
Aduard ⊙ ✝ Groningen ⊙
Bozum ✝

In Drenthe, but still more in Friesland and Groningen, numerous Romanesque village churches

S.W. France via cistercian and premonstratensian monasteries

WESTPHALIA

Velsen ⊙

IJsselmuiden ✝
Kampen ✝
Ootmarsum ✝
Denekamp ✝
Oldenzaal ⊙
Enschede ✝

Muiden ⊙
Nederhorst den Berg ✝
Ermelo ✝
Wijhe ✝
Deventer ⊙
Zutphen ⊙

SAXONY

Rijnsburg ✝
Utrecht ●
Beekbergen ✝

The Hague ✝

Lek

Numerous Romanesque village churches in the area between the great rivers and in the river basins of IJssel and Vecht

Waal

Nijmegen ✝

RHINELAND, SOUTHERN GERMANY

Rhine

MEUSE VALLEY

Neuss ⊙

SCHELDT REGION

rdenburg

Scheldt

Thorn ✝
Roermond ✝
Aldeneik ✝ Odiliënberg ✝
Susteren ✝

Cologne ⊙

Ghent ●

In Southern and Central Limburg numerous Romanesque village churches

Leuven ●
Tienen ✝
St. Truden ✝
Tongeren ✝
Maastricht ⊙
Rolduc ✝
Aachen ●

UPPER RHINE LOMBARDY

Nivelles ⊙
Soignies ✝
Namur ✝
Amay ✝
Huy ✝
Liège ✝
St.-Severin-en-Condroz ✝
Stavelot ✝

Aulne ✝
Lobbes ⊙
Fosse ✝
FRANCE
LOMBARDY
Meuse
Xhignesse ✝

Walcourt ⊙
Celles ⊙

abound in France. There are examples of such doorways, e.g., at Ely and Malmesbury; but in both cases the details are saturated with insular details. Perhaps the most definite connections with the Continent occur in the Romanesque carvings at Lincoln (*c.* 1145). It is known that Lincoln had a pair of column figures in its central doorway, and some of the detail resembles work at St-Denis. However, the frieze in relief which extended across the whole of the west front above the doorways perhaps owed more to Italy than to France. In fact it is becoming increasingly evident that much of the twelfth-century sculpture in England was ultimately derived from Italy, although how these influences reached England is not yet fully understood. It may very well have had something to do with the Low Countries and the Mosan area, with which England was in close touch throughout the Romanesque period. This connection is perhaps more evident in the sphere of metalwork and illuminated manuscripts than in sculpture or architecture.

During the twelfth century English painting reached great heights of achievement largely in the form of a series of sumptuous decorated psalters and bibles. Outstanding landmarks are: the St Alban Psalter (now at Hildesheim in Germany) dating from *c.* 1123; the Bury Bible at Cambridge; the Lambeth Bible in London; and the Winchester Bible in the Cathedral Library in Winchester.

ROMANESQUE ARCHITECTURE IN SCOTLAND

From the few examples of Romanesque architecture which have survived in Scotland one may conclude that a most interesting fusion of native and foreign traditions took place here. Malcolm Canmore's marriage to an English princess and the immigration of refugees after the Norman invasion for the first time introduced the influence of English Romanesque art. Thus the church of Dunfermline was clearly influenced by Durham Cathedral, and the choir of Jedburgh is derived from Romsey. Perhaps the most interesting example, however, is Kelso Abbey, which has a double transept and a groundplan highly reminiscent of the Rhineland and Mosan churches

191. The façade of S. Domingo in Soria is reminiscent of Poitou as regards its sculpture, and of Italy as to its shape and lay-out. **192.** The doorway of Tudela, which is close to Gothicism in style, gives clear evidence of French influence. **193.** The development in style in the course of most of the twelfth century may be followed in the cloisters of Silos; they are among the masterpieces of Romanesque sculpture in Spain. **194.** The Moorish influence of the Mudéjars is evident in the cloisters of S. Juan de Duero in Soria. **195.** S. Lorenzo in Sahagún is one of the brick churches built by the Mudéjars. **196.** The abstract ornamentation of the Puerta del Obispo of the cathedral of Zamora shows Islamic influence; the recurrent decoration of the archivolts is especially typical. **197.** The Old Cathedral of Salamanca is close to south-western France in style, particularly as regards its crossing tower.

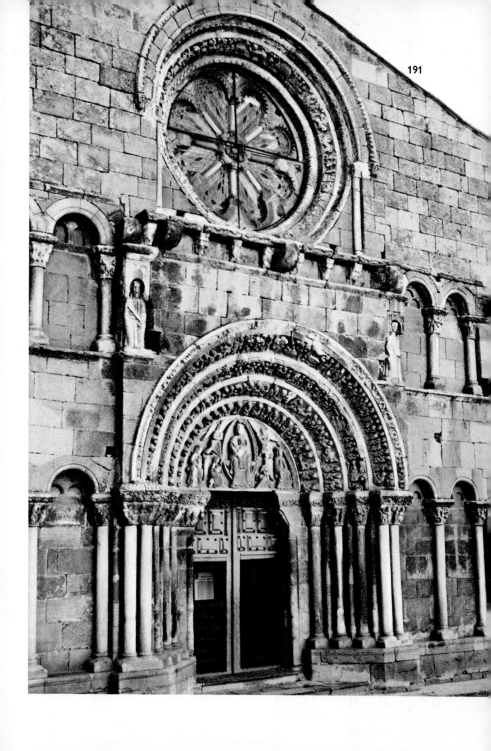

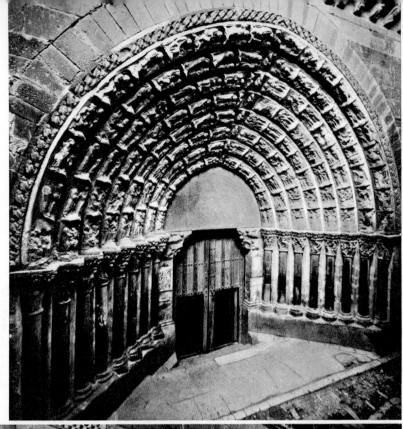

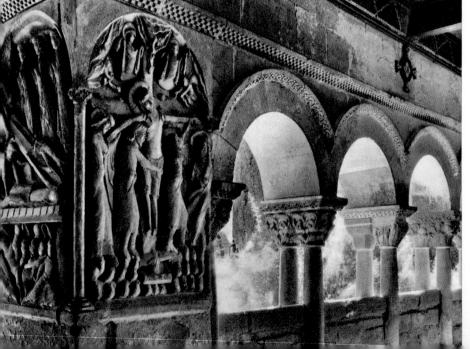

192 194

193 195

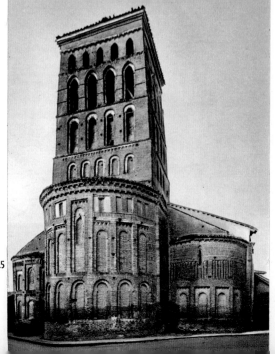

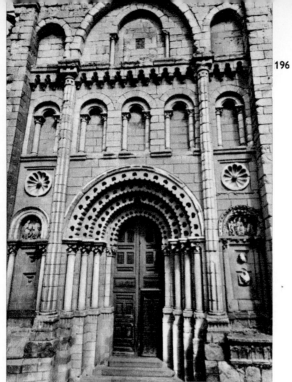

196

198

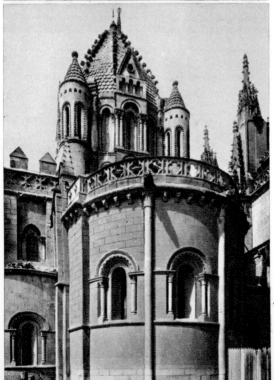

197

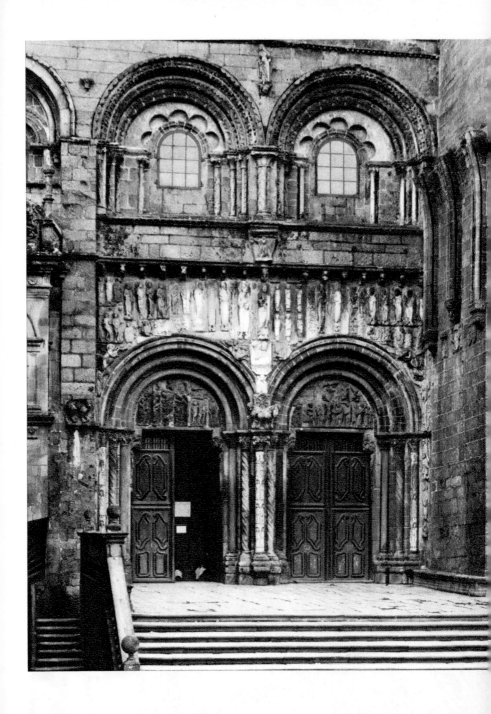

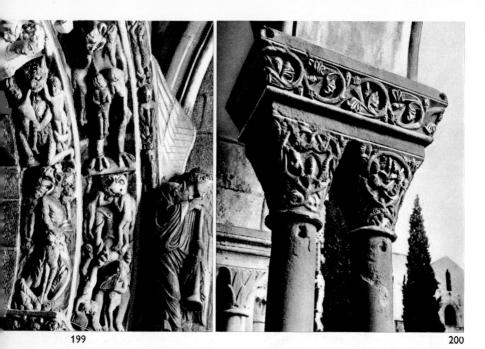

199

200

201

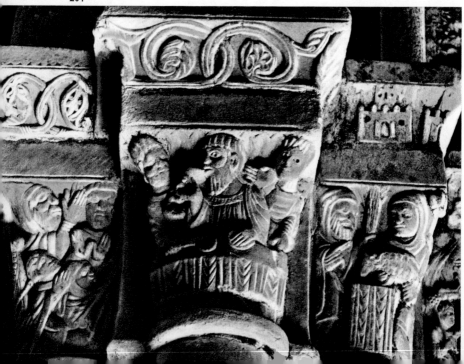

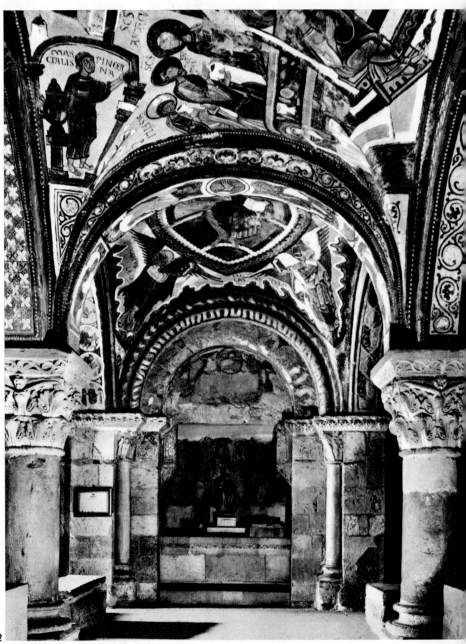

202

203

204

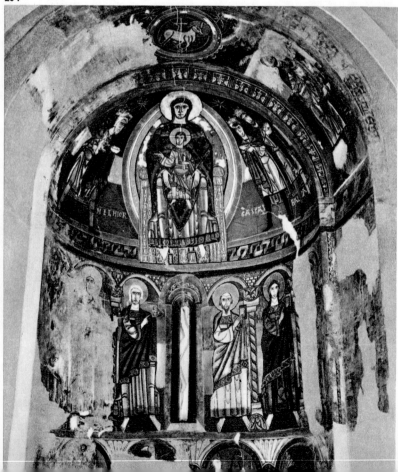

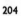

with their eastern and western choirs. It is difficult to say whether these Carolingian and Ottonian designs reached Scotland directly from the continent, or via England.

ROMANESQUE ARCHITECTURE IN IRELAND

An independent Irish Romanesque style existed only between the beginning of the twelfth century and the English conquest of 1171. In general, churches are built on the plan of a simple hall, and only the restrained decoration assigns them to the twelfth century. An exception is Cormac's Chapel at Cashel, founded in 1134 by the prince-bishop Cormac McCarthy, King of Desmond. The two towers flanking the choir indicate Rhineland or Mosan influence, but it is equally possible that they followed the example of Hereford Cathedral, built in the second decade of the century. Irish and English elements are fused in the church of St Saviour at Glendalough, probably founded by Laurence O'Toole before he became bishop of Dublin in 1162.

The chancel arch of Tuam Cathedral, which has five recessed orders, is particularly rich in ornamentation. Here, as well as in a number of doorways, English motifs, such as chevron moulding, are combined with the native Irish themes of the well-known stone crosses. The erection of such crosses continued in the twelfth century, for instance at Tuam. Christchurch Cathedral in Dublin, built in the English Romanesque style without any native elements, reflects the English conquest, and marks the end of Irish Romanesque proper.

8. THE BORDER COUNTRIES

ROMANESQUE ARCHITECTURE IN SCANDINAVIA

The Scandinavian countries possessed a highly characteristic architecture of their own even before the introduction of the Romanesque. It was a style of building in timber, of which the stave churches which have survived in

198. The Puerta de las Platerias of the cathedral of Santiago de Compostela, in which earlier fragments have been incorporated, is akin to the Porte Miégeville of St-Sernin in Toulouse. **199.** Detail of the Puerta de la Gloria of the same church. **200.** Capitals in the cloisters at Poblet. **201.** The capitals in the cloisters of Tarragona Cathedral give evidence of the Romanesque character of this complex, which was completed in the Gothic style. **202.** The Capilla de los Reyes near San Isidoro in León is famous for its magnificent capitals as well as for its paintings which are related to similar works in France. **203.** The Three Kings; detail of the altar at Mosoll, a Byzantinizing work dating from c. 1200. **204.** The painting in the apse of Santa Maria in Tahull, dating from c. 1123, is tranquil and monumental in delineation and design.

Norway are the last remaining examples (Plate 217). They are connected with the art of the Vikings, which is evident also from the elaborate decoration of interlace carving (Plate 15).

The Romanesque style was introduced into these regions from the countries of north-western Europe, notably Germany and England, although Lombardy also left its mark here.

Denmark in the second half of the eleventh century had a number of bishops who were great builders, notably Vilhelm, bishop of Roskilde (1060–74) and his successor Svend Normand (1074–88). They were responsible for the earliest group of churches, generally known as the Roskilde group. These were simple in design and followed the basilican scheme without transepts, as may be seen in the church of Our Lady in Roskilde. The cathedral of this town was originally similar. Mention must also be made of the churches of Ribe and Viborg (Plate 218), and of the Benedictine abbey church of Ringsted. The latter belongs entirely to the Roskilde group; the other two, and the cathedral of Lund, which is now part of Sweden, contain elements inspired by the Rhineland, with strong Lombard influence. A number of brick churches date from the second half of the twelfth century, most of them, and at the same time the best preserved, in Seeland; for instance the church of Kalundborg and the abbey churches of Ringsted, Sorø and Vitskøl. The island of Bornholm possesses a curious group of small round churches.

ROMANESQUE ARCHITECTURE IN SWEDEN

It was not until the eleventh century that the Anglo-Saxon missionary St Sigfrid and a group of his disciples succeeded in establishing Christianity in Sweden. The earliest remains of stone churches, at Sigtuna on Lake Mälar consequently show English influence. They date from the last decades of the eleventh and the first half of the twelfth century. The same applies to the cathedral of Gamla Uppsala, to which the episcopal see was transferred from Sigtuna around 1135. All these churches are cruciform in shape, with a central tower over the crossing. The abbey church of Vreta (first half of the twelfth century) is of the same shape.

Quite the most interesting building is Lund Cathedral, built by Master Donatus, who was probably Italian. He commenced work in or around 1123. Over a spacious crypt he superimposed a chancel and transept of the Rhineland type, but Lombard in detail. The 'dwarf gallery' surrounding the choir is one of the earliest of its kind. The chancel is built with alternating bays and incorporates the remains of an earlier eleventh-century church. The two western towers presumably were a later addition. The doorways with their column-bearing lions are pure examples of the north Italian style. The church was consecrated in 1145 (Plate 220).

SCANDINAVIA

† ○ Church

Trondheim

Borgund

Bergen

NORWAY

Hamar

Oslo

tavanger

Gamla Uppsala

Sigtuna

SWEDEN

FINLAND

SOVIET UNION

DENMARK

Lund

GERMANY

SWEDEN

Viborg

DENMARK

Kalundborg

Sorø

Ribe

Roskilde

Ringsted

GERMANY

The conversion of Norway began under Olav Trygvasøn (995–1000) and was completed under Olav the Saint (1016–30). Missionaries from the British Isles were involved.

Before about 1100 there was hardly any building in stone. When, in the course of the twelfth century, masonry techniques were introduced into the architecture of these regions, it was natural that the western part of the country should come under Anglo-Norman influence, while churches in the south and east were more akin to those of Denmark and northern Germany. For instance, the original cathedrals of Oslo and Hamar, cruciform basilicas on cylindrical piers, with a central tower and a semi-circular choir, were influenced by the school of Hirsau. The Anglo-Norman type is represented by the cathedral of Stavanger, which is a three-aisled structure without transept and with a western tower (Plate 219). St Mary's church in Bergen is the earliest example with a triforium and compound piers.

The Romanesque reconstruction of the cathedral of Trondheim (Nidaros) began in 1152, when the city became the archiepiscopal see. At that time a transept was added to the nave which Olav Kyrre had erected between 1066 and 1093 over the tomb of St Olav. The church was subsequently rebuilt in the Gothic style.

ROMANESQUE ARCHITECTURE IN DALMATIA

In actual fact, Dalmatia may hardly be counted among the border countries, since, as far as its architecture was concerned, it was totally dependent on Italy. Even in pre-Romanesque times there were links with northern Italy, and especially Ravenna (which is easily explained by its geography). The Eufrasian basilica at Parenzo (Poreč) and the ruins of antique Pola demonstrate the point. S. Donato in Zadar, which dates from the ninth century, has the pilaster strips and blind arches found at Ravenna, while its cruciform lights belong to the earliest Romanesque of northern Italy (Plate 224). Further south a good example is provided by St John's on the island of

205. Norwich Cathedral gives evidence of French influence in its choir with ambulatory. **206.** At Ely the eastwork terminates in three rectangular apses. **207.** Durham Cathedral is the first church outside Lombardy which was entirely stone vaulted (1128–1133). The rib vaulting is interrupted after every second bay by a transverse arch. **208.** In Rochester Cathedral there are tribunes over the aisles. **209.** Western transept of Ely Cathedral. **210.** Durham has a twin-towered façade. **211.** At Southwell the tribunes open on to the nave by wide arches. **212.** Lincoln Cathedral, reconstructed in the Gothic style, contains three Romanesque doorways. **213.** The chevron motif is used in St Mary's, Iffley, and particularly in **(214)** the Galilee at Durham. **215.** The doorway at Malmesbury was influenced by Burgundy. **216.** The reliefs at Lincoln, on the other hand, were influenced by the Ile-de-France.

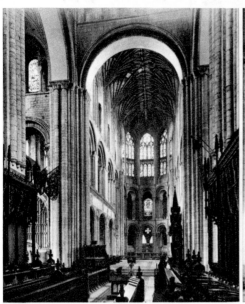

205

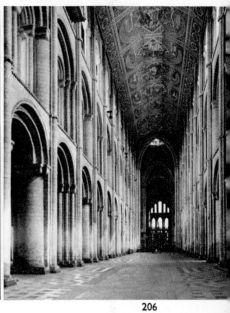

206

207

208

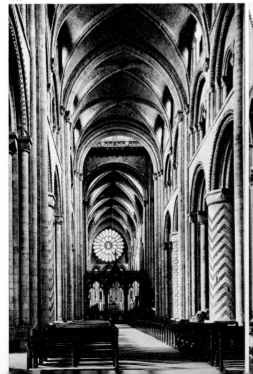

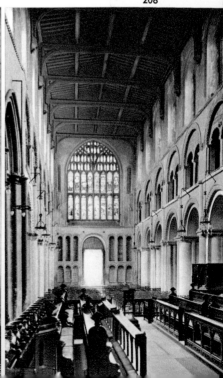

213

214

215

216

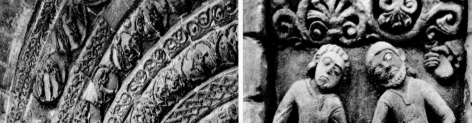

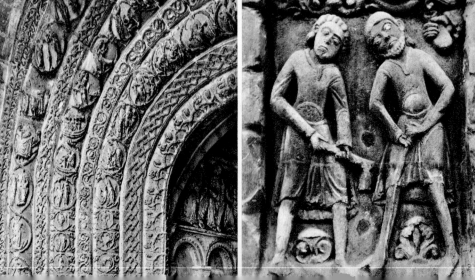

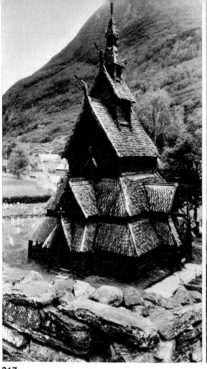

217

218

219

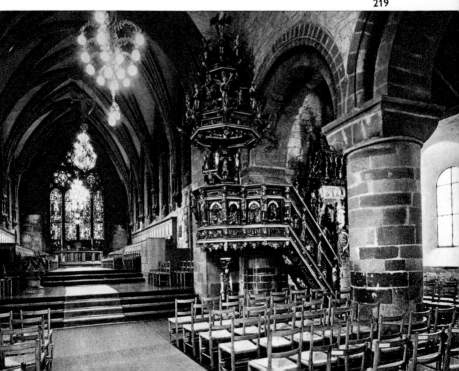

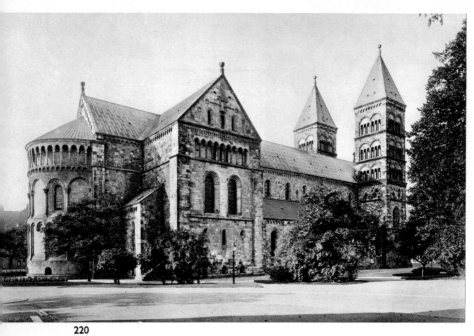

220

221 222

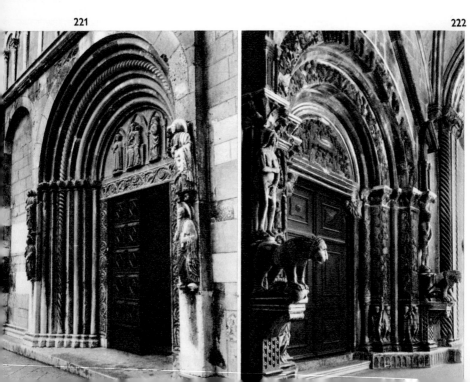

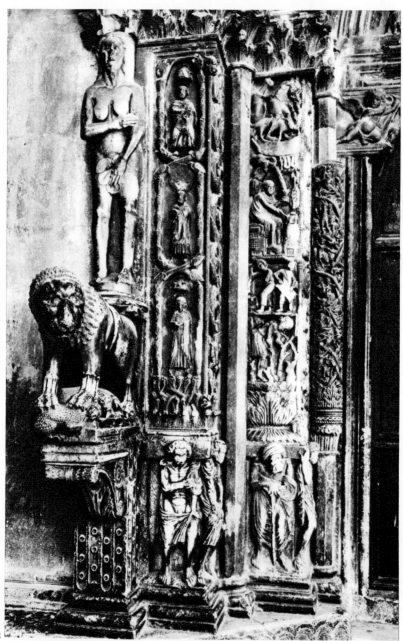

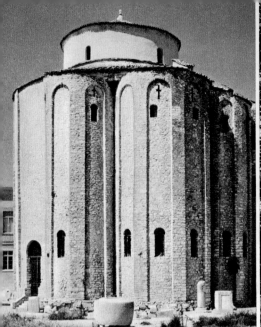

224

225

226

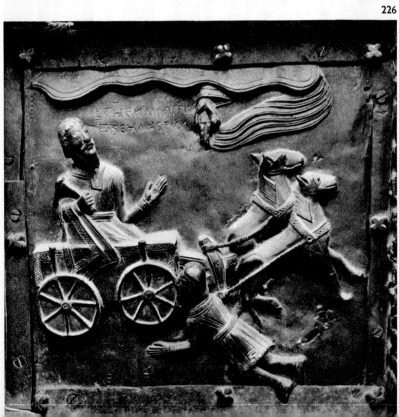

Lopud near Dubrovnik. One notes a certain preference for round and centrally planned structures, and there is frequent use of the 'Longobard' stone interlace ornament.

The influence of northern Italy continued throughout the Romanesque period. It was, however, complemented, and indeed surpassed, by that of Apulia. Even when, as in the case of Zadar Cathedral, elements have clearly been borrowed from the Pisan style, one may wonder whether this was direct borrowing—which, in view of the fact that both Pisa and Zadar were seafaring cities, is not impossible—or whether the Apulian-Pisan churches (such as Troia) acted as intermediaries. The cathedral churches of Korcula (Curzola) and Trogir (Trau) are good examples of Apulian influence. The latter is famous for its doorway, carved in 1240 by Radovan (Plates 222–223). Apart from the capitals, which make an already somewhat French-Gothic impression, this doorway is purely Apulian. Its minor details may, however, have been inspired by the doorways of S. Marco, particularly as regards the representations of the months on the jambs. The tympanum represents the Nativity, while the archivolts are decorated with biblical themes. The doorway is flanked by the figures of Adam and Eve and by lions, which, unlike their northern Italian counterparts, have nothing to support; they are in fact typically Apulian, intended solely for ornament. Similar lions flank the doorway of the cathedral of Korcula, the birthplace of Marco Polo. It faces a very small square, so that it cannot be viewed from a distance. One has the impression that this fact induced the architect to exploit to the full the contrast between fine, smooth masonry and the superabundance of the main ornamental themes, i.e. the doorway, the rose window, and the roofline of the façade with its acroteria in the shape of masks and a pineapple at the apex. Equally profuse decoration characterizes the superstructure of the sturdy campanile to the left of the façade. Other remarkable campanili are those of the cathedral churches of Rab, Zadar, and especially of Split (Spoleto). The latter was incorporated in a section of the enormous palace built by the Emperor Diocletian. Unfortunately, the Romanesque campanile was drastically and irreverently reconstructed in the

217. Timber 'stave church' at Borgund, Norway. 218. Viborg Cathedral, Denmark, belongs to the Roskilde group. 219. The Romanesque sections of Stavanger Cathedral, Norway, correspond to Anglo-Norman style concepts. 220. Lund Cathedral, Sweden, was built in the Rhineland manner to Lombard designs by Master Donatus. 221. Churches in Dalmatia (Yugoslavia) are closely related to those of Apulia and were influenced by the style of Pisa. The latter is discernible in Zadar Cathedral. 222, 223. The doorway of Trogir Cathedral, made by Radovan, is more Apulian in style, with French and Venetian features. 224. St Donat, Zadar, is an example of Lombard Early Romanesque architecture. 225. The Cathedral of St Demetrius in Vladimir (USSR). 226. Detail of the bronze doors of the cathedral of St Sophia in Novgorod (USSR).

nineteenth century, but its original form was retained, and it is not surprising that classical elements were added to the Lombard and Apulian features (Plate 221).

Venice also played its part, although at the time only on a modest scale. It was not until the Gothic period that Venetian influence became predominant. In general one might conclude that the Romanesque architecture of Dalmatia was inspired by northern Italy as regards groundplan, and by Apulia as regards its total decorative effect. This means that most of the churches are three-aisled basilicas, with three apses and no transept. S. Crisogono in Zadar, rebuilt in 1175, even has a 'dwarf gallery' surrounding the main apse.

There are numerous campanili of the Lombard type, with pilaster strips, arched friezes, and double and triple openings. Rab (Arbe) is particularly famous for its towers.

ROMANESQUE ARCHITECTURE IN HUNGARY

After Otto the Great had defeated the Hungarians in 955, they were converted to Christianity by force, but it was not until the reign of King Stephen the Saint (996–1038) that the Church was established and churches were built everywhere. The king himself had a palatine chapel built at Székesfehérvár.

Romanesque architecture in Hungary may be divided into three periods, influenced respectively by Italy, France and Germany. To the first period belongs the cathedral of Pécs, dating from the eleventh and twelfth century. It is a timber-roofed three-aisled basilica, with three apses. It is obvious that it was inspired by Italian examples dating from the tenth and eleventh centuries, a fact which is confirmed by the ornamental sculpture. The sole non-Italian feature is provided by four identical towers on the corners of the building. Usually these towers are incorporated in the rectangular groundplan, as at Esztergom and Székesfehérvár, but in Pécs they adjoin the side walls. There are several theories about the origin of this unusual arrangement, but none of them can be considered conclusive.

The influence of French architecture began when the Cistercians settled in Hungary in 1142. Nothing remains of the earliest churches founded by the monks of Cîteaux, but French influence is clearly apparent in the church of the Benedictine abbey of Vértesszenkerest, founded in 1146, and in the second cathedral of Kalocsa, which dates from the second half of the twelfth century. The latter had a transept and a choir with an ambulatory and radiating chapels, and was rib vaulted. Only two Cistercian churches survive, both dating from the thirteenth century: Kercz, founded in 1202, and Apátvalva, founded in 1232. Both are built on the usual Cistercian plan, with this exception: that the chancel of Kercz has a polygonal instead of a rectangular termination.

Gertrude, the German wife of King Andreas II, favoured her countrymen

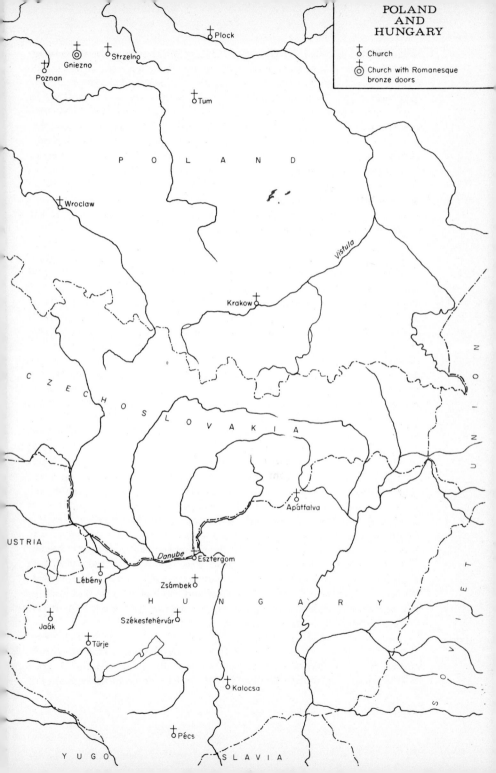

POLAND
AND
HUNGARY

⊕ Church

◎ Church with Romanesque
 bronze doors

○ Plock

◎ Gniezno ○ Strzelno
⊕ Poznan

⊕ Tum

P O L A N D

⊕ Wroclaw

Vistula

⊕ Krakow

C Z E C H O S L O V A K I A

⊕ Apátfalva

USTRIA

Danube ⊕ Esztergom

⊕ Lébény ⊕ Zsámbek

H U N G A R Y

⊕ Jaák ○ Székesfehérvár

⊕ Türje

⊕ Kalocsa

⊕ Pécs

Y U G O S L A V I A

S O V I E T U N I O N

to such an extent, that the Hungarians found it necessary to assassinate her in 1213. German influence is evident in the final group of Romanesque churches, such as those of the Benedictine abbeys of Lébény (1206–10), Jaák (1210–41), Türje (*c.* 1240), Zsámbék (before 1255), and others. All are built on the cruciform plan, with either one or three apses, and two western towers. It is noteworthy that north Italian features were reintroduced, this time at second hand, together with the southern German forms. For instance, these churches are decorated with Lombard friezes and pilaster strips, and the towers are of the German-Lombard type encountered in Austria and Trentino as well. The German preference for paired windows was not shared. The western doorway of Jaák even has column-bearing lions, a feature which also occurred in a doorway, no longer extant, of the cathedral of Esztergom; it dated from around 1200–9.

ROMANESQUE ARCHITECTURE IN POLAND

Under Duke Mieszko of the Piast dynasty, the country had been converted to Western Christianity (966); Poznán was the first bishopric. In 1000 Gniezno became an archiepiscopal see, and in the reign of Boleslav III (*d.* 1138), Kraków was made the capital.

The earliest churches date from the late tenth century. As they were castle chapels, their function was defensive as well as religious. They usually consisted of a circular core surrounded by four apses, which gave the groundplan the semblance of a Greek cross. One of the best-known examples is the chapel of St Felix and St Audactus in Castle Wawel in Kraków. Others consisted of a rectangular or circular space with one apse; they are akin to similar structures in Silesia and Bohemia. These designs, based on Slav traditions, were, however, soon to be replaced by the Romanesque style introduced from the west, and in this process itinerant north Italian architects and stonemasons were to play an important part here also. In the larger churches the basilican design became predominant, with a transept and a deeper choir than usual; while exteriors were enlivened with the usual Lombard features of pilaster strips and small arcades. Crypts were relatively rare; but there is one example in the cathedral of Wrocław (Breslau), and the church at Wawel has a western crypt. Externally, sculpture was restricted to the doorways and their tympana, whereas in the interior not only capitals and plinths, but also pillar shafts were decorated with sculpture. This typically Polish ornamentation is found in Czerwinsk, Wrocław, Tum near Leczyca, Strzelno and elsewhere. The highlight of Polish doorway sculpture is the western entrance of the former Benedictine abbey church of St Mary Magdalen in Wrocław.

Apart from Lombard, German and Norman influences, Mosan elements penetrated into Poland as well. Here and there, for instance in the monastery church of Czerwinsk, they are evident in the sculpture of capitals. But the most celebrated instance is provided by the bronze doors of the cathedral of

Gniezno. Each door is decorated with nine scenes in relief, representing the life of St Adalbert and his mission to the Baltic countries under the patronage of the Polish king Boleslav Chobry. Each door is cast in one piece, like those at Hildesheim. They were probably made by two different artists, whose origin and dates are uncertain. It is supposed that they were commissioned by King Boleslav II, who reigned from 1102 to 1138. According to one theory the doors were cast in Magdeburg; others consider they were made in Bohemia. The Mosan influence is accounted for by the fact that monks from Mosan abbeys occupied high places in the Church in Poland, amongst others Alexander, bishop of Płock, and Vauthier, bishop of Wrocław, both from the abbey of Malonne near Namur. The Benedictine foundations in Poland (e.g. Wawel, Tyniec, Lublin Wielkopolski) also owed their existence to Italian and Mosan abbeys, and it was the Benedictines in particular who furthered Romanesque art. But the same is also true of the Augustine canons whose houses (e.g. Slaska Góra, Sobótka, Wrocław) were founded chiefly by French institutions. The Premonstratensians also founded numerous monasteries. The Cistercians came to Poland mainly from Morimond in France, and from Italy. They were active in the conversion of the more easterly regions, as far as Ruthenia. As elsewhere, so in Poland, they built numerous abbeys in their own characteristic style: Jędrzejów (1210), Łekno (1153), Lad (1146), Sulejów (1223), Pomorski Kolbacz (1173), Oliwa (1178), Wachock (1179), Koprzywnica (1185), and others.

It is therefore not surprising that all kinds of influences from the west combined in Poland, nor that Gothic made an early appearance here: as early as 1204 pointed arches and ribs were used for the first time in Trzebnica Slaska.

ROMANESQUE ARCHITECTURE IN THE MIDDLE EAST

Romanesque architecture was introduced in the Middle East chiefly as a result of the Crusades, and since the earliest of these were predominantly French, the style in these regions is based on that of France. Nevertheless, in spite of obvious affinities with examples in Provence, Burgundy and Languedoc, Romanesque architecture in the newly founded kingdoms of Antioch and Jerusalem may be said to have had its own indigenous character. Conversely, the East had its effect on architecture in France: consider, for instance, the dome construction in Périgord, and especially the advance of the pointed arch, which was used in Egypt and Syria as early as the seventh and eighth centuries. In Europe the latter made its first appearance around 1100; and the earliest domes in Périgord were constructed for the original cathedral of Périgueux, built from 1104 onwards.

The majority of the Romanesque churches in Syria and Palestine date from c. 1120 or later. They are distinguishable by their simple groundplan, usually three aisles ending in apses, their plain and solid manner of con-

struction, the trend to incorporate the semi-circular apses in a rectangular enclosure, the predominance of pointed arches and the use of flat terraced roofs. Transepts occur in Tyre, Caesarea and Sebastea (Samaria). The church of the Holy Sepulchre in Jerusalem also was enlarged by the crusaders with a transept and a deep chancel, with ambulatory and radiating chapels. Semi-circular apses within rectangular enclosures are found in Nazareth, Ramleh, Mount Thabor, Tortosa and Caesarea. The Cluniac abbey of Mount Thabor had two western towers, each enclosing a small chapel with an apse. Several of these churches are in ruins; of others only the foundations remain. From those which have survived more or less undamaged, we learn that the aisles were usually fairly lofty, and that the majority were roofed with continuous pointed barred vaults. The church of St Anne in Jerusalem has a central cupola on pendentives in the Byzantium manner (i.e. like Périgord). The cupola of the church of the Holy Sepulchre also rests on pendentives, but has a drum.

· Apart from the predominant French influences, features of Italian architecture may be noted in places. Tripoli in the Lebanon, for instance, has a Lombard campanile and a portal which contains north Italian elements.

ROMANESQUE SCULPTURE IN THE MIDDLE EAST

As mentioned above, the style of building in general is fairly plain, and sculpture on the whole is abstract and decorative. Capitals often approach the Corinthian form, with Byzantine and Islamic elements. It is noteworthy that wall shafts frequently have a square termination just below the capitals.

There are a few examples of richer sculptural ornamentation. The two lintels of the southern doorway of the church of the Holy Sepulchre are decorated respectively with a row of figures and a somewhat classical-looking continuous tendril ornament, in which all kinds of creatures have been incorporated. It is reminiscent of sculpture in Aquitania and Toulouse. The capitals of the uncompleted cathedral of Nazareth (building ceased after the defeat of the crusaders and the fall of Jerusalem in 1187) belong to the masterpieces of Romanesque sculpture in the Holy Land: entirely French in this case. The lively figures in high relief which decorate these capitals are placed beneath elaborately carved canopies, architectural in form.

We have already referred to the affinity between the capitals in the cloisters of Monreale and those of Nazareth (p. 77). It does indeed appear that sculptors who had to flee from Palestine after the collapse of Western power found refuge in southern Italy. At the same time there is remarkable similarity to the well-known capital at Plaimpied (Plate 105). Finally, mention should be made of some splendid illuminated manuscripts made in the Middle East, of which Queen Melisande's psalter in the British Museum (Ms. Egerton 1139) is perhaps the best known (dated c. 1130–40).

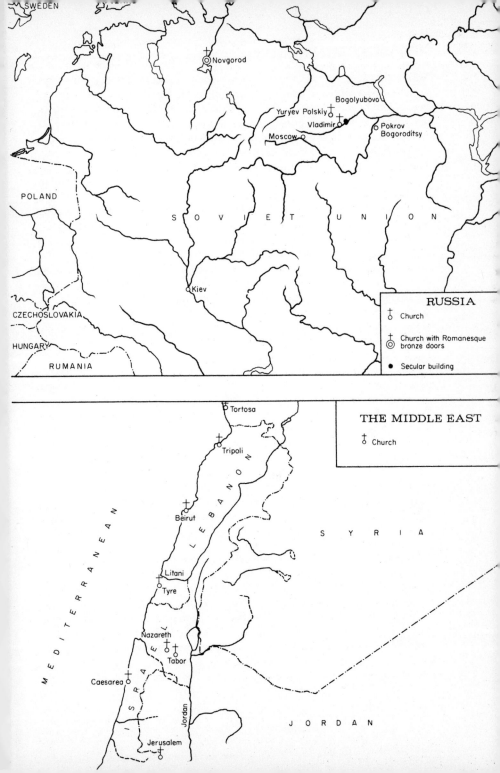

RUSSIA

† ○ Church

† ○○ Church with Romanesque
bronze doors

● Secular building

THE MIDDLE EAST

† ○ Church

SWEDEN

○ Novgorod

Bogolyubovo

Yuryev Polskiy ○
Vladimir ●
Moscow ○
Pokrov
Bogoroditsy

POLAND

S O V I E T U N I O N

Kiev ○

CZECHOSLOVAKIA

HUNGARY

RUMANIA

Tortosa ○

Tripoli ○

M E D I T E R R A N E A N

Beirut ○

L E B A N O N

S Y R I A

Litani ○
Tyre ○

Nazareth ○
Tabor ○

I S R A E L

Caesarea ○

Jordan

Jerusalem ○

J O R D A N

Russia cannot be regarded as border territory of the Romanesque—the frontier has been crossed and a veil of doubt and uncertainty envelops even instances of affinity. A definite exception must, however, be made in the case of the bronze doors of the cathedral of St Sophia (Holy Wisdom) in the ancient city of Novgorod, south of Leningrad (Plate 226). These are certainly of German origin, this being evident amongst other things from the portrait of Bishop Wichmann of Magdeburg on the right-hand door. This figure, at the same time, serves to date the work: Wichmann was promoted archbishop in 1154, a title which he does not yet bear here. He had been made bishop in 1152, so that we may conclude that the doorways were made between 1152 and 1154. Alexander, bishop of Plock, is also represented. His pontificate lasted until 1156, so that it seems probable that the doors were intended for the cathedral of his city. It does in any case appear that they were altered and adapted for their present situation, for most of the square panels have been enlarged by the addition of a narrow strip containing a single figure. Some of these are obviously Russian, as is the sensitively modelled figure of a centaur in the bottom right-hand corner. A small upright figure in the opposite corner bears the inscription *Riquinus me fecit*. This was probably a Magdeburg bronze-caster, who made the work in the middle of the twelfth century.

Twelfth- and early thirteenth-century Russian architecture embraces one regional group of buildings which are important for Romanesque architecture, namely the works commissioned between 1100 and 1240 by the rulers of the principality of Vladimir-Suzdal', from Vladimir Monomakh to Yuri II, whose army was defeated in 1238 by the Tartars. Monomakh's son Yuri I Dolgoroeki, and especially the latter's son and successor Andrei, were great patrons, who commissioned not only numerous churches, but also magnificent palaces. The most remarkable feature of their style of building is the presence, not only of Caucasian, but also of Romanesque features borrowed from the West. For instance, monumental and decorative sculpture receives an emphasis which in Russia is strikingly unusual. A chronicler informs us that God sent 'artists from every country' to Andrei, and elsewhere we read that the Emperor Frederick Barbarossa despatched architects from Germany to Suzdal'.

Several buildings from this period have been preserved to a greater or lesser extent. There is first of all the church of the Protection and Intercession of the Holy Virgin at Prokrov Bogoroditsy, near the confluence of the rivers Nerl and Klyazma. It dates from 1166. It is a slender structure with arches and pilasters, of a kind which had occurred even earlier in this region, for example in the church of St Boris and St Gleb in Kideksja. Here the decoration is Lombard but on the Prokrov church all the articulation has become more ornate and stands out in greater relief. Thus the arched friezes rest on pillars supported by corbels. The three portals, in the west,

north and south walls of the church, have archivolts widening towards the exterior. These are of a distinctly Romanesque character. Not only these doorways, but also the capitals and corbels provided opportunities for the sculptors, as did the wide blind arches under the roofline. Just as the groundplan, with its three portals, reminds us of the architecture of Armenia (Ani), so also does the sculpture show affinity with Caucasian and Armenian art of the tenth and eleventh centuries. But the manner in which the sculpture has been applied to the walls is reminiscent of German, Austrian and Hungarian architecture, which in turn was influenced by Pavia in Lombardy. The same applies to the form of the doorways, which invariably lack a tympanum. One might even ask oneself whether there may have been influence in the opposite direction, i.e. from Russia to the West, in churches such as Schöngrabern.

After Andrei had been assassinated in 1175, his younger brother Vsevolod III continued his building activities. The great cathedral of the Dormition of the Virgin in Vladimir, which was destroyed by fire in 1183, was reconstructed in the new style. A culminating point of the period is the church of St Dmitri, begun in 1193 or 1194, and completed in 1197 (Plate 225). In spite of eighteenth- and nineteenth-century restorations, this church provides the richest example of the style of Vladimir-Suzdal'. The sculptural decoration is much more abundant here, and even continues up to the drum of the slender cupola. A late example, finally, is the church of St George (1229–34), built by Yuri's brother Svyatoslav Vsevolodovitch in Yuryev-Polskiy. The church collapsed in 1471, but was reconstructed by the Moscow architect Yermolin. Its walls were decorated with sculpture over their entire surface, more than was the case anywhere else. However, when the church was reconstructed, the exact patterns of the sculpture were ignored, with the result that they became mixed up. The church, moreover, was reduced to half its original height. Nevertheless the sculpture of Yuryev-Polskiy is of the greatest importance.

Finally, we must mention the remnants, though modest, of Andrei's palace at Bogolyubovo. Of this building, which, to judge from descriptions, must have been one of the most glorious residences in eastern Europe, nothing remains but part of the northern staircase tower, which from the palace gave access to the upper gallery of the chapel. Here too we find, in the two lower stages, the 'Romanesque' of Vladimir-Suzdal', with pilasters, blind arcading and Lombard friezes supported by small pillars.

BIBLIOGRAPHY

Aubert, M., *L'architecture cistercienne en France*, Paris, 1943.

–, et al., *L'art roman en France*, Paris, 1961.

Badenheuer, F. and Thümmler, H., *Romanik in Westfalen*, Recklinghausen, 1964.

Bagné, E., *La alta edad media*, Barcelona, 1953.

Baldass, Buchowiecki, Mrazek, *Romanische Kunst in Oesterreich*, Vienna, 1962.

Beckwith, J., *Early Medieval Art, Carolingian, Ottonian, Romanesque*, London, 1964.

Beutler, Chr., *Bildwerke zwischen Antike und Mittelalter*, Düsseldorf, 1964.

Beyer, O., *Romanik in Spanien, die früben katalanischen Kirchenbilder*, Kassel, 1960.

Blindheim, M., *Norwegian Romanesque Sculpture 1090–1210*, London, 1965.

Brehier, L., *Le style roman*, Paris, 1941.

Brenk, B., *Die romanische Wandmalerei in der Schweiz*, Berne, 1963.

Brigode, S., *Les églises romanes de Belgique*, Brussels, 1944.

Busch, H., *Germania romanica, die hohe Kunst der romanischen Epoche in mittleren Europa*, Vienna and Munich, 1963.

–, and Lohse, B., *Romanische Plastik in Europa*, Frankfurt a.M., 1961.

Clapham, A. W., *Romanesque Architecture in Western Europe*, Oxford, 1959.

–, *English Romanesque Architecture*, London, 1965.

Collon-Gevaert, S., Lejeune, J., Stiennon, J., *Art roman dans la vallée de la Meuse au XIe et XIIe siècle*, Brussels, 1962.

Conant, K. J., *Carolingian and Romanesque Architecture, 800–1200*, Baltimore, 1959.

Crichton, G. H., *Romanesque Sculpture in Italy*, London, 1954.

Decker, H., *Italia romanica, die hohe Kunst der romanischen Epoche in Italien*, Vienna and Munich, 1958.

Delogu, R., *L'architectura del medioevo in Sardegna*, Rome, 1953.

Denis, V., and Vries, Tj. E. de, *Kunst aller Tijden*, Amsterdam and Brussels, 1963.

Deschamps, P., *Terre sainte romane*, Paris, 1964.

Dimier, M. A., *Recueil des plans d'églises cisterciennes*, Paris, 1949.

Durliat, M., *Hispania romanica, die hohe Kunst der romanischen Epoche in Spanien*, Vienna and Munich, 1962.

–, *L'art catalan*, Paris and Grenoble, 1963.

Eschapasse, M., *L'architecture bénédictine en Europe*, Paris, 1963.

Evans, J., *Cluniac Art of the Romanesque Period*, Cambridge, 1950.

Focillon, H., *L'art des sculpteurs romans*, Paris, 1931, 1964.

–, *Art d'Occident, Le Moyen Age roman et gotique*, Paris, 1938.

–, *L'an Mil*, Paris, 1953.

Francastel, P., et al., *L'art mc'an*, Paris, 1953.

Francovich, G. de, *Benedetto Antelami e l'arte di suo tempo*, Florence and Milan, 1952.

Gall, E., *Dome and Klosterkirchen am Rhein*, Munich, 1956.

Gantner, J., Pobé, M., Roubier, J., *Gallia romanica, die hohe Kunst der romanischen Epoche in Frankreich*, Vienna and Munich, 1955.

Grivot, D., Zarnecki, G., *Gislebertus, sculpteur d'Autun*, 1960.

Grodecki, L., *L'architecture ottonienne*, Paris, 1958.

Hamilton, G. H., *The Art and Architecture of Russia*, Baltimore, 1954.

Harvey, J., *English Cathedrals*, London, 1961.

Henri, Fr., *L'art irlandais I-III*, La Pierre-qui-Vire, 1962–1964.

Hutton, E., *The Cosmati, the roman marble workers of the 12th and 13th centuries*, London, 1950.

Jantzen, H., *Ottonische Kunst*, Munich, 1947 (Hamburg, 1959).

Julian, R., *Les sculpteurs romans de l'Italie septenrionale*, Paris, 1952.

Kayser, F., *Kreuz und Rune, Langobardisch-romanische Kunst in Italien, I: Werdezeit*, Stuttgart, 1964.

Kluckhohn, E., *Die Bedeutung Italiens für die romanische Baukunst und Bauornamentik in Deutschland*, Marburg, 1955.

Korevaar-Hesseling, E. H., *De wereld va het Romans*, Amsterdam and Brussels, 1963.

Krauze, A., et al., *The Sacred Art in Poland, Architecture*, Warsaw, 1956.

Kubach, H. E., *Die frübromanische Baukunst des Maaslandes, Zeitschrift für Kunstwissenschaft*, VII, pp. *113 ff.*, 1953.

–, *Die spätromanische Baukunst des Maaslandes, Das Münster*, VII, pp. *205ff.*, 1954.

–, and Bloch, P., *De Bloeiperiode van het Romaans*, Amsterdam and Brussels, 1965.

Kusch, E., *Alte Kunst in Skandinavien*, Nuremberg, 1964.

Leask, H. G., *Irish Churches and Monastic Buildings: I. The first phase and the Romanesque*, Chester Springs, 1955.

Lefrançois-Pillion, L., *L'art roman en France, architecture, sculpture, peinture, arts mineurs*, Paris, n.d.

Leisinger, H., *Romanesque Bronzes, church portals in mediaeval Europe*, London, 1956.

Lemaire, R., *Les origines du style gothique en Brabant, I, L'architecture romane*, Brussels and Paris, 1906.

Loukomski, G. K., *L'architecture religieuse russe du XIe siècle au XVIIe siècle*, Paris, 1929.

Magni, M., *Architettura romanica comasca*, Milan, 1960.

Mâle, E., *L'art religieux du XIIe siècle en France*, Paris, 1922.

Meer, F. v. d., *Atlas van de Westerse Beschaving*, Amsterdam and Brussels, 1963.

Messerer, W., *Romanische Plastik in Frankreich*, Cologne, 1964.

Michel, P. H., *La fresque romane*, Paris, 1961.

Novotny, F., *Romanische Bauplastik in Oesterreich*, Vienna, 1930.

Ozinga, M. D., *De romaanse kerkelijke bouwkunst*, Amsterdam, 1949.

Petricioli, I., *Pojava romanicke skulpture u Dalmaciji*, Zagreb, 1960.

Pinder, W., *Die Kunst der deutschen Kaiserzeit bis zum Ende der Staufischen Klassik*, Leipzig, 1935.

Porter, A. K., *Lombard Architecture*, New Haven, 1915–1917.

–, *Romanesque Sculpture of the Pilgrimage Roads*, Boston, 1923.

–, *Romanische Plastik in Spanien*, Florence and Munich, 1928.

Puig i Cadafalch, J., *L'arquitectura románica a Catalunya*, Barcelona, 1909–1918.

–, *Le premier art roman*, Paris, 1938.

–, *La géographie et les origines du premier art roman*, Paris, 1935.

Quintavalle, A. O., *Antelami sculptor*, Milan, 1947.

Reinhardt, H., *Die kirchliche Baukunst in der Schweiz*, Basle, 1947.

Rice, D. Talbot, *English Art, 871–1100*, Oxford, 1952.

–, *A concise History of Russian Art*, London, 1963.

Saalman, H., *L'architecture romane*, Paris, 1962.

Salmi, M., *L'architettura romanica in Toscana*, Milan and Rome, 1927.

–, *La scultura romanica in Toscana*, Florence, 1928.

Salvini, R., *Wiligelmo e le origini della scultura romanica in Emilia*, Milan, 1955.

–, *La scultura romanica in Europa*, Milan, 1956.

Schaffran, E., *Die Kunst der Langobarden in Italien*, Jena, 1941.

Schnitzler, H., *Rheinische Schatzkammer II, Die Romanik*, Düsseldorf, 1959.

Schrade, H., *Vor- und frühromanische Malerei*, Cologne, 1958.

–, *Die romanische Malerei*, Cologne, 1963.

Verzone, P., *L'architettura religiosa dell'alto medio evo nell'Italia settenrionale*, Milan, 1942.

Webb, G., *Architecture in Britain, The Middle Ages*, Baltimore, 1956.

INDEX

References to illustration numbers are given in italic.

239

SOURCES FOR ILLUSTRATIONS

(in alphabetical order)

A.C.L., Brussels: 14, 127, 142, 143, 170, 172; Aistrup, I., Vedbaek: 218; Alinari, Florence: 17, 18, 22; Anderson, Rome: 19; Archives Photographiques, Paris: 70, 78, 83, 84, 86, 91, 93, 94, 95, 96, 97, 98, 100, 101, 102, 105, 106, 110, 115, 116, 118, 120, 122, 123, 125, 126, 128, 129, 130, 169; Beek, M. van, Amsterdam: 185, 201; Brogi, Florence: 20; Colorphoto Hans Hinz SWB, Basle: 167; Gabinetto Fotografico Nazionale, Rome: 11; Gaudilliere, Boyer: 65, 68, 71, 77, 85; Heyden, A. A. M. van der, Naarden: 1, 4, 29, 41, 87, 124; Lahaye, F., Maastricht: 7, 15, 88, 114, 149, 157, 176, 184, 200, 203, 217, 221, 222, 223; Marburg, Bildarchiv: 9, 104, 133, 134, 139, 145, 151, 154, 155, 159, 161, 163, 164, 165, 173, 174, 199; Mas, Barcelona: 177, 178, 179, 180, 181, 182, 183, 186, 187, 188, 189, 190, 191, 192, 193, 194, 195, 196, 197, 198, 202, 204; Matt, L. von, Buochs: 33, 34; Italian National Tourist Office, Amsterdam: 44; Yugoslav National Tourist Office, The Hague: 224; National Buildings Record, London: 206, 207, 208, 209, 211, 212, 214, 215, 216; Rheinisches Bildarchiv, Cologne: 147; Scott, W., Bradford: 205, 210; Sibbelee, H., Nederhorst den Berg: 66, 67, 108, 148, 225, 226; Smith, E.: 213; Splendide Bourgogne, Tournus: 117; Stavanger Aftenblad, Stavanger: 219; Werbe- und Verkehrsamt, Bildarchiv, Münster (Westph.): 168.